Advance Praise for
ArtCurious

"Jennifer Dasal understands that it's the stories that make art interesting, not names and dates and movements. This book is bursting with useful and entertaining tales that will forever change the way you look at some of the world's best loved artworks."

—Sarah Urist Green, author of *You Are an Artist*

"The term 'art history' is often equated with a good cure for insomnia—well, this book won't let that happen! Jennifer Dasal has transformed 'art history' into 'you will *not* believe this,' one crazy, artsy story at a time."

—Danielle Krysa, *The Jealous Curator*

"For all those who remember—yawning—the tedium of art history lectures in dark classrooms, Jennifer Dasal's *ArtCurious* is here to shake you awake, open your eyes, and get your heart racing. This is art history as adventure, mystery, whodunit, and even comedy. In short, a passionate pursuit of the innately interesting. You'll never look at art—or art history—the same way again."

—Bridget Quinn, author of *She Votes*

"Dasal reveals in this entertaining survey the weird, wacky, and unbelievable backstories of some of the world's greatest artists and most famous works of art. . . . Both art aficionados and novices will find something to appreciate in this offbeat and informative outing."

—*Publishers Weekly* (starred review)

PENGUIN BOOKS

ARTCURIOUS

Jennifer Dasal is the curator of modern and contemporary art at the North Carolina Museum of Art in Raleigh, North Carolina, and the host of the independent podcast *ArtCurious*, which she started in 2016 and which was named one of the best podcasts by *O, The Oprah Magazine* and *PC Magazine*. She holds an MA in art history from the University of Notre Dame and a BA in art history from the University of California, Davis. She has also completed PhD coursework in art history at Pennsylvania State University. She lectures frequently on art both locally and nationally.

ARTCURIOUS

Stories of the Unexpected,
Slightly Odd, and Strangely
Wonderful in Art History

Jennifer Dasal

PENGUIN BOOKS

PENGUIN BOOKS

An imprint of Penguin Random House LLC
penguinrandomhouse.com

Copyright © 2020 by Jennifer Dasal

Penguin supports copyright. Copyright fuels creativity, encourages diverse voices, promotes free speech, and creates a vibrant culture. Thank you for buying an authorized edition of this book and for complying with copyright laws by not reproducing, scanning, or distributing any part of it in any form without permission. You are supporting writers and allowing Penguin to continue to publish books for every reader.

Photo credits appear on pages 259–260.

LIBRARY OF CONGRESS CATALOGING-IN-PUBLICATION DATA

Names: Dasal, Jennifer, 1980– author.
Title: Artcurious : stories of the unexpected, slightly odd, and strangely wonderful in art history / Jennifer Dasal.
Description: First. | New York : Penguin Books, 2020. | Includes bibliographical references and index.
Identifiers: LCCN 2020013857 (print) | LCCN 2020013858 (ebook) | ISBN 9780143134596 (paperback) | ISBN 9780525506409 (ebook)
Subjects: LCSH: Art—Anecdotes. | Artists—Anecdotes. | Art--History—Miscellanea. | Curiosities and wonders.
Classification: LCC N7460 .D37 2020 (print) | LCC N7460 (ebook) | DDC 709—dc23
LC record available at https://lccn.loc.gov/2020013857
LC ebook record available at https://lccn.loc.gov/2020013858

Printed in the United States of America

Set in Warnock Pro
Designed by Cassandra Garruzzo

To Josh and Felix

The essence of all beautiful art, all great art, is gratitude.
FRIEDRICH NIETZSCHE

Contents

The Strangely Wonderful

ArtCurious, or Why
Art Isn't (Always) Boring

make my living surrounded by art—loads of it. As the curator of modern and contemporary art at the North Carolina Museum of Art in Raleigh, North Carolina, my days are spent roaming our galleries, researching the collection, and gleefully debating the merits and connections between works of art. While being this close to the art is enough of a reward on its own, I think one of the best parts of the job is meeting fellow art lovers: those who reminisce about childhood field trips to the museum, praise a recent reinstallation, or ask about the location of a particular painting as if it were a long-lost friend. These people—the ones who wax rhapsodic about brush strokes and craftsmanship, about symbolism and inspiration—are *my* people.

However, you might be surprised to hear that I like meeting committed *non-art* types just as much. Regularly I am introduced to those who slept through college art history classes, snoring over a professor droning on about sfumato and *contrapposto*. I hear from museum patrons who admit that their visit was influenced not so much by the art, but by the museum café's excellent burger and sweet potato fries. There are the students sheepishly revealing their presences as merely a concession to art-friendly grandparents. There are also the people who pause to stare at a work before inevitably demanding, point-blank, "What's the big deal anyway?" Similarly, some feel uncomfortable even setting foot inside a museum, alienated perhaps by a lack of exposure to the arts and a fear that they will be unable to understand them, or a sense that the art world was never quite welcoming in the first place.

Art just isn't everyone's thing. I get that.

It may come as a shock to you that an art historian like me could, in fact, be uniquely suited to sympathize with these art doubters, but I am. I truly relate to those who proclaim, time and time again, that art just isn't for them.

I can relate because I used to *be* them.

Art most definitely wasn't my thing when I was growing up. Instead, I was predisposed toward words, so when I began writing stories as a young child, I was happy with my narrative structure and character development (even if the names of said characters left something to be desired. A unicorn named Beautiful? *Really, five-year-old Jen?*). But the idea of illustrating my own tales made me squirm uncomfortably on my desk chair. Grasping a variety of crayons and markers, I would scrawl away in hopes of bringing my words to life in an aesthetically pleasing manner. And I was always disappointed at the mess that materialized on my page, rather than the masterpiece I hoped to see.

Not that I fared much better within a structured artistic environment. Picture me, a middle schooler, armed with nothing but a pencil, an eraser, and a piece of paper. I'm given one directive: I, and my fellow students, have exactly five minutes to draw "a perfect circle." No compass, no ruler—just our bare hands maneuvering the most basic drafting tools. "Don't worry," our art teacher assured us, "you can erase as much as you want. But you'd better get as close to *a perfect circle* as you can! Letter grades will be given."

This dreaded circle exercise began every art class during my middle school years. To this day, I have no concept of how useful this exercise is or if it is a common educational method. But I've never forgotten how my artwork was scrutinized for middle school course credit or how it made me feel. *This must be what art is all about,* I told myself. *And it's torture.* I suspect some variation of these events has affected others out there too. Maybe even you.

And that's a real shame. Because, as I was about to discover, art can be so much more.

By the time I reached the start of my freshman year in college, I had successfully avoided art at all costs, focusing my energies on science instead. I declared my major early and proudly—geology, with a paleobiology emphasis—and planned all my courses out accordingly: chemistry, calculus, earth sciences. I was *stoked*. But I needed a course to fulfill that pesky little humanities requirement.

Through an act of what felt at the time like supreme bad luck, every course I wanted to try—film studies, folklore and fairy tales, great books—was full. Frustrated, I made an appointment with a course counselor. "No problem," she assured me. "We'll just find you any class that is open and we'll see what we can do."

With a flick of her wrist, she dropped a course catalog onto her desk—a book so thick that it made an alarming *thunk* when it landed—and opened the alphabetical listings to the very beginning—the letter *A*. After a few seconds, she glanced up confidently. "Here we go, art history! *Everyone* takes art history courses here. Let's just see if you can get in."

Before I had time to open my mouth in protest, she had already logged into her computer and registered me. Without my blessing, I was about to delve into a semester-long course I detested. Art? Art *history*? It sounded excruciating, ridiculous, useless, boring.

By midsemester of my freshman year, though, the joke was on me. Having entered the study of art under duress, I started to realize that I actually looked forward to art history class, to the backstories, the hidden symbolism, even the terminology, finding it more compelling than my chemistry lab or my geological studies. Stranger still, I experienced the oddest impulse during my downtime. While my roommates devoured Stephen King and Dean Koontz, as well as the occasional Fabio-covered romance novel, I gravitated toward reading ahead in my art history textbook and spending hours immersed in the beautiful full-color illustrations (*cough* *Nerd alert!* *cough*). The effect was unsettling, and it caused me to question what I had long considered to be core beliefs: *I don't like art. Art history is boring.* Right? *Right?*

Wrong. I actually *loved* learning about art.

And here's why. Art history, to me, is all about *stories*: what compels an

artist to create, what a subject or theme might reveal about an art collector or patron; how an artwork was received or reviewed when it was first made. Though I learned every art term that came my way in school—tenebrism, single-point perspective, lost-wax method—and memorized artist names, time periods, and artwork dates, I quickly discovered that the *whats* of art history were far less enthralling to me than the *hows* and the *whys*: how can you illustrate a three-dimensional object believably in a two-dimensional form? How do artists' personal stories affect their output, if at all? Why would a painting or a sculpture cause such a furor as to shock an entire section of society? These questions thrilled me, and the answers were as moving and engrossing as any novel or play. I simply couldn't get enough.

Art history opened up a new and undiscovered world of knowledge unlike anything I had ever experienced previously. It immersed me in history (duh), world religions, philosophy, great works of world literature, scientific analysis, and, yes, even a little math here and there. Through the study and love of art history, I've mastered the plot points of many Greco-Roman myths via ancient sculpture, as well as paintings by Titian and Rubens; absorbed the basic tenets of Buddhism; cataloged the names and identifying features of hundreds of Catholic saints through sacred architecture spanning millennia; dug into the nitty-gritty of political dissidence and revolution in the paintings of the Neoclassicists; and become more attuned to the power of advertising through its elevation to fine art through Lichtenstein and Warhol. (Not to mention that art history does wonders for appreciating Beyoncé music videos.) In short, art history has transformed me, and if you give it a chance, it just might transform you too.

I find it to be a comedic act of karmic retribution that today, as someone who makes a living by being fully immersed in the world of art, I'm frequently bombarded by the same art-is-boring comments that I shared when I was younger. Sure, I still meet acquaintances who go all googly-eyed when I mention my job as a museum curator, but I've been surprised by the sheer number of apathetic reactions I receive to art and to museums. While I never expect or need people to *adore* art the way I do, I always

smile knowingly and say, "I know. I used to feel the same way. You just need a good story to get you into it."

Enter the *ArtCurious* podcast.

In mid-2016, I debuted this audio show with the hope that I could share some of the tales that made art history so intriguing for me, as an art doubter. *ArtCurious* isn't—and wasn't meant to be—an introduction to art history or a replacement for an art education but as a way to share fascinating narratives of art, artists, and how our world has been affected by them in strange, unexpected ways—because the best stories are the odd ones, the funny ones, the mysterious and uncomfortable ones. I wanted to take art history away from being stuffy or rarefied and make it more easily accessible—because art history can be educational, sure, but it can also be *fun*. *ArtCurious* is a podcast all about the good stuff. And now, in 2020, *ArtCurious* is a book all about that good stuff too.

I frequently note to friends that I am most excited by a great story, and that stories make all the difference in transforming a mundane object or idea into something truly special. "If you can tell me a truly rockin' tale about a tape measure," I tell them, "I will be enthused about tape measures *forever*." It is with this same mindset that I curated the stories in this book. While there will never be a dearth of fantastic and important stories to share about art and artists, the chapters herein were selected because they are some of my favorite examples of the unexpected, slightly odd, and strangely wonderful. With any luck, this book will bring you into a world that enthuses you too; and you'll find yourself declaring to your friends, "I just heard this random story about the *Mona Lisa*, and now I'll never think about that painting in the same way!"

The simple act of sharing art history through cool stories can be entertaining, sure, but it can also have deep and long-lasting effects. Art is one of the few things that connects us profoundly to one another and reveals our common humanity. And art is an impeccable time machine, linking us to even the earliest of creators (and anyway, cave paintings are way cooler than the elementary tools found within those caves, right?). Access and exposure to art and art history is essential to building and maintaining a well-rounded society—heck, even a well-rounded person. But even if you

are already on board with the whole art thing, you still might need a little nudge to rekindle your fire. That's where this book comes in, sharing weird and wonderful stories that remind us that the arts—and our creative drives—matter. Because art isn't (always) boring. Sometimes it's exactly what we need to make our lives more colorful.

The Unexpected

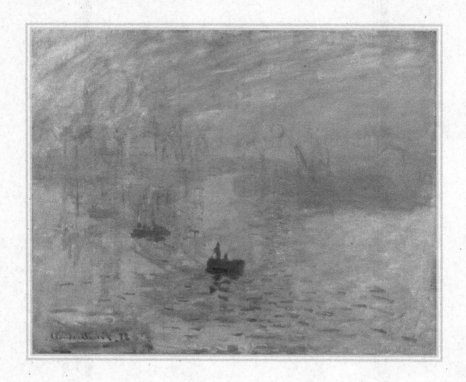

Claude Monet, *Impression: Sunrise*, 1872

CHAPTER 1

Your Mom's Favorite Painter Was a Badass: Claude Monet and the Subversive Impressionists

Other painters paint a bridge, a house, a boat. . . . I want to paint the air in which the bridge, the house, and the boat are to be found—the beauty of the air around them, and that is nothing less than the impossible.

CLAUDE MONET, ARTIST

The Impressionists are only . . . makers of spots [of paint].

EDMOND DE 8ONCOURT, CRITIC

Growing up, even though my mother exposed me to culture in its various iterations—the symphony, ballet, theater—I remember very little emphasis on visual art, other than the framed exhibition poster featuring one of Claude Monet's myriad water lily scenes that hung on my parents' bedroom wall. It held interest for me only in that it was chock-full of purples and pinks (the *best colors in the world* to six-year-old me).

I do recall, though, the day that my (lack of) knowledge of Claude Monet (1840–1926) moved from a bedroom wall to the greater world. My mother had scored my family tickets to a Monet show at San Francisco's de Young Museum, and we were all going to make a day of it—art! Lunch! Family bonding! She was thrilled.

My dad and I, though, were not. My father, to this day, isn't hugely interested in what he (affectionately) deems "art crap," and I couldn't think of anything worse to do on a sunny Saturday in the city than stare at a bunch of moldy old paintings by some moldy old dead dude.

He and I grudgingly trudged through the museum's packed galleries alongside my mom, who marveled at Monet's pastel-tinged paintings of delicate willow trees, rose trellises, footbridges, and those damned water lilies. At one point toward the end of the exhibition, long after Impressionism fatigue had set in, we came across a large horizontal canvas about ten or twelve feet in length hanging alone on a wall. It was a riot of color and brushstrokes, but had no discernible scene or subject matter. *What the heck is this supposed to be?* I grumbled internally (obviously, I wasn't aware of this little thing we call abstraction). My dad seemed to be thinking the same thing and quipped aloud, "This must be where he cleaned off his paintbrushes at the end of the day."

Together we laughed: it's not a painting! Just the framed remnants of a total mess! We had finally experienced that sought-after family bonding— only with Monet's paintings as the butt of the joke. And for a long time, the memory of that exhibition stayed with me, confirming my impressions of Monet: sloppy, light, pretty, and trivial. Claude Monet, the most boring painter of my childhood.

As I grew older, this concept of Monet-as-dull-painter didn't leave my mind; if anything, I grew more fervent in my convictions. Part of the reasoning for this was that I began to see him *everywhere*: flowers festooning umbrellas, haystacks reproduced on scarves. He was museum-store gold, adorning items that would make the perfect gifts for your mom (or my mom), and it further solidified my impression that Monet was nothing but decorative, along the same lines as popular artists like the saccharine Thomas Kinkade (1958–2012), "the Painter of Light," whose tableaux of insipidly aglow cottages could be found in malls throughout America during the same period (sorry, Thomas Kinkade fans).

When it came time for me to take the final course in my university's Introduction to Art History series, which covered artmaking from the nineteenth century onward, I scanned the syllabus and spotted a week dedicated solely to the merits of Impressionism. I rolled my eyes, returning to my time-honored complaint: *Oh great. This will be a waste of time.*

I have had to eat my words ever since.

Because what I quickly learned was that the Impressionists—old Claude Monet included—were rebels, rule breakers, troublemakers all. Think that Monet, Renoir, Degas, and others were trite and uninteresting? Wrong: they were actually subversive badasses who transformed visual art forever.

To understand how the Impressionists changed the course of art with such moxie and radical dissidence, we need to understand what art was like before they disrupted it all. The nineteenth century proved to be a tumultuous time in visual culture, wherein every art movement butted against the previous one with disdain. The first half of the century featured the rise of Romanticism, all swoony and obsessed with portraying the extremes of human emotion and natural grandeur, and distinctly at odds with the staid and stoic Neoclassical style that came before. German painter Caspar David Friedrich (1774–1840), one of my favorite artists, best represented the Romantic viewpoint and proudly declared, "A painter should not paint merely what he sees in front of him, but also what he sees within himself. If he sees nothing within, he should not paint what he sees before him." Feelings— and making the viewer feel things too—became a big freaking deal. Use your good friend Google to compare the eerily quiet *The Death of Marat* (1793, Musée Oldmasters, Brussels) by Jacques-Louis David (1748–1825) with the charged drama and energy of the shocking *The Third of May 1808* (1814, Museo Nacional del Prado, Madrid) by Francisco de Goya (1746–1828), and you'll see what I mean: David's Neoclassical portrait is a tone poem of virtue and mourning, but Goya's Romantic scene is bleak, harsh, and just plain horrific. Both paintings portray murder, but Goya's is more terrible and stirring.

Naturally, the latter half of the nineteenth century kicked off with a rebellion against such overt emotions and turned instead toward representation of the *real*. And thus the aptly named Realism was born. *No more of this overblown, imaginative stuff! Show the world like it is!* The enfant terrible of midcentury French painting, a gruff lout named Gustave Courbet (1819–77), was the exact opposite of Friedrich, and proclaimed, "Painting is

an essentially concrete art and can only consist of the representation of real and existing things." Take Courbet's 1869 work, *The Wave* (Musée des Beaux-Arts de Lyon), one of many seascapes that the artist would complete. Courbet only painted a crashing wave if he stood in front of it and watched it break—and did so not to evoke a strong emotion in a viewer, but simply because that's what the waves in the ocean looked like at that exact moment in time and in a specific place. No symbolism or feelings necessary.

Complicating matters a bit were the tried-and-true methods of artistic study, exhibition, and appreciation, all spearheaded in France by the state-sponsored *Académie des Beaux-Arts* (Academy of Fine Arts) in Paris, previously known as the *Académie de peinture et de sculpture* (Academy of Painting and Sculpture). At this juncture in history, if you were an artist, you *had* to either train at the Academy, be represented in its annual Salon exhibition, or both. There was really no other way to get your art seen or to make a viable living as a creative type. Even though private art galleries slowly began to pop up toward the end of the century, if you weren't part of the Academy and the Salon, you were *nothing*, artistically speaking. And that's not even taking into consideration the preferred artistic style promoted by the Academy, which was deemed . . . wait for it! . . . Academic.

Many of the professors teaching at the Academy expounded time-honored methods of Academic art production that balked against the opposing forces of both Romanticism and Realism: art, they said, should be based on the intense study of Classical Greco-Roman sculpture and inspired by the idealization of the human form. Not all crazy and emotive, but not exactly like the real world either. And artists were encouraged to think grandly in their subject matter: religion, mythology, and ancient history were deemed best, while scenes of daily life (often called genre scenes) or images of flowers or animals were seen as trite in comparison. Painting a sunset or a bouquet of roses for the sake of it wasn't good enough—you needed to have meaning, story, and idealism behind it all.

This confusing and contradicting art world soup is the realm into which Claude Monet, the future Impressionist god, stepped when he arrived in

Paris in 1859. Though the artist was born in the Parisian capital in 1840, he spent most of his childhood in the Normandy port town of Le Havre, about two hundred kilometers northwest of Paris. Like many artists, Monet expressed his talents early, frequently doodling in his textbooks and creating caricatures of his classmates, much to the dismay of his teachers. But chastising him did not work. As Monet noted later, "Even in my childhood, I could never be got to obey rules." He fared similarly at home. Old Papa Monet, Adolphe, wasn't thrilled with the arts—he was a businessman who owned his own company (the nature of which is still a bit unclear)—and he was vocal in his hopes that young Claude (also known as Oscar, or Oscar Claude) would carry on the family business. This thought brought Monet about as much joy as seeing Monet's paintings would, for little me, 130 years later. Thankfully, though, Mama Monet, Louise, was on her son's side. She was an admirer of the arts herself, and so she supported his artistic training until her death in 1857.

That same year, Claude met Eugène Boudin (1824–98), an established artist whose way of doing things was different—*he painted outside! In the fresh air! With bugs and birds and stuff!* This was radical and possibly even a little weird because most artists merely sketched a preparatory drawing outside, and then worked in designated studios or other art spaces to complete their works and with their myriad tools at the ready. But not Boudin. He introduced young Monet to his method of working *en plein air*, or making entire paintings outdoors, soup to nuts. Even more important, Boudin confirmed what Monet was beginning to realize about himself: he wanted to do this for a living. He wanted to be a great artist.

Naturally, being a great artist in the mid-nineteenth century meant moving to Paris, which Monet finally did, two years later, with only the most grudging blessing from his father (going against his father's wishes and hopes is yet another sign of Monet's rebellious nature, one that would grow more frequent as his father's distrust of art as a career grew). He applied and was accepted to study at the Académie Suisse, which had a reputation of being more advanced and far cooler than the Académie des Beaux-Arts. But after a period of stringent training, it appears that Monet became disillusioned with the traditional art school setting and preferred,

instead, to learn at the feet of a more forgiving master: Swiss painter Charles Gleyre (1806–74), whom he joined after a year spent in North Africa for national service.

Gleyre, to most, is a footnote in art history, but the sheer number of famous men who passed through his studio is insane: Jean-Léon Gérôme, Pierre-Auguste Renoir, James Abbott McNeill Whistler, Alfred Sisley, Frédéric Bazille, and many others. Gleyre himself painted in the Academic style, but his methods of instruction were relaxed, and he fostered an environment conducive to camaraderie and experimentation.

And what a camaraderie it became! Monet quickly grew attached to his fellow students, particularly Renoir, Sisley, and Bazille, and they gathered alongside other like-minded artists in their social circles: Camille Pissarro, Edgar Degas, Berthe Morisot. Immersed fully in modern Parisian life, they frequented cafés to discuss the latest techniques in painting, argued over the best way to depict urban development while lounging in newly built public parks, and gaped at the innovations of Édouard Manet (1832–83) and Gustave Courbet, who dominated and shocked Salon audiences in previous years with works like Courbet's *A Burial at Ornans* (1849–50, Musée d'Orsay, Paris) and Manet's *Olympia* (1863, also at the Musée d'Orsay). All these artists agreed that painting *en plein air* was the way to go and would often take trips beyond Paris to set up their easels, side by side, and work joyously in a quiet country lane or a breezy seaside village.

The Great Renoir Protest of 2015

On October 5, 2015, a small group of art lovers convened in front of the Museum of Fine Arts, Boston, railing against none other than Pierre-Auguste Renoir, the Impressionist painter most known for his pretty, blithe scenes of the Parisian bourgeoisie in the late nineteenth century. The protest seemed to come out of nowhere, inspired neither by a current exhibition nor a new discovery of something scandalous in the artist's past. So why were they protesting?

One reason: those lovely, insipid paintings. Renoir paintings are so pleasant and inoffensive as to be offensive, according to the protesters, led by Max Geller, founder of the Instagram account Renoir Sucks at Painting. In mock anger, Geller and his cohort held signs exclaiming "God Hates Renoir" and chanted insults (my favorite burn: "Other art is worth your while! / Renoir paints a steaming pile!").

And they do have a point. When compared to his compatriots, Renoir certainly isn't as groundbreaking or experimental, nor as pointed in his social commentary or as politically engaged. But in his own small way, he was rather revolutionary: at a time when art was all about the gritty reality of modern life, Renoir was committed to beauty. For Renoir to stick to portraying lovely things was his own gentle act of rebellion. As he once famously proclaimed, "Why shouldn't art be pretty? There are enough unpleasant things in the world."

Portraying their modern surroundings and painting them outdoors made up just the tip of the metaphorical iceberg that differentiated these artists from those who came before. Of utmost importance was the *way* they painted these surroundings: quickly, with pure, bright pigments often highlighted with a strong white base tone that brought a sparkly illumination to the surface. Such pigments, rapidly built up with thick and loose brushstrokes, were meant to convey the shifting and changing effects of light and atmosphere, as well as the fleeting, personal understanding of color (what looks blue to one person might read as teal to another—and that can make a big difference when you're painting the ocean, for example). It was a fresh and new way of creating, and it most certainly did not jibe well with traditional Academic painting, which Monet and pals snubbed as too dull, not lively, and certainly outmoded. These scrappy artists were out to find ways to become, as writer Charles Baudelaire would famously say, "the painter[s] of modern life."

It must have been an exciting time, but not an altogether comfortable one. As had happened with Manet and Courbet and many others before

them, Monet and his cohort struggled mightily at the hands of the Salon. Salon exhibitions, though juried by a range of artists and instructors, were nevertheless tied to the Academy and its preferred methodologies and subject matters. If a painting was too different and broke from too many art-historical traditions, it would not be accepted for the official exhibition. "Too *weird*," you can imagine a judge muttering. "Not traditional enough," another might say. As subjective and snooty as the Salon members could be, they were still the be-all and end-all of artistic taste, as well as being the most public demonstration of artmaking, and Monet knew all this. He *had* to get into the Salon to become well known and successful. There was no other way around it.

After a few near misses, Monet was invited to exhibit at the Salon of 1865 a few of his earlier, more Academic works—two Normandy seascapes inspired mostly by his time with Boudin. The following year he, too, was given the exhibition green light with a piece titled *Camille,* or *The Woman in the Green Dress* (*La Femme en robe verte,* 1886, Kunsthalle Bremen, Germany), a stunning painting of a brunette—Monet's future wife, Camille—seen from behind, bedecked in a black fur-lined jacket and a sprawling green-and-black-striped gown. It's gorgeous and arresting, and it got the attention of the Salon and art critics alike. But it brought few sales or additional commissions, and the early hope that his previous Salon acceptances engendered was soon replaced with despondency as he was repeatedly rejected over the following years. What's more, Monet frequently lived in dire poverty, with his paintings often seized by creditors when the artist couldn't afford to pay his bills. His few surviving letters from this time period are enough to give a reader whiplash, as they jump back and forth between proclaiming, "I have hope for the future!" and "[the] fatal rejection [of the Salon] has virtually taken the bread out of my mouth, and despite my expertly modest prices, dealers and art lovers are turning backs on me." In short, he felt like an utter failure.

By 1868, the situation had grown so critical that he attempted to commit suicide, throwing himself into the Seine River with hopes of drowning. He failed—and we, in the world, are all the better for it. (He also severely underplayed his attempt, writing to Bazille, "I was so upset yesterday that I

made the blunder of throwing myself in the water. Fortunately, there were no bad results.")

By the early 1870s, Monet and his pals were at their wit's end, frustrated by having to play the Salon game and submitting themselves to criticism time and time again with little or no return. Naturally, Monet was broke once more (though several scholars note that this wasn't necessarily the problem of dwindling sales, but the artist's extravagant spending habits and his refusal to save cash), and yet he was so heartbroken by his rejections that he refused to submit to the Salon after 1870, meaning that his income prospects were meager at best. He frequently hounded friends and acquaintances to buy his work at deep discount, all while pestering Bazille and other confidants for loans with increasing melodrama and intensity. And while some of his fellow artists were faring slightly better at the Salon and at life in general, they all knew that something needed to change in the way Art, with a capital A, was approached. It was time to take matters into their own hands.

In December 1873, they sprang into action: Monet, Pissarro, Renoir, Morisot, and Sisley (alongside Paul Cézanne, Edgar Degas, and others) founded the *Société anonyme coopérative des artistes peintres, sculpteurs, et graveurs* (or the Cooperative and Anonymous Society of Painters, Sculptors, and Engravers) with the hope of exhibiting their works independently, without Academy or Salon connections—in fact, members of the *Société anonyme coopérative* were told to shun the Salon outright, and any member who applied for exhibition there would be subsequently disbarred from the artists' society (and probably lose a group of pals in the process). Considering how powerful the Salon was, such a requirement was a risk—true, the Salon could make or break an artist, but there wasn't any guarantee that the Society could garner any attention or traction for these artists either. But it was a risk that the beleaguered group of friends was willing to take, and though their styles and subject matter differed in many ways, there was strength to be found in numbers. Joining one another for support in the goal of "painting modern life" was paramount, and five months later, in the spring of 1874, they opened their first exhibition, in the former studio of the photographer Nadar on le boulevard des Capucines, to the Parisian public.

The Dark Side of Impressionism:
The World of Edgar Degas

Not everything comes up roses in Impressionism. One glance at Edgar Degas's delicate, tutu-garbed dancers sends many art lovers into deep swoons, but lingering just beneath the surface of these pleasing pictures is something far darker.

Rehearsal of the Ballet Onstage, from around 1874 (Metropolitan Museum of Art, New York), presents viewers with a view of a stage packed with ballerinas, dramatically lit from below. A quartet practices at center stage, but most of the dancers are waiting their turn in the wings. The action here isn't so much in the dancing, but in the *not dancing*. More of the ballerinas—whom Degas often referred to as "little rats"—are stretching, yawning, tying their shoes, and even scratching their backs rather than performing a *grand jeté*. They're bored, not graceful, and the elegance with which we typically associate ballet is not evident here.

What's most unnerving, though, is the presence of two mysterious men seen at stage left, slouching in chairs and watching the women's every move. They seem predatory and possessive, and indeed, there has long been a precedent for that reaction: a link, warranted or not, between sugar daddies and the young, beautiful ladies of the stage whose lives are unmoored (or ended!) when their "companions" tire of them. Such unspoken but all-too-common connotations might explain why this image was denied publication by the *Illustrated London News* on the grounds of "impropriety." So much is hinted at here: sexual indecency, voyeurism, and even the sadomasochistic brutality of ballet itself. When considered alongside the reality of the creation of this work—Degas would hire these women as models for his ballet scenes, requiring them to stand or hold poses for excruciatingly long periods of time—this side of Impressionism is enough to make you sick to your stomach.

To be fair, the Society had a couple of big things working in its favor. The first is that there was already a precedent for this type of rebellious,

non-Salon art show—though, strangely enough, the French state was involved in its creation. In 1863, after a maddening round of Salon rejections, including the refusal of one of the most important paintings of the nineteenth century, Manet's *Le Déjeuner sur l'herbe*, or *The Luncheon on the Grass* (1863, Musée d'Orsay, Paris), public furor against the Salon and its jury skyrocketed. News of the dissent over the Salon reached the inviolable halls of Emperor Napoleon III, who sought to engender support and sympathy toward himself as much as toward artists, and he made a fascinating decision: open an alternative salon exhibition, and let the public see the rejected works.

The *Salon des Refusés*, or the Salon of the Refused, was a sensation: thousands of spectators crowded the Palais d'Industrie exhibition hall every day to view the works of art, even topping the attendance for the Paris Salon that year. While many critics and salongoers attended the *Salon des Refusés* as a kind of joke, the nineteenth-century equivalent of watching a truly terrible movie, nevertheless, something incredible happened: it opened eyes to other directions that artists could, and would, take. Art didn't need to be strictly regimented; there were avant-garde makers who were willing to push the envelope. Though the importance of the *Salon des Refusés* wouldn't be understood for many years later, it still set a tone of righteous experimentation: the *Refusés* themselves refusing to kowtow to tradition. Strangely enough, though, petitions to organize further versions of the *Salon des Refusés* were rejected, which meant that the refused were refused the chance to have another refusal show (is your head spinning yet?).

The *Salon des Refusés* greatly inspired the independent art exhibition organized by the *Société anonyme coopérative*, and the precedent it set made the acceptance of the Society's own exhibition that much stronger. A second favorable element was the decision to invite several well-established, like-minded artists to participate in the 1874 show in hopes of not only celebrating their works, but also as a way to add cachet to the art show. Monet invited his old mentor, Eugène Boudin, as well as another influential artist, the Dutch painter Johan Jongkind (1819–91). Both, however, gently declined the invitation, perhaps because of the severe decree forbidding present and future Salon participation. The Salon could bring attention,

governmental support, private commissions, and the like—for artists who had already been successful there, as Jongkind and Boudin had been, being associated with this group of rebels was probably a dangerous career move. Similarly, Manet opted out of participating, as being represented in the Paris Salon remained a lifelong goal of his. Pissarro, though, was successful in converting Paul Cézanne to the show, so it worked, to a degree. With that, the Society opened its first-ever exhibition in April 1874, with Cézanne opting to include his 1870 work *A Modern Olympia* (private collection), Renoir putting forth a new painting called *The Dancer* (1874, National Gallery of Art, Washington, D.C.), and Monet, most tellingly, presenting a view of the port of his hometown, Le Havre, with a work titled *Impression, Sunrise* (1873, Musée Marmottan Monet, Paris). It was their first hopeful step toward changing their fortunes.

And fortunes did indeed begin to change—but you wouldn't have known it from the reactions and opinion pieces published in local art rags. Most critics *hated* these paintings. On April 29, 1874, critic Émile Cardon published an article titled "*L'exposition des révoltes*" in *La Presse*, the first penny press newspaper in France. His take on the group exhibition was that its refusal to obey the tenets of traditional artmaking was a gross and foolhardy conceit. In words dripping with condensation, he noted:

> This school does away with two things: line, without which it is impossible to reproduce any form, animate or inanimate, and color, which gives the form the appearance of reality. . . . The excesses of this school sicken or disgust.

That same day, critic Jules Castagnary, in the competing penny press paper *Le Siècle*, ponied up in favor of the show with his review, "L'exposition du boulevard des Capucines," where he praised what Cardon had condemned:

> I swear . . . there is talent here, even much talent. These young people have a way of understanding nature which is not in the least boring or banal. It is lively, light, alert; it is ravishing.

These opposing reviews plainly encompass general opinion about the 1874 exhibition: a mixed bag of praise and censure for the unabashed break with tradition. One article, however, had the most influence, both short-term and long-term, on the future of the artists of the Society. A humor piece, written by critic Louis Leroy as a conversation between himself and Academic painter Joseph Vincent, appeared in the illustrated daily paper *Le Charivari* on April 25, 1874, the exhibition's opening day. In the article, Leroy and Vincent scoff and swoon repeatedly over the Death of Fine Art, until they reach Claude Monet's *Impression, Sunrise*, a canvas that most critics ignored or glossed over. The men noted the title of the painting, which led Vincent to comment sarcastically, "Impression—I was certain of it. I was just telling myself that, since I was impressed, there had to be some impression in it . . . and what freedom, what ease of workmanship! *Wallpaper in its embryonic state is more finished than that seascape* [italics mine]." What doubters had insinuated about these artists was made plain: their works were nothing more than sketches, unfinished, unpolished, and incomplete. They were *impressions*, Leroy sneered derogatorily, and he used Monet's title against him, officially naming the show *The Exposition of the Impressionists*.

The Impressionists! Even though it was meant to be an insult, it made perfect sense, as these artists strove to create paintings quickly and purely, with the intention of capturing the light and color of a moment—capturing an impression, indeed. The public loved the name, even if they weren't totally on board with the art, but even more amazing was that the Society's members soon adopted it with verve and enthusiasm (except for grumpy-pants Degas, who preferred the word *realism* to describe himself, and basically disliked most of what the other Impressionists stood for anyway). Breaking out on your own and thumbing your nose at the Establishment? That's cool. Turning an insult into a powerful self-identifier? Now that's badass.

All press is good press, so the mixed reception gained by the newly named Impressionists did much to bring them attention and visitors through each

subsequent year. Between 1874 and 1886, the group would hold eight "Impressionist" exhibitions (though they were never explicitly named as such), and each one was more interesting, successful, or influential than the year prior. Though few sales were made at the exhibitions themselves, the fact that the art was seen year after year made a big impact, an effect doubled by the care and foresight of famed art dealer Paul Durand-Ruel, who fervently supported the group and shopped their works in Paris and London (and eventually in New York). By the mid-1880s, Claude Monet's distressing financial straits were a thing of the past, and most of his cohort were independently supporting themselves as well. They did it! They were real-life, professional working artists, and they did it their way.

But just because their professional lives began to move more smoothly didn't mean that the artists themselves were all hunky-dory. As Impressionism's popularity slowly increased, the once close-knit group began to splinter. Monet felt comfortable enough with his finances and his position within this new, changing art world that he distanced himself from his fellow Impressionists in order to promote his individual style and subject matter, which was moving solidly toward a series of multiple canvases portraying the same scene in varying times of day and weather. By the time of the fifth "Impressionist" exhibition of the Society, held in 1880, Monet shockingly refused to participate, opting instead to enter works . . . at the *Paris Salon.* He openly flaunted his decision, which expressly rejected the founding rules of his own group, and he never looked back—especially given the fact that one of his works was *accepted* for exhibition at the Salon! How hardcore is that, to strike it out on your own and to reappear, victoriously, in front of the critics who once dismissed you? But the decision wasn't without its serious downsides: the other Impressionists resented him, and their friendships suffered or collapsed altogether.

Twenty years later, Claude Monet was so lauded and well known that the Parisian newspaper *Le Temps* published his autobiography, *Claude Monet par lui-même* (which roughly translates to *Claude Monet in His Own Words*), an account of the artist's artistic development completed a full twenty-six years prior to his death. In that article, Monet deftly

solidified the myth of his subversive, rebellious path, recalling an argument he reportedly had with his father prior to his move to Paris:

> I squarely announced to my father that I intended to become a painter and was moving to Paris to learn.
> "You will not get a penny!"
> "I shall do without."

This was Monet undoubtedly dramatizing his father's concerns for the sake of a good narrative, highlighting his poverty and Salon rejections, too, in order to make his later successes seem even more grandiose. He ends by bragging, "Today, everyone wants to know us."

The Limits of Vision: Claude Monet's Cataracts

In the 1995 hit film *Clueless*, the lead character, a chic social butterfly named Cher (Alicia Silverstone, in her breakout role), comments on a high school classmate's appearance to her friend Tai. "Do you think she's pretty?" Tai asks. "No, she's a full-on Monet," Cher scoffs. "It's like a painting, see? From far away, it's okay, but up close, it's a big old mess."

Even as an art historian, I can think of no better way to describe some of Claude Monet's post-1900 paintings. Consider the artist's famed Japanese bridge, a centerpiece in his garden in Giverny, France, which provided him with artistic fodder for more than a quarter century. Early iterations of these bridge paintings feature luminous colors, delicate attention to light and shadow, and short, broken brushstrokes. But a late-era bridge painting, like *The Japanese Bridge*, from around 1918 (now at the Musée Marmottan Monet, Paris), is shockingly garish, a rainbow of reds, yellows, and purples interspersed with puce green and baby blue. The barest of a red arch—the bridge itself?—can be seen if you really squint, but nothing here screams "landscape," and certainly not a specific garden feature.

Why this shift in style? The change was most likely due to his worsening eyesight. In 1905, around the time of his sixty-fifth birthday, the artist began to complain of problems of color perception. Greens and blues became literally harder to see. To make up for this loss, he turned instead to tones that he *could* perceive more clearly: yellows, reds, browns, and violets. What, exactly, was the problem with Claude's eyes? He was developing cataracts, which would increase with severity over the next two decades. The artist's growing frustration with his eyesight led him to seek corrective surgery (yet only for his right eye, oddly enough).

Post surgery, Monet's right eye recovered some of its clarity and perception, and he was able to see blues and greens once more—but the left eye, which Monet refused to have treated, continued to degrade. Corrective lenses did help, to a degree, but the alteration in size, shape, and even colors that the lenses produced was "quite terrifying" to the painter. Such variations in scale might explain the increased size of his brushstrokes too—each line or daub was magnified to his own eyes. Claude's messiness, then, is likely due to the strain and stress of his eye problems, which meant that he had to work more quickly to avoid pain and frustration. Those bigger, sloppier brushstrokes were merely a side effect.

So what changed? How did Impressionism go from being so hated to so loved, and Monet become the art world superstar we worship today? Sure, the passage of time certainly helped—in that twenty-year span, Monet's works were seen by an ever-growing audience, many of whom began to clamor for his newly trendy canvases of Japanese bridges, dusky cathedral exteriors, and (yes) water lilies floating in serene ponds. But what made these works, and others like it, stand out among the myriad pretty paintings throughout history?

For me, the enduring legacy of Impressionism comes down to two things. First is these artists' commitment to modernity, of finding worthy subject matter in a world that is still so familiar to us today: a suburban dinner party, a dimly lit city street, a crowded restaurant. Impressionism

pulls us in because we can see our own lives in it, as if we're the ones enjoying our leisure time in the company of friends, raising a glass of wine. *We*, as modern people in a modern world, are the subjects.

Second, Impressionism—for one of the first times in art history—was about valuing the *subjective* point of view about things that seem like they should be *objective*: light, color, shadow. A great example of this concept is a famous pair of canvases: Monet's and Renoir's *en plein air* images of La Grenouillère, a popular "frog pond" boating location on the Seine outside of Paris. Monet and his buddy Renoir sat side by side and painted La Grenouillère at the same time—and their canvases are *crazily* different. Monet's scene is mottled in muddy tones of green, brown, and blue; Renoir's is sparkling with whites and pastels. Renoir gets more of the details down, spending time to delineate a poster or the ribbon on a woman's hat; Monet's version provides more of a rough impression (sorry, not sorry for the pun). That these artists' canvases look totally different is totally OK, and the point, really. A personal view of the world was valued as never before. With these two facets, the Impressionists engagingly and memorably broke new ground and changed the course of art history.

And yes, I agree—these paintings look really, really nice reproduced on a silk tie or a note card, and that doesn't hurt either. But let's all try to remember that superb badassery was behind this beauty in the first place.

Jackson Pollock, *Number 1, 1950 (Lavender Mist)*, 1950

CHAPTER 2

Secrets and Lines:
The CIA/AbEx Connection

A vast machinery for popularization of art is now available, and we face the question: who controls it and to what ends?

STUART DAVIS, ARTIST

In order to encourage openness we had to be secret.

TOM BRADEN, FORMER HEAD OF THE INTERNATIONAL
ORGANIZATIONS DIVISION OF THE CIA

Here's a truth bomb for you: there isn't a lack of conspiracy theories out there. Almost every big mystery or question has a slew of alternative, wonky explanations involving anything and everything from Big Brother to the Illuminati to the Masons. Oswald wasn't the lone gunman! The *Apollo 11* moon landing never happened and was filmed instead on a Hollywood sound stage! The government is hiding proof of alien life! Even the art world isn't exempt. How about the idea that the *Mona Lisa* on view at the Louvre is a fake (see chapter 5). Or that German Renaissance polymath Albrecht Dürer coded his works with secret messages and poisoned lead pigments to destroy his enemies. Or that the Central Intelligence Agency (CIA) funneled money into the arts, toward revolutionary painters like Jackson Pollock (1912–56) and Mark Rothko (1903–70), in order to fight the Cold War. All crazy, right?

Except that this last one isn't a conspiracy theory at all. It's a true story of Cold War propaganda, CIA secrets, lies . . . and fine art. How's that for a twist?

Almost no one better embodied the American machismo of the early 1950s than Jackson Pollock. He was rough, and rough living: stern, a little burly, hard drinking, and fast driving (to a fatal fault on that last one, it would turn out). And his world-famous drip paintings, like *Number 1, 1950 (Lavender Mist)* (National Gallery of Art, Washington, D.C.)—created by splattering and drizzling paint onto large unstretched canvases laid across his studio floor—were completed with a combination of precision and energy as he danced around and on them, flicking his paintbrush or palette knife, all with a wizened glare and a limp cigarette hanging from his lips. Jackson Pollock was like America itself—tough, individualistic, unbeatable.

Or at least that was the impression transmitted to the millions of consumers who read about Jackson Pollock in *Life* magazine in August 1949, when he was thrust into the spotlight in an article that was subtitled "Is He the Greatest Living Painter in the United States?" Pollock, a little-known artist prior to the late 1940s, was breaking big—but he was also a wounded figure who attempted to hide his weaknesses under a stony face and a pile of vices. He was a cultural beacon, to be sure, but a shaky one.

Jackson Pollock's "Action Painting" and the "My Kid Could Do That!" Wisecrack

When art newbies view a Jackson Pollock painting for the very first time, they sometimes utter a bemused or contemptuous statement: "My kid could do that!" And it's true that the American Abstract Expressionist dubbed "Action Jackson" for his dribbled, splattered canvases created works that appear almost ridiculously simple in execution. In recent years, however, art historians have joined forces with theorists—particularly physicists and mathematicians—to study Pollock's drip paintings, and were surprised by their discoveries: an abundance of fractals, or the root geometric patterns and rhythms observable in nature, as well as a reliance on the complexities of fluid dynamics. Though Pollock himself was not a scientist, he was able to subconsciously harness scientific principles to create

paintings that are rather complex in their rhythms and style and practically as unique as a fingerprint. So no, your five-year-old can't make a true Pollock painting, no matter how hard she tries (but she can sure make a mess in the process).

Pollock turns out to be an excellent personification of the United States itself in the years immediately following World War II. As author Annabell Shark details in her essay "MoMA, The Bomb and the Abstract Expressionists," the United States, though energized from its triumphs in the war, wasn't as indomitable as it seemed:

Perhaps America could be described at this juncture in history as a trembling victor, owning the world outright . . . wealthier by leaps and bounds than the rest of the world put together; full of bluster; full of the kill. And simultaneously terrified that it might just lose its grasp.

America, it seems, was heroic and tough, a little rough around the edges, and apparently unbeatable, sure; but just under the surface boiled a crippling self-doubt. It reminds me of a particular blustery, hard-living artist.

The connection between Jackson Pollock and postwar America goes further as, unbeknownst to the artist, his paintings were to become stand-ins for all that America stood for as it raced to strengthen its all-too-fragile global dominance.

Stating that the Cold War was a time of tension between East and West after World War II is putting it mildly. It was an all-out war of ideology, a rivalry aimed at proclaiming the best economic and governmental systems. While there were many different countries involved, the Cold War can be best represented by the relationship between two superpowers: the United States and the Soviet Union. War was never officially declared, of course, and the two nations didn't fight in the traditional guns-and-grenades sense,

but both tried to outdo each other and declare the inherent superiority of their chosen ruling schemes: "Capitalism is the answer!" the United States asserted. "Communism all the way!" countered the Union of Soviet Socialist Republics.

President Dwight D. Eisenhower defined America's goals for the Cold War soon after taking office in 1953, declaring:

> Our aim in the Cold War is not conquering of territory or subjugation by force. Our aim is more subtle, more pervasive, more complete. We are trying to get the world, by peaceful means, to believe the truth. That truth is that Americans want . . . a world in which all people shall have opportunity for maximum individual development.

Okay, Ike, that's great and all. But how could America show its superiority without military might or bloodshed? The answer: *psychological warfare*, what he described as a "struggle for the minds and wills of men."

Psychological warfare is all about *culture*—and by *culture* in this case, I mean various examples of the arts and humanities that suffuse a particular society, not necessarily the customs or traditions of a particular group. When you think about it, culture (especially pop culture) is a huge motivator. The movies we watch, the plays we attend, and the books we read influence everything from fashion to psychology to intellectual theory. Most of all, though, culture affects how we spend money. A pop song used in a car commercial suddenly makes the Billboard charts because everyone and his sister purchased a download of it in a flash; a pair of shoes touted by Rihanna on Instagram sells out within minutes (and among my friends, Phoebe Waller-Bridge's fabulous jumpsuit from 2019's second season of the TV show *Fleabag* received an inordinate number of our hard-earned dollars). Such culture-driven purchases were de rigueur in the late 1940s too, even though the technological reach wasn't nearly as expansive as it is today. Movie stars, radio performers, and fashion icons still held sway, as did cultural institutions like museums. So perhaps it isn't a surprise, then, that the U.S. government opted very early on to include fine art—so linked

for centuries to culture and spending among the upper classes—in its plans for Cold War domination.

When President Harry S Truman formed the CIA in September 1947, a subsection of the agency, known as the Propaganda Assets Inventory, was tasked with shaping the minds of the greatest thinkers of the world. This was no easy task, surely, especially given the fact that so many of the most influential writers, critics, artists, musicians, and philosophers—both in America and across Europe—found certain tenets of communism, at its egalitarian core, very appealing. And with many of these influencers immigrating to the United States in the wake of World War II, the intelligence community was concerned that *they'd bring their Commie ways along with them, oh my gracious!*

Originally, the Propaganda Assets Inventory focused its attention on print-based media. Its reach was extensive, eventually maintaining more than eight hundred newspapers and magazines around the globe, and its purpose was, in the words of Frances Stonor Saunders, author of *The Cultural Cold War*, "to nudge the intelligentsia of Western Europe away from its lingering fascination with Marxism and communism toward a view more accommodating of 'the American way.'" Yet words could only do so much to combat the influence of these "Reds." Adding other cultural properties—literature, music, theater, and fine art—was deemed a necessary action.

How can art—especially abstract art—fight an ideological war? That was the first question that popped into my mind when I first learned about the Propaganda Assets Inventory's inclusion of fine art in its covert program. *Sure, I get the use of a propaganda poster or pamphlet, but a random oil painting?* It turns out that while the execution of the program was complicated, the idea behind it wasn't. In the Soviet Union, the tenets of Socialist Realism dictated what subject an artist could paint and how to paint it: the triumphs of the socialist way of life, depicted in a realistic manner. In comparison, artists in the United States were unencumbered by edicts or ideologies, able to illustrate whatever they wanted (or illustrate nothing at all!) in whatever manner they wanted. And *that* was a trait that made the United States great.

The Propaganda Assets Inventory had, as its model *and* warning, the U.S. Department of State, which had organized an arts exhibition just one year prior (1946) to openly promote the cultural superiority of the United States. The show, *Advancing American Art*, was funded by a State Department allotment of $49,000 for the purchase of seventy-nine paintings from famed modern artists like Georgia O'Keeffe, Romare Bearden, Marsden Hartley, Arthur Dove, and Jacob Lawrence, among many others. The artists selected for the exhibition were chosen not only for their talent, but for their diversity too—another major positive pointing to America's preeminence (which, in the pre–civil rights era, was actually pretty radical too). After the exhibition premiered at New York's Metropolitan Museum of Art, the show was divided in half and shipped off for display in separate sections of the world: one to Europe, where it was intended to be presented in France, Czechoslovakia, Poland, and Hungary; the other to Latin America and the Caribbean, with planned stops in Cuba, Haiti, and Venezuela. The nations chosen for the *Advancing American Art* tour were ones that toed the ever-so-delicate line between democracy and communism, and this art—with all of its innovation, creativity, and liberty—was meant to gently steer these countries toward the American way. This art was going to *save the world!*

Except that even before the exhibition departed from the United States for its intended mission, it was already proclaimed a total disaster. Americans who attended the exhibition at the Met in New York largely denounced the show because the works of art themselves—though not purely abstract—were thoroughly *modern*: bright, expressive, brushy, with varying (that is, *not much*) interest in conservative art traditions. These were paintings about modern-day life—cities, noise, colorful communities, and social change—and much of it wasn't pretty. Everyday Joes hated it, as did most of the influential politicians who weighed in on the exhibition's success (or lack thereof). About the exhibition, Secretary of State George C. Marshall received an angry letter from the chairman of the House Appropriations Committee, who exclaimed, "The paintings are a travesty upon art. They

were evidently gotten up by people whose object was apparently to (1) make the United States appear ridiculous in the eyes of foreign countries, and to (2) establish ill-will toward the United States." Most famously, President Truman took great offense to *Circus Girl Resting* (1925, Jule Collins Smith Museum of Fine Art, Auburn University, Auburn), a painting by Japanese American artist Yasuo Kuniyoshi depicting a buxom, bob-haired performer seated in a skimpy red slip and partially unrolled thigh-high nylons. Truman, not known as a great lover of modern art, scoffed at the canvas and then said, "If that's art, then I'm a Hottentot."

The situation took a turn for the worse after several members of Congress suggested a thorough background search on all the artists chosen for *Advancing American Art*. Of the forty-seven artists featured in the exhibition, eighteen were identified in the records of the House Un-American Activities Committee, with three artists pinpointed as card-carrying communists. Suddenly the art exhibition explicitly intended to defeat communism was berated for being anti-American (oh the irony!), and its international tour schedule was curtailed before being canceled outright. Secretary of State Marshall took the situation a step further by publicly vowing that no taxpayer money would be spent on modern art ever again, nor would any artist ever suspected of being a communist be able to exhibit in any government-sponsored function. As historian Jane De Hart Mathews summarized in a 1976 article, "The perception of avant-garde art as un-American had now been incorporated into official policy." And as a final nail in the coffin, the State Department put the offending art for sale at pennies on the dollar, eager to distance itself from the unfortunate exhibition. So much for screaming America's cultural superiority to America, let alone to the rest of the world.

There was a silver lining, though: public institutions and museums, especially colleges and universities, were offered a 95 percent discount on the works from *Advancing American Art*, which meant that some truly amazing pieces ended up in collections that may not have been able to afford them otherwise. The University of Oklahoma, for example, snagged a Georgia O'Keeffe painting for approximately fifty dollars. What a score!

. . .

To CIA officers working within the Propaganda Assets Inventory subsection, the main problem with the *Advancing American Art* debacle hadn't been its artistic merits or contents. It was its public nature, which was practically begging for criticism from conservative circles (Tom Braden, future CNN host and the former head of the International Organizations Division with the CIA, scoffed about this American philistinism: "You have always to battle your own ignoramuses or, to put it more politely, people who just don't understand."). The idea of weaponizing art for the good of the country was simply too great to pass up, but the situation needed to be handled a little more delicately, a bit more . . . covertly, perhaps. And though much of the art in the State Department exhibition was good by today's standards—some of it was even great!—a continued promotion of the same art and artists was a recipe for a repeat disaster. They needed to find a new group of truly unique, truly American artists to highlight for their top-secret cultural Cold War.

In the late 1940s, a group of loosely affiliated artists started to make waves in New York City art circles. These were the Abstract Expressionists (simplified by some to AbEx)—a name, as Willem de Kooning emphasized, wasn't adopted by the group but by critics who needed an easy way to describe the art itself: abstract (yes, there's not much that is figurative or representational here) and expressive (yes, that's some pretty energetic, brushy paint going on there). Though they were a bit loath to officially connect to one another—"It is disastrous to name ourselves," de Kooning cautioned—they were similar in their interests in nonrepresentational art and in experimentation (and sometimes a little left-wing politics on the side).

Almost immediately, the art created by AbEx folks started getting attention as something wholly new and utterly American. Frederic Taubes (1900–81), an artist and contributor for the *Encyclopedia Britannica*, praised the just-emerging style in the encyclopedia's 1946 edition, calling it "independent, self-reliant, a true expression of the national will, spirit and character . . . U.S. art is no longer a repository of European influences, that is not a mere amalgamate of foreign 'isms,' assembled, compiled, and

assimilated with lesser or greater intelligence." Critic Clement Greenberg, AbEx's top promoter, conflated the art movement with America in an even stronger way, writing in 1948, "The main premises of Western Art have at last migrated to the United States, along with the center of gravity of industrial production and political power."

Not that such praise was the norm for the Abstract Expressionists. Artist and critic Leon Golub bemoaned AbEx's lack of concept and subject in a 1955 critique published in the *College Art Journal*, writing, "Abstract [E]xpressionism is non-referential and diffuse. . . . What is the difference (and how can these differences be recorded) between a subliminal impulse, the cosmos, or a fanciful doodle?"

Rudolf Abel: Painter, Photographer, and Soviet Spy in Cold War Brooklyn

In 1953, an unassuming middle-aged artist named Emil R. Goldfus (your first hint of unreality) rented an art studio and a room in a boardinghouse near present-day Bedford-Stuyvesant. As a painter and photographer who purportedly trawled the city for models and subjects, Goldfus's erratic comings and goings didn't ring too many warning bells for his boho neighbors—but maybe they should have. It turns out that Emil Goldfus was the pseudonym of Rudolf Abel (itself *another* pseudonym for a man born in England as William August Fisher, who had been sent to infiltrate New York as a KGB mole during the Cold War. For four years, Abel posed as a burgeoning artist and secretly reported on U.S. anti-communist happenings to the Soviet government until his arrest by the FBI in June 1957, which was trumpeted by *The New York Post* as "the most important spy ever caught in the United States." Fisher/Abel/Goldfus's larger-than-life artist/spy story has a cinematic connection too—it provided a worthy subject for director Steven Spielberg, whose 2015 film, *Bridge of Spies*, garnered accolades, including an Academy Award win for veteran actor Mark Rylance in the role of Abel.

At first glance, the selection of Abstract Expressionism as the new hope for the proclamation of American cultural superiority seems risky and a little odd. Consider the fact that the paintings displayed in *Advancing American Art* weren't even fully abstract—meaning that, as an example, you could still recognize that the subject of Jacob Lawrence's *Harlem* (1946, Jule Collins Smith Museum of Fine Art, Auburn University, Auburn) is indeed Harlem and its buildings and people, even if the neighborhood and its inhabitants don't exist in real life in the painting's palette of black, white, and red. Yet even with identifiable subject matter, the American public bashed the exhibition so heavily that it was considered an utter fiasco. Choosing, then, to market ultra-avant-garde AbEx works—all color drips and brush swishes—would have seemed nuts to anyone on the outside. The Abstract Expressionists were considered to be wilder and even anarchic compared to many of their colleagues marketed in *Advancing American Art*, and in the late 1940s, their works weren't well loved outside of small artistic and academic circles (and even within the art cognoscenti, there were still big doubters, as we see from Leon Golub's criticism above). But remember the CIA's intentions here: they needed art as proof of advanced minds and advanced civilization, centered on freedom of expression and individuality. AbEx was truly art for the sake of art, art for the sake of experimentation, art created because it *could* be created, and not intended for education or moralization. The artists involved were vastly varied in their artistic output and style too, further emphasizing that even artists functioning under the same umbrella term (Abstract Expressionism) could be wonderfully disparate from one another. You'd never confuse a Barnett Newman with a Willem de Kooning, or a Lee Krasner with a Mark Rothko. Combined, these aspects caused AbEx to stand in stark contrast to Socialist Realism, the preferred artistic style of the Soviet Union, making it appear stringent and pedantic, which would *really* anger the Russians. As Donald Jameson, a former CIA operative, revealed in an interview with Frances Stonor Saunders in 1994:

We recognized that this was the kind of art that . . . made socialist realism look even more stylized and more rigid and confined than it was.

Moscow in those days was very vicious in its denunciation of any kind of non-conformity to its own very rigid patterns. So one could quite adequately and accurately reason that anything they criticized that much and that heavyhandedly [sic] was worth support one way or another.

The secrecy with which the CIA pursued Abstract Expressionism was not only integral to successfully fooling the Soviet Union but also to keeping any associated artists in the dark. In Jameson's words, "[M]ost of [the Abstract Expressionists] were people who had very little respect for the government in particular and certainly none for the CIA." Multiple artists self-identified as anarchists, particularly Barnett Newman, who was so taken by anarchism that he would later write the foreword to the 1968 reprint of Russian author Peter Kropotkin's 1899 *Memoirs of a Revolutionist*, describing the anarcho-communist's influence upon his life and work. In other words: tell Clyfford Still or Helen Frankenthaler that you wanted to use their paintings to forward a government agenda, and the answer would most likely have been a firm *no*.

The CIA's answer to these problems was something known as the long-leash policy. This solution kept CIA operatives at a remove of two or three degrees from the artists and art exhibitions—sometimes even more—so that they could not be linked to any furtive governmental bankrolling. In order to fulfill this need, they elicited the participation of arts foundations, artists groups, and, most crucially, art museums, requesting their assistance in organizing special exhibitions, events, and collections. Such activity was funneled through a new arts agency created by the CIA named the Congress for Cultural Freedom (CCF), which was developed in 1950 and not revealed as a CIA project until 1966. It would always appear, then, that a museum or arts corporation was presenting and promoting Abstract Expressionism, *never the government, no way!* And no one was the wiser, not even the artists themselves. *Especially* not the artists themselves.

Secrets in Art: Is Dan Brown Right?
A Musical Look at *The Last Supper*

Ever since author Dan Brown hit the mainstream with his smash novel, *The Da Vinci Code* (2003, Doubleday Books), conspiracy theorists everywhere have been reading a lot into works of art. But are there indeed art secrets hidden in plain sight? Some think so, digging into the deeper meanings behind artworks by Michelangelo to Van Gogh and Picasso. But Leonardo da Vinci's *The Last Supper* (1498, Santa Maria delle Grazie, Milan) might *actually* have a da Vinci code after all. In 2007, an Italian musician and computer scientist named Giovanni Maria Pala released a forty-second composition gleaned from the placement of—wait for it—*bread* and *human hands* in Leonardo's crumbling fresco. When played, "It sounds like a requiem. It's like a soundtrack that emphasizes the Passion of Jesus," explains Pala. I'm skeptical, but at the same time, it wouldn't be a total surprise if it really *was* a da Vinci code after all. Leonardo was famously one of the most talented and curious humans who ever lived, who not only invented musical instruments and studied the physics of sound transmission, but also tinkered with musical scoring and composition, some scribblings of which still survive in his various notebooks. If anyone could create an indelible, if fragile, work of art and secretly hide a song in it, it's Leonardo. (For more art history and music fun, see chapter 10.)

The museum most closely involved with the CCF's plans for cultural domination was the Museum of Modern Art (MoMA) in New York City, focused through the participation of Nelson Rockefeller, a politician, philanthropist, and future vice president of the United States under Gerald Ford. Rockefeller and MoMA go hand in hand, as his mother was one of the cofounders of the institution, which he called Mommy's Museum (aaargh!). He was not unfamiliar with the intelligence world either, as the former coordinator of Inter-American Affairs for Latin America during World War II, yet another propagandistic front agency.

For the CCF, then, Rockefeller's cooperation was ideal. He used his privileged position as the president of MoMA's board of trustees to arrange for some of the CCF's biggest and most successful AbEx exhibitions, including the landmark 1958–59 showcase *The New American Painting*. The exhibition was, according to its March 11, 1958, press release, "organized in response to numerous requests [to] the Museum's International Program," leading one to assume that other countries were clamoring for these "advanced tendencies in American painting," rather than being coordinated through MoMA's personnel on the order of the CIA. Under the auspices of the MoMA brand, *The New American Painting* traveled for one year straight, visiting practically every major Western European city, including Basel, Milan, Berlin, Brussels, Paris, and London. The widespread touring of the show in American-friendly countries—unlike the on-the-communist-fence locations chosen for *Advancing American Art*—was strategic, a way to cement alliances among like-minded Cold Warriors *and* to promote the much-lauded cultural preeminence of the United States for the first time in history.

As with exhibitions of Abstract Expressionism in America, the responses to *The New American Painting* were mixed. *The Times* in London declared its showing at the Tate Gallery to be "the finest of its kind we have yet had . . . the aesthetic barometer [of] why the United States should so frequently be regarded nowadays as the challenger to, if not actually the inheritor of, the hegemony of Paris." But art critic Georges Boudaille found the paintings to be strangely depressing and unknowable, asking in the French literary publication *Les Lettres françaises*, "Where does this dramatic sensation of nightmare and stain come from? What do these disturbing spatters express? What?"

The Tate London showing of *The New American Painting* provides us with an intriguing case study on how the CCF operated its long-leash policy. After the exhibition opened at Paris's Musée National d'Art Moderne in January 1959, a delegation from the Tate attended the show and was thrilled by its contents. Upon requesting an extension of the tour's run to accommodate a London stop, the Tate cohort learned that the steep fees associated with the show were simply too pricey to accommodate, and

disappointedly accepted their art-less fate. But behold! What happened next? An art-loving American millionaire named Julius "Junkie" Fleischmann appeared, almost as if by magic, and ponied up the funds. The show, happily, then continued on to London.

A fairy godfather materializes and bankrolls a major exhibition in a foreign country simply for the love of art? *How magnanimous!* By now, though, we know the real story: the money provided to travel the show to the UK wasn't actually Fleischmann's but cash funneled through him from an organization called the Farfield Foundation—yet another secret arm of the CCF disguised as a charitable body. The Tate didn't know. The exhibition's visitors didn't know. And the artists exhibited certainly didn't know either. Such feints were rather easy to pull off too. As Tom Braden later recounted, "We would go to somebody in New York who was a well-known rich person and we would say, 'We want to set up a foundation.' We would tell him what we were actually trying to do and pledge him to secrecy, and he would say, 'Of course I'll do it,' and then you would publish a letterhead and his name would be on it and there would be a foundation. It was really a pretty simple device."

By the way, it should be noted that Julius Fleischmann, like Nelson Rockefeller, had a direct connection to MoMA: he was a member of its governing board. Many MoMA supporters seem to have been involved in similar ways. The CIA/MoMA link was never "official," exactly—and many have disputed the partnership over the years—but as writer Louis Menand noted in a 2005 article for *The New Yorker*, no formal deal between the agency and the museum needed to be made because all figures were essentially on the same page. Fighting communism, varnishing the country's image, and celebrating art? For the cultural elite at MoMA—and others in boardrooms and lounges all over New York City—it was a no-brainer.

When these dealings of the cultural Cold War were revealed in the late 1960s, a reexamination of the rise of Abstract Expressionism naturally followed, with a focus on a major question: Would this game-changing art "movement"—if such a disparate group of characters and artwork could be

defined as such—have risen to such prominence without the backing of the CIA? Especially considering the long antipathy of the United States toward avant-garde art, it is certainly strange to consider AbEx's precipitous rise to the top. The ascendancy of Abstract Expressionism is frequently cited as the singular moment when art glory was ripped away from Paris and established instead upon U.S. soil. Would it have reached such heights if the CIA hadn't been involved?

For what it's worth, I think it would have, and I like to point to my own art education as proof for my theory. In neither my undergraduate nor graduate classes in art history was the secret governmental backing of AbEx ever mentioned, as interesting as that fact may be. Because really, does it matter? When I look at a Mark Rothko color field painting like *No. 14, 1960* (San Francisco Museum of Modern Art, San Francisco), I'm moved by the blending of color and the soft blur of forms, leading me to experience an almost meditative state after a brief period of time. The way that a bright orange pigment subtly transitions to a border of brushy plum and onward to a rectangle of purplish-blue so dark but with a strange luminosity—I find it practically transcendental. Rothko's works—like Jackson Pollock's, like Grace Hartigan's, like Robert Motherwell's—are thoroughly different from what came before, and they are astounding in their uniqueness. The Abstract Expressionists, as we've already established, were a hugely innovative bunch. Their works heralded a new way of making art, a fresh manner of seeing, of abstracting and illustrating the physical world as well as their individual internal worlds. And regardless of whether or not these paintings were co-opted to fight the Soviets, I'm fairly certain they would have reached a pinnacle anyway.

The most probable effect of the government's covert backing of Abstract Expressionism is the appreciation and fame that many of these artists received during their lifetimes (or shortly thereafter)—a boon not always enjoyed by struggling creators. The international visibility of AbEx seemingly accelerated the typically slow-moving wheel of contemporary art appreciation by stalwart institutions. Indeed, just a year after Jackson Pollock's 1956 death in a car accident, the Metropolitan Museum of Art (the stalwart-iest of institutions!) purchased Pollock's landmark 1950 painting

Autumn Rhythm (Number 30) for $30,000, the equivalent of approximately $300,000 today. In the art world, many of us typically might not bat an eye at such a sum, considering that works of art often garner bucketloads more than that at auction (I'm looking at you, *Salvator Mundi*—see chapter 8), but this was an unheard-of price in 1957, particularly for an institution that rarely backed contemporary artists via art purchases—and especially not emerging or midcareer artists. Even though Pollock was already dead, and thus easier to accept into the art canon, the Met's purchase was a move that might be considered either super prescient, or just plain odd. Either way, it communicated a big message: Pollock and his works were important.

It was a conclusion that the U.S. government had already made years prior. For it, though, the importance centered not on how the art was created, nor who was creating it, nor even which museum was presenting it or what the work's legacy might be. Instead, its significance was its visibility, so that a few splashes of paint or swipes of a palette knife could be transformed into an international symbol of freedom and individuality—a sublime apotheosis from canvas to country. As Eisenhower declared in 1954, "As long as our artists are free to create with sincerity and conviction, there will be healthy controversy and progress in art. How different it is in tyranny. When artists are made the slaves and tools of the state; when artists become the chief propagandists of a cause, progress is arrested and creation and genius are destroyed."

Walter Sickert, *Jack the Ripper's Bedroom*, 1906–1907

Was British Painter Walter Sickert Really Jack the Ripper?

It is said that we are a great literary nation but we really don't care about literature, we like films and we like a good murder. If there is not a murder about every day they put one in.

WALTER SICKERT, ARTIST

Walter Sickert was connected with Jack the Ripper long before I appeared on the scene. I'm not the first one to think of him. But I'm the first to investigate him the same way we would a suspect today.

PATRICIA CORNWELL, AUTHOR

O ne afternoon during my first year of graduate school, I took a break from my studies to browse the shelves at my favorite bookstore. While perusing the titles on a table of new releases, a particular book caught my eye. What I noticed first was its dust jacket: an image of a browning, jagged, handwritten letter, across which huge, blood-red letters trumpeted the author's name—Patricia Cornwell. I assumed it was yet another crime novel, and though I had never read a Patricia Cornwell book, I was sure that it wasn't my bag. And so, intending to move on, I gave it one more cursory glance . . . only to be drawn in by three words: *Jack the Ripper.*

Now, I am as intrigued by unsolved crimes as your regular Joe, so I cracked the cover of the book—*Portrait of a Killer: Jack the Ripper, Case*

Closed (New York: G. P. Putnam's Sons, 2002)—only to learn that Cornwell had purportedly solved the mystery of Jack the Ripper's identity, which had evaded researchers, historians, and police for more than one hundred years. That's noteworthy—but what really caught my eye was Cornwell's accused suspect: the well-known English painter Walter Sickert. Jack the Ripper, she claimed, one of the most notorious serial killers in history, was an artist. Hot damn.

I bought her book that day.

More ink has been spilled about Jack the Ripper than almost any other comparable figure—and much of the consistent interest in his homicides is due to the unsolved aspects of the story. It's the ultimate mystery in the true crime genre. If you're seeking in-depth descriptions of the horrible Whitechapel Murders of 1888, there are legions of books, articles, and websites that will fill you in on every grotesque detail (but by God, please don't google images of victim Mary Kelly unless you are prepared for a graphic horror show). Even if you're not a carnage connoisseur, you probably know the rough outline of the Ripper tale anyway because it has permeated history and popular culture, providing us with plenty of opportunity for titillation and provocation. There are walking tours of the murder locations in London, ending in a pub to allow visitors the chance to get a nice stiff drink to bolster their spirits; the BBC America show *Ripper Street* (2010–16), imagined London in the wake of the crimes as detectives looked for answers and hoped to ward off new killings; and for the Hollywood spin, there's the 2001 thriller *From Hell*, based on the graphic novel of the same name and starring Johnny Depp as a police inspector intent on tracking down Jack. The interest in the Ripper murders isn't limited to England or the United States. In 2013, a comedic play depicting the murders was produced in China—and yes, I did say "comedic"—and in Japan, a musical featuring a hugely popular South Korean pop star named Sungmin was a hot-ticket show for *years*—and yes, I did say "musical." Fascination with Jack, and his dirty deeds, runs deep.

• • •

In case you don't remember the awful details, or you've been kept blissfully unaware, here's a primer on these infamous crimes.

On the morning of August 31, 1888, a woman named Mary Ann Nichols, known as Polly Nichols, was discovered dead in the section of London known as Whitechapel. Her throat had been severed by two deep cuts, but that wasn't all—the lower part of her abdomen had also been ripped open, revealing an incredibly deep and jagged wound. Murder, on the whole, wasn't all that unusual during this period. But Polly Nichols's death—or more precisely, the way she died—was so violent and bloody that its occurrence immediately created a furor and panic in Whitechapel.

Just eight days after the Nichols slaying, another murder was committed. Annie Chapman's lifeless body was discovered early on the morning of September 8, 1888, with a similar lethal wound as that of Polly Nichols—two severe throat slashes. And like the Nichols murder, Chapman, too, had had her abdomen sliced wide open. But this time, that wasn't all—her entrails were pulled away and draped over her shoulder, and it was later discovered that her uterus had been fully removed.

Who was this maniac, this deranged killer? There were very few clues, and even fewer leads. At the end of September, the killer—or someone posing as the killer—contacted the local press and identified himself by the name of "Jack the Ripper." Jack taunted the press with warnings of future crimes, and Londoners lived in abject fear that their wives, mothers, and daughters might be the next victims. Was he only targeting "unfortunates," those who tramped from poor house to poor house, or was any woman, regardless of status, a potential target? And would Jack move on to attack men as well? Or worse—children?

Londoners didn't have to wait long to learn the identity of Jack's next victim. Three days after Jack mocked the press with his letter, he killed again—but this time, he struck *twice*. The killings of September 30, 1888, would later be known as the Double Event, a major milestone in the Ripper timeline. The first victim was Elizabeth Stride, whose death was brought

about by a very deep slice across the throat, leading to massive and quick blood loss. Curiously, Stride's appearance provided clues to the Ripper's choice to kill twice in one night: Stride's clothing had been pushed up over her body, but her abdomen was left intact—an obvious deviation from the killer's grotesque modus operandi. Theories hold that Jack had been interrupted before he could mutilate Stride's abdomen, which left him raging with feelings of inadequacy and incompletion, so he struck again.

Less than one hour later and less than a mile away from the Stride crime scene, a policeman named Edward Watkins entered Whitechapel's Mitre Square, where he discovered the corpse of a woman later identified as Catherine Eddowes. Like her unlucky counterparts, Eddowes had had her throat severed, and her abdomen was savagely ripped open by a long, deep, jagged wound. And like Annie Chapman before her, Eddowes's entrails had been removed. Her intestines had been cut out and now lay beside her body, and most of her uterus had been removed too, along with her left kidney, which went missing. But here the Ripper again upped the ante, and slashed her face too—as if the bodily mutilation hadn't been bad enough.

If there was one thing Jack the Ripper enjoyed almost as much as killing, it was toying with the authorities. "Saucy Jacky," as he referred to himself in one message (gotta hand it to the guy—he was good at nicknames), loved sending taunting letters to police and public officials, and in late October 1888, *The Illustrated Police News*, a sensationalist crime tabloid, reported that more than seven hundred Ripper-related letters had been received by Scotland Yard. Some, undoubtedly, were helpful in nature, providing hints, clues, and accusations, while others were fraudulent, written by pranksters to provoke and capitalize on the Ripper hysteria. A handful of letters survive, though, that many believe to be authentic, written by the killer himself. One such missive was received by a man named George Lusk, the chairman of a volunteer neighborhood watch group called the Whitechapel Vigilance Committee. Shortly after the committee's inception, Lusk received a mysterious package. Its contents were appalling: half of a human kidney and a handwritten letter, which proclaimed that it was written "From hell." Chock-full of grammatical and spelling errors, it reads:

From hell
Mr Lusk,

Sir
 I send you half the Kidne [sic] I took from one woman prasarved
[sic] it for you tother [sic] piece I fried and ate it was very nise [sic]. I
may send you the bloody knif [sic] that took it out if you only wate [sic]
a whil [sic] longer

signed
Catch me when you can Mishter [sic] Lusk

Frequently these letters contained doodles and ink splatters, some artistically arranged to look like splashes of blood.

The majority of October 1888 passed without murder or word from Jack the Ripper. Citizens and the police alike were relieved, hoping that the killer had been caught during the ongoing investigation, or that he had fled the area, or—most unlikely—that he had chosen to end his killing spree. Their relief, though, was short-lived, and a fifth murder proved to be the most gruesome of them all.

On November 9, 1888, an Irishwoman named Mary Kelly was found dead in her own room, lying on her blood-soaked bed. Her mutilations were the most horrific inflicted upon any of the victims, probably because the Ripper murdered her in the seclusion of a private home rather than a street or alleyway. He could do *more* because he had time to kill (pardon the expression) without fear of being discovered. Like the others, Kelly's throat was sliced open, and the many mutilations that followed occurred postmortem and would have taken up to two hours to complete, according to Kelly's autopsy.

As one onlooker reported of the crime scene, "It appeared to be the work of a devil."

Mary Kelly's death is the last of what is known as the canonical five, or the five deaths that have been directly linked to Jack the Ripper. Other

crimes, though probably connected to Jack, have not been confirmed, and all these years later, we still don't know who Jack the Ripper was, nor do we know why he committed his terrible deeds. But that doesn't stop law enforcement and armchair detectives alike from speculating ad nauseam. New potential Jacks bubble up from the fog of Victorian history every few years. To date, Jack has been allegedly identified as a frustrated lawyer, a Polish immigrant, a royal prince, a psychotic doctor, and even a madwoman (Jill the Ripper!)—and that's only a handful of the purported suspects. But at the turn of the millennium, renowned British artist Walter Sickert (1860–1942) was pulled back firmly into the suspect spotlight after decades spent lingering on the sidelines.

In 2002, Patricia Cornwell, known for her highly popular novels featuring forensic sleuth Kay Scarpetta, released a bombshell statement: she claimed to have solved the mystery of Jack the Ripper's identity, and the Ripper, she said, was Walter Sickert. Cornwell had not originally intended to write about Jack—she claimed to have known nothing of his famous crimes before beginning her research—but a 2001 introduction to the Ripper crimes through Scotland Yard's deputy assistant commissioner John Grieve thoroughly intrigued her. "Perhaps I could use New Scotland Yard in my next Scarpetta thriller," Cornwell relayed in her 2017 book, *Ripper: The Secret Life of Walter Sickert* (Seattle: Thomas & Mercer). "If so I would need to know factual details about the Ripper cases. Perhaps Scarpetta would have fresh forensic insights about them." When Cornwell questioned Grieve about the usual suspects, he dismissed many of them before commenting, "There's one interesting chap you might want to check out as long as you're going to look into it. An artist named Walter Sickert. . . . I've always wondered about him."

Walter Richard Sickert was born on May 31, 1860, in Munich to a Danish-German father and an Anglo-Irish mother. As is common in many artist biographies, Sickert had family members inspiring his future career: his father, Oswald, was a painter and printmaker, and surrounded his son with the tools of his trade, so even though Walter himself never had any

formal training in art during his childhood, he picked up many of the basics from around his home. He even asserted that his grandfather, too, had been a successful artist, a painter who counted King Christian VIII of Denmark as one of his patrons, though this claim has been disputed.

At the age of eighteen, the creative Sickert began a career as an actor, appearing in small-scale productions and tours throughout England under the stage name Mr. Nemo. It was the perfect first career for a young man who loved disguises and melodrama. But something else beckoned like no other: painting. Against his father's wishes, he enrolled in his first art classes, and in 1882, he had the supreme good luck of becoming an apprentice and studio assistant to the American painter James Abbott McNeill Whistler, of *Portrait of the Artist's Mother* (*Whistler's Mother*) fame (*Arrangement in Grey and Black No. 1*, 1871, Musée d'Orsay, Paris), then based in London. The following year, Whistler entrusted his pupil to deliver his renowned maternal portrait to an art exhibition in Paris, and while in France, Sickert was introduced to Edgar Degas. This was a watershed moment for Sickert, as Degas's "modern" subjects—actresses, ballerinas, and other exploited city dwellers at the center of contemporary life—beguiled him. Originally, Sickert's preferred subject matter was landscapes, but under Degas's guidance, he moved away from the natural world and toward the unnatural—the garishly lit, shadowy environment of London's music halls and theaters. The energy of such locations thrilled him, but so did their seedy underbellies. Like Degas, he gravitated toward creating grittier, emotionally and tonally ambiguous interior scenes with roughly painted, gauzy figures. These works of art made Sickert famous—he is frequently deemed the greatest British painter between J. M. W. Turner and Francis Bacon. However, they are also used today to link him to Jack the Ripper.

The connection between Sickert and Jack the Ripper is not a recent theory, and Patricia Cornwell wasn't its originator either. Ripperologists—yes, that's an official term!—first turned their steely glazes toward Walter Sickert in the 1970s, not as the murderer but instead as Jack's potential accomplice or confidant, a case first made by Stephen Knight in his book *Jack the*

Ripper: The Final Solution (London: Panther Books, 1977). In the 1990s, however, a closer examination of Sickert's potential involvement hit bookshelves and news headlines with the release of Jean Overton Fuller's tome *Sickert and the Ripper Crimes* (Oxford: Mandrake, 1990). Fuller's theory—that Sickert *himself* was Jack the Ripper—was quickly dismissed by critics and crime aficionados in favor of the much more scandalous, if sketchy, royal conspiracy theory, which posited Albert Victor, known as Eddy, the Duke of Clarence (and Queen Victoria's ne'er-do-well grandson), as Saucy Jacky. Fuller's comprehensive look at Walter Sickert's potential Ripper connections included one important element: the first discussion of Sickert's art as a reflection of his murderous past. Her theory, though, was largely forgotten until Patricia Cornwell revived it with *Portrait of a Killer: Jack the Ripper, Case Closed*, which shot to the top of the bestseller charts. To date, Cornwell has published three books touting her Sickert-Ripper analyses. In addition to *Portrait of a Killer*, she released *Chasing the Ripper*, an Amazon Kindle e-single, in 2014, and followed it up with a "reboot" of *Portrait of a Killer* in 2017, now renamed as *Ripper: The Secret Life of Walter Sickert* (Seattle: Thomas & Mercer). Though others maintain a belief of Sickert's culpability in the Ripper case, it is Patricia Cornwell whose voice proclaims it the loudest.

Portrait of a Killer: Jack the Ripper, Case Closed*, as well as *Ripper: The Secret Life of Walter Sickert*, detail Sickert's life and the Ripper crimes in hundreds of pages. Cornwell's theory hinges on a variety of potential evidence and assumptions, many taken from modern-day psychological studies on serial killers as well as contemporary forensic practices—the primary difference between her books and previous interpretations of Sickert-as-Ripper. Cornwell wanted to do what was unthinkable—indeed unknowable—back in the 1880s, when the Ripper was active: namely, use DNA testing and scientific analyses to examine the evidence as if the crime had happened in the twenty-first century, not the nineteenth century. With these benefits, she hoped, came the possibility of identifying the infamous killer once and for all—and Cornwell fervently believes that she has done just that, through a combination of art historical interpretation, psychological profiling, and investigation of physical evidence.

Caravaggio the Killer—and Victim?

One of the most renowned figures in art history was a confirmed killer: namely, Caravaggio, the bad boy of Italian Baroque art, who murdered Ranuccio Tomassoni in 1606. It was long assumed that Caravaggio stabbed Tomassoni following a tennis match gone horribly wrong. In 2002, however, art historian Andrew Graham-Dixon, a leading expert on Caravaggio, uncovered new evidence suggesting that Caravaggio was motivated by love—or at least lust. Graham-Dixon theorizes that the two men fought over the same woman—a sex worker named Fillide Melandroni—and that Caravaggio attempted to cut off Tomassoni's testicles after he insulted Melandroni's honor. Per the rules of Roman street fighting, killing was not the end goal, but castration was—yet Tomassoni died after being accidentally slashed through the femoral artery. This new evidence begat an even more intriguing theory: that Caravaggio *himself* may have been murdered in an honor killing. His early death at the age of thirty-eight, and the reason behind it, have been a mystery for four hundred years. Now, Graham-Dixon and others have suggested that Caravaggio, while on the run from prosecution for his crime, was killed by members of Tomassoni's family seeking revenge for his death. If it's true, then we can definitely assert one thing: *karma is a real doozy, man.*

For nigh on two decades, Cornwell worked not only with forensic scientists, medical examiners, handwriting analysts, archivists, historians, and various law officials (including Scotland Yard commissioners who essentially inherited the long-cold case), but also called upon art authorities to provide their expertise. Curators and art historians—Sickert specialists in particular—shared their knowledge of the painter's life, habits, and works of art, and together they identified some distressing similarities between the painter and the deranged killer from an aesthetic perspective, similarities first noted by Jean Overton Fuller. They hypothesize, for example, that the artist's impasto—an especially thick layering of paint—and his "slashing" brushstrokes hint at a deeply misogynistic mindset and a bent

toward violence. Even creepier, historians identify several Sickert paintings as eerily reminiscent of surviving crime scene photos of several Ripper victims. The dense, dark atmosphere of his *Nuit d'été (Summer Night)* (1906, private collection), as well as the positioning of the female nude's body on the bed therein, recall the postmortem images of the first Ripper victim, Polly Nichols. In *Putana a casa (Prostitute at Home)* (1903–4, Harvard Art Museums, Cambridge—a gift to the university from Patricia Cornwell herself, who previously owned the painting and hundreds of other drawings, letters, and paintings by Sickert), the strange black lines painted across the face of the subject—a sex worker—look less like shadows than savage gashes. The immediate comparison is to the facial mutilation of Catherine Eddowes, clearly documented in her autopsy photographs. Patricia Cornwell wastes no time in pointing out that facial mutilation frequently points to an intense hatred of the person being attacked. A third painting, *Le Lit de cuivre* (*The Brass Bed*, c. 1906, versions in private collections and in the Royal Albert Memorial Museum, Exeter, UK) is even more chilling when compared to the horrifying images of Mary Kelly, dead *in her own brass bed*. Does this painting present viewers with an experiment in light and shadow on yet another female nude, as other artists during Sickert's era— such as the Impressionists—did? Or does it suggest the frenzied flaying Jack the Ripper performed on his so-called final victim? Much of this is interpretation and conjecture—could we be seeing what investigators *want* to see in Sickert's paintings? Possibly. But there are bizarre parallels in multiple works of art by the British painter.

Admittedly, murder was a recurring theme throughout Walter Sickert's artistic career, a topic he never shied away from illustrating. Consider a group of paintings called *The Camden Town Murder.* Completed around 1908, these four canvases (though more may be considered tangentially related) depict a "ripped from the headlines" subject: the murder of a part-time sex worker named Emily Dimmock in Camden Town, a district of northwest London, on the evening of September 11, 1907. Dimmock was murdered in her home, killed by a deep slit to the throat, and like the Ripper homicides nearly two decades prior, the "Camden Town Murder" caused a sensation in the press. Sickert, a noted newshound, was aware of

the crime and the furor surrounding it, and had no qualms with recreating such scenes in his artwork. "After all," Sickert proclaimed in a 1934 lecture, "murder is as good a subject as any other." To some, however, such paintings are clues—confessions even—that point to Sickert's culpability. Both Cornwell and Fuller indicate that the similarities between the victim photographs and Sickert's works are so strong that one wonders if anyone but the murderer himself could have depicted such scenes.

Death Is Coming for You: The Creepy Side of . . . Fruit Bowls

I love still lifes: those gorgeous bowl-of-fruit, bouquet-of-flowers paintings, glossy with dazzling red tulips, golden pears, and shiny, half-drunk goblets of wine, all displayed with an intense naturalism. They are feats of technical prowess, and with works like Johannes Torrentius's *Emblematic Still Life with Flagon, Glass, Jug and Bridle* (1614, Rijksmuseum, Amsterdam) I can barely keep myself from reaching out to touch the painting to confirm its two-dimensionality (PSA: Don't do this. Keep your hands off the art. *I'm talking to you, Dad.*). They are mind-boggling.

While still life panels are artistically impressive, what interests me most is the knowledge that many of these paintings—so beautiful! So calming!—were intended to remind viewers of one simple thing: the Grim Reaper is looking over your shoulder, and you'd better shape up, *or else*. Virtually all still life paintings in the Dutch Golden Age had a message embedded therein, transmitted via a sophisticated visual language. Such scenes frequently included clocks, hourglasses, skulls, or skeletons, sometimes paired with a fading flower or a toppled glass of wine. These symbols were intended to remind viewers of their short time on earth and that the grave is around the corner (*gee, thanks for this comforting message*). No wonder, then, that art journalist Carola Eißler begins her still life entry in Hatje Cantz Publishing's art dictionary with a warning: "Still lifes are not for people with weak nerves."

Next in Cornwell's hypothesis are more personal details that convince her of Sickert's murderous hatred of women. Walter Sickert, she declares, was childless and possibly impotent, most likely due to a botched childhood surgery performed to correct a "penile fistula"—a hole formed in the genitals when the urethra does not open from its usual location at the head of the penis. While this abnormality is not uncommon—it's listed as the second-most common birth defect in boys, according to urological texts—and is easily treatable today, it was surely a nightmare to repair when Sickert underwent surgery as a young boy in the 1860s. The resulting impotence the adult Sickert reportedly experienced may have led to disappointment—not only in the artist himself, but in his potential lovers as well. Did these women deride and ridicule him for his condition? And in response, did his sexual frustration and misogynistic rage lead him to seek other means of gratification? This is where Cornwell's knowledge of current-day psychosexual dysfunction may shine some light on the Ripper's possible murderous motivations.

Finally, there is Cornwell's purported physical indications, including DNA evidence. *For real? DNA evidence?* Yes, according to Cornwell. An investigative team, financially backed by the author herself, performed DNA testing on surviving documents, including envelopes and stamps, from Walter Sickert's personal correspondence as well as several of the "Ripper" letters mailed to the police and the press from 1888 on. A mitochondrial DNA test (mtDNA) produced similar donor sequences in several cases, meaning that they likely originated with the same person. A few of these documents even supported a further link: matching watermarks, suggesting that both Sickert and the Ripper used the same stationery. While others have commented upon the wide availability of this shared paper, Cornwell's researchers suggest that the matching Sickert and Ripper pages might have stemmed from the same print run of just a smattering of paper. And then, a small final blow: drawings and doodles, uncannily alike, populate both sets. *Who's going to be a big doodler? An artist, of course!* (Jean Overton Fuller dismissed Sickert as the doodler in her book, however, noting that the sketches in so-called Ripper letters are "impossibly badly drawn.")

What are the chances that a physically and psychologically damaged man—whose artworks imply an intense fascination with death, violence, and a possible deep-seated resentment of the fairer sex—would use the same stationery as Jack the Ripper, or that an mtDNA link could be argued between the two figures? For these reasons—and many others, enough to fill two tomes of more than five hundred pages each!—Patricia Cornwell is convinced of Sickert's guilt. In a 2002 interview with Diane Sawyer on ABC's *Primetime*, she revealed her theory, declaring, "This is so serious to me that I am literally staking my reputation on this. Because if someone literally proves me wrong, not only will I feel horrible about it, but I will look terrible."

The response to Patricia Cornwell's 2002 *Portrait of a Killer: Jack the Ripper, Case Closed* was swift and rather mixed. *Publishers Weekly* gave the book a starred review, declaring it "compassionate, intense, superbly argued, fluidly written and impossible to put down," and the reviewer's prediction that it would achieve bestseller status was quickly proven true. Others, though, took an opposite viewpoint. In his December 15, 2002, book review for *The New York Times*, writer Caleb Carr (himself a bestselling crime novelist, the author of *The Alienist*, among others) called the work an ". . . exercise in calumny" and ". . . a sloppy book, insulting to both its target and its audience." Carr was not alone in his condemnation. Cornwell herself later described her UK book tour as "a ten-day deposition," noting her shock at the negative reactions, even though she was duly warned by a Scotland Yard contact, "You know you will be hated for this, Patricia."

The art world, by and large, has similarly scoffed at the assertion of Walter Sickert as Jack the Ripper. Art dealer Andrew Patrick, who has sold multiple Sickert paintings to collectors, including Patricia Cornwell, scoffed, "Everyone knows that this stuff about Sickert is nonsense. He loved these dramatic titles, and to play with the idea of menace." Curator Richard Stone, a Sickert expert, chimed in: "It all sounds monstrously stupid to me."

Even with the recent release of *Ripper: The Secret Life of Walter Sickert*,

many continue to question the connection of Walter Sickert to the White-chapel crimes. How do the facts of the case—few though there may be—and of Sickert's life and art coincide, if at all? Various sites, including the thorough but not unbiased Casebook.org, provide readers with step-by-step breakdowns of Sickert's potential involvement. Now it's time for us to do the same, albeit on a smaller scale.

First, let's take the artistic interpretations of Walter Sickert's artwork. We can concede that Sickert was indeed fascinated with life's sharper edges and the gritty glamour of the city. But so, too, were other artists of Sickert's time and milieu who sought to portray modern life in all its strange facets. Consider Edgar Degas, Sickert's mentor. With Degas, many art lovers immediately imagine ethereal ballerinas in wispy tutus, but not all in Degas's image are sweet and innocent. Many of his tableaux are permeated with the threat of domestic violence, exploitation, and sexual abuse, and in the worlds of theater and dance in the nineteenth century, such things were sadly associated (see chapter 1). This heavy subject matter came with the territory for artists in the second half of the nineteenth century—even going back to Édouard Manet, one of the fathers of Modernism—who wanted to show life as it *was*, warts and all, particularly during a time of great urbanization and social upheaval. Degas painted bleary alcoholics, Manet's masterpieces simmer with disconnection and alienation, and Henri de Toulouse-Lautrec's irresistible Moulin Rouge scenes are surprisingly jarring in their garish colors and stark lighting. Walter Sickert was in very good company with his paintings.

But what about his Camden Town Murder *series*, you may wonder. *Patricia Cornwell and Jean Overton Fuller position them as oil paint confessions!* Two important points may be made here, if I may play devil's advocate. First, it's probable that Sickert shrewdly used sensationalism to his best advantage, completing *The Camden Town Murder* series in order to shock people into paying closer attention to his work (and for the associated press coverage and sales). It wasn't out of character for Sickert to do this; he even produced a dark, brushy, and rather indistinct painting titled

Jack the Ripper's Bedroom (c. 1906, Manchester Art Gallery, UK) that could be seen as a grabby attempt at infamy (riveting side note: Sickert allegedly rented a room that had been previously inhabited by Jack the Ripper, according to the building's landlady. While some see this as evidence that Sickert himself *was* the Ripper, it is also reminiscent of those who willingly pay today to stay in the Lizzie Borden Bed and Breakfast in Fall River, Massachusetts—the frisson of being connected to a killer, however loose, is a huge draw).

Second, the noted similarities between Sickert images and photographs of Ripper victims, particularly Mary Kelly and Catherine Eddowes, may be explained as well—and may have even been purposeful. Cornwell posited to Diane Sawyer that "this painter never painted anything he didn't see. Never." However, this is an incorrect assumption. Like many other artists of his time, Sickert frequently used photography as a tool on which to base his compositions, and the significant time gap between the Ripper crimes and the creation of Sickert's most questionable paintings is meaningful too. The grisly crime scene photographs of Mary Kelly's corpse, for example, were not available for public consumption until 1899, when printed in Alexandre Lacassagne's *Vacher l'éventreur et les crimes sadiques* (*Vacher the Ripper and Sadistic Crimes*, in which Joseph Vacher, the French Ripper, is profiled alongside his British counterpart and other serial killers). Sickert, who summered in France yearly before moving there in 1898, probably knew of Lacassagne's shocking publication and, considering his enthrallment with true crime, may have used its images as source materials for many years. The dating of works like *Le Lit de cuivre* and *The Camden Town Murder* works bear this out—each was created almost twenty years following the Whitechapel massacres. If Sickert was Saucy Jacky, would he have waited so long to confess in his paintings?

Before we scoot away from analysis of Sickert's paintings, it is my responsibility as an art historian to note one very important point: art, like beauty, is in the eye of the beholder. Though we try our best to understand and interpret a work of art based on our education and training, much of an art historian's job is subjective. Take my personal reading of Sickert's *Jack the Ripper's Bedroom*. In my years of looking at this image, I construed

the scene as containing a strange, menacing figure wearing a frock coat and red gloves, standing at the window. But only during my research for this chapter did I read the curatorial analysis of this work from the Manchester Art Gallery, which houses the painting. "A dressing table and chair are just distinguishable beneath the filtered pink half-light coming through the horizontal slats of the blind that covers the window at the back of the room," it notes. "The items of furniture are so indistinct as to make it conceivable that there is person sitting on the chair, although there is no one there." Under the influence of the painting's title, as well as Patricia Cornwell's writings, I saw what I *wanted* to see—a chilling image of a murderer lying in wait. Now don't I feel silly.

Wait—Is That a UFO?

Perhaps inspired by too many episodes of *Ancient Aliens* on the History Channel, believers and art aficionados alike are claiming evidence of extraterrestrial sightings in works of art throughout the ages, with a particular onslaught of space explorers located in medieval and early Renaissance Christian paintings. Led by computer scientist and "UFOlogist" Jacques Vallée, believers have identified hundreds of works of art that purportedly document the historical presence of alien life. A circular cloud bank, similar to a flying saucer, projects a laser-like beam to Earth in Carlo Crivelli's *The Annunciation with Saint Emidius* (1486, National Gallery, London). A blue-and-gold vessel—a spaceship?—floats near a shepherd, who shields his eyes from its powerful rays, in the *Virgin and Child with Saint John* (artist debated, fifteenth century, Palazzo Vecchio, Florence). This last painting is so popular with UFO fans that it is graced with the (unofficial) alternate title of *Madonna of the UFO*. And these are only the tip of the metaphorical art iceberg, with "sightings" in art reported in Chinese scrolls, stone-age Iraqi sculptures, French coins, and far beyond. What gives? As much as I'd like to believe, my inner Dana Scully is not convinced: typically, these paintings represent

otherworldly religious figures—angels, spirits, ghosts, gods and goddesses—and how best to visualize these mystical characters than to present them zooming through the sky on a star? These figures look strange precisely because they are considered beyond human understanding. But will that deter the UFOlogists? Probably not— because art interpretation, like beauty, is in the eye of the beholder.

Cornwell's accusation of Walter Sickert also hinges on a modern-day psychological profile, which proposes a traumatically botched surgery for a "fistula of the penis" as the basis for his transformation into history's most elusive serial killer. Cornwell gleaned the details from Sickert's only surviving relative, John Lessore, Sickert's nephew by marriage to his third wife, Thérèse Lessore. John Lessore stated that it was only family hearsay that promoted the sensitive location of the fistula, and no documentary evidence exists to confirm that it affected his sexual life in any way, including but not limited to his supposed impotence. Likewise, Sickert's assumed sterility might also be bunk. Rumors swirled, both during Sickert's lifetime and long after, about illegitimate children the artist had sired. Even one of Sickert's closest friends, French painter Jacques-Émile Blanche, wrote in 1902 that Sickert was "an immoralist . . . with a swarm of children of provenances which are not possible to count." Sickert's first wife, Ellen, divorced him on account of adultery, and it was common knowledge among friends that Sickert kept a mistress in Dieppe, his home away from home. Sickert may very well have been a misogynist—that wasn't unusual for the time period, unfortunately—but his plumbing probably worked just fine *and* probably didn't drive him to commit homicide.

But what about that DNA evidence that reportedly connects Sickert to known Jack the Ripper letters? This is where things get interesting and complicated, because *multiple* DNA examinations were performed on Sickert and Ripper materials, providing different results. The first test attempted to link the artist as the murderer via a nuclear DNA test. This is the type of DNA test with which most of us are familiar, the ones used for the past couple of decades to trace ancestry and to prove the identities of

baby daddies and potential killers alike. This evaluation returned a negative result, meaning no conclusive evidence could be located to connect Sickert and Jack. It was only at this point that Cornwell's team moved on to the mtDNA test.

As a nonscientist, I wrinkled up my nose in confusion at this distinction. Isn't DNA . . . *DNA*? Well, yes and no. Whereas nuclear DNA will uniquely match a single person to the evidence, mitochondrial DNA cannot, as it is not unique. What it *can* do is limit results to a certain segment of a population. In this way, it is analogous to blood typing: if you're looking for a killer who has type A positive blood, you can throw out suspects who don't—goodbye, O negative! That being said, your pool of type A positive suspects might still number in the thousands or millions. MtDNA experts estimate that between 1 and 10 percent of any given population will have similar strains of mitochondrial DNA. So let's do some math: if we assume a very generous 1 percent estimate, then we can naturally conclude that only 1 percent of the UK's population would have shared mitochondrial DNA with that found on Ripper letters. A turn-of-the-century census states that London's population had grown to approximately forty million people. One percent of this number is four hundred thousand. *Four hundred thousand!* Including Walter Sickert in this suspect pool certainly doesn't mean that he *isn't* Jack the Ripper, but it doesn't necessarily mean he *is* either, and what remains are hundreds of thousands of people who still might fit the murderous bill.

Credit where credit is due, though: in Patricia Cornwell's 2017 reworking of her theory in *Ripper: The Secret Life of Walter Sickert*, she concludes that "the [DNA] analysis probably shouldn't have been done at all," confessing that the fragility of documents and materials, as well as inadequate handling, may have contaminated the evidence over the course of more than a century. "[W]hile certain matches we got might be significant," she writes, "we'll never know for sure."

Was Walter Sickert *really* Jack the Ripper, then? Well, as neither a Sickert specialist nor a scholar of abnormal psychology, I'm certainly not qualified

to say, but I must note that I am extremely hesitant to identify Walter Sickert as the killer. So much of the purported evidence against him is suspect, subjective, and coincidental. At the same time, even I must confess that little things do add up, and perhaps coincidences aren't coincidences at all. But if we follow the dictum that people are presumed innocent until proven guilty, Sickert—though suspicious in many ways—probably could not be convicted if on trial today. If anything, twenty-first-century audiences might be the guilty ones for misunderstanding the artist, misinterpreting his works, and letting the whole thing get out of hand. The best summary I've yet found of the Sickert/Ripper hysteria is a pointed, snarky op-ed by UK art critic Jonathan Jones. Jones sympathizes with "poor Sickert" in a December 2013 article in *The Guardian* before trying his hand at Ripperology art interpretation. "Who knows," Jones writes sarcastically:

> Perhaps [Sickert] was Dracula, that other renowned Victorian monster. After all, Dracula enters modern culture in a novel published in Sickert's London when this harsh, demonic painter was at work. I have researched this using the latest technology, and when you look closely at Sickert's painting of Minnie Cunningham [*Minnie Cunningham at the Old Bedford*, 1892, now in the Tate Collection, London], she has two small puncture marks on her throat. As for her name, "Minnie" is clearly a reference to Mina Harker in Stoker's *Dracula*—which is therefore a veiled portrait of Sickert and his dark side. The red dress Sickert's Minnie Cunningham wears is a confession of the blood he needs to stay alive. Case closed: Walter Sickert was Dracula. Or perhaps he was just a powerful painter whose art addresses the same themes of sex and city life that have turned the crimes of a nameless murderer into a modern myth.

Point taken, Jonathan Jones. Maybe Walter Sickert isn't Jack the Ripper after all. Maybe he was just a guy fascinated with true crime and with a bent toward the dramatic. But until someone comes up with a better suggested culprit, I'm going to keep one (skeptical) eye on Sickert.

Norman Rockwell, *Murder in Mississippi*, 1965

Sentimental, Cheesy, and . . . Socially Conscious: Norman Rockwell and the 1960s

The startling truth is this: as this narrative unfolded, amidst all the voices breaking free, telling their stories for the first time, the loudest voice of all was that of Norman Rockwell.

JANE ALLEN PETRICK, AUTHOR

How will I be remembered? As a technician or artist? As a humorist or a visionary?

NORMAN ROCKWELL, ARTIST

In their home, my grandparents kept a whole bookshelf of leather-bound albums, and I loved to leaf through them for hours when I was growing up. There was one volume that I returned to again and again: my grandmother's scrapbook filled with comics cut from newspapers, and magazine illustrations she found amusing. I spent many an afternoon poring over these treasures with my grandfather, sitting on his lap and giggling. He found one image in particular hilarious, and his joy over it was infectious: a picture of a school-age girl seated on a wooden bench, braids messy, shirt half untucked, her rumpled plaid skirt barely revealing a bandaged knee. With a satisfied and mischievous grin, she meets the viewer's gaze with one opened eye—because her *other* eye is fused shut and bruised, all black, blue, and pink. This little girl has been in a skirmish, and though she waits outside a school principal's office and is sure to be reprimanded, it's evident that she's ultra pleased with herself. *Victory is mine!* she might be thinking.

And we are powerless to do anything but cheer her on. My grandfather loved her, and so did I.

This illustration from *The Saturday Evening Post*—it graced the cover of the May 23, 1953, issue—was my first introduction to the work of Norman Rockwell (1894–1978). Rockwell's name is practically synonymous with *The Post*, as he worked for nearly fifty years to create more than three hundred indelible covers for the magazine. *The Young Girl with the Shiner* (1953, Wadsworth Atheneum, Hartford) is one of his most popular creations with the perfect combination of Rockwellisms: gentle humor, light childhood misbehavior, and nostalgic Americana. And it's wonderfully cheesy.

This cheese factor is one of the reasons that over the years, art snobs have blatantly dismissed Rockwell, the same way that popular artists are typically dismissed if they aren't considered rule breaking or innovative. In the hallowed halls of many American art museums, curators frequently scoff when the name Norman Rockwell is spoken, scrambling to declare, "Not me! I'm *not* organizing a damned Norman Rockwell exhibition!" (You'd think that we're all worried about our coolness and fancy reputations, and you may be right: God forbid we curators engage with melodrama or wholesomeness.) He's no Andy Warhol (though Warhol later named Rockwell as one of his favorite artists!), and certainly no Jackson Pollock or Georgia O'Keeffe, or even Jeff Koons, though Koons has some ironic Rockwell DNA in his bones. The art establishment can't get over Rockwell's innate corniness. That, combined with the fact that many consider Norman Rockwell to be "*just* an illustrator," guilty of painting for the masses and not a *fine artist*, means that many museums and galleries keep themselves at arm's distance. Turns out it has been this way since the mid-twentieth century, when the artist was at his pinnacle. On a visit to the Art Institute of Chicago in the 1950s, Rockwell met an art student who recognized him, only to remark, "My art professor says you stink!"

I'll admit that my own experiences of glancing through my grandmother's humor scrapbook had inured me to this maudlin vision of Norman Rockwell. It wasn't a negative viewpoint by any means, but neither did I think much about him and his work in a serious way. He was saccharine

and enjoyable to look at, but nothing about his work was particularly challenging or interesting to me.

And then I saw his 1965 painting, *Murder in Mississippi* (Norman Rockwell Museum, Stockbridge, MA). And I never took Norman Rockwell for granted again.

Norman Percevel Rockwell was born in New York City on February 3, 1894, and like many other soon-to-be famous artists, he knew from an early age that he was destined to be an illustrator. Destiny seemed to think so, too, because it brought him success after success while he was still a teenager. While still a kid, basically—just fifteen!—he received commissions for Christmas cards and book illustrations before striking it big when he was hired as the art director for *Boys' Life* magazine, the official publication of the Boy Scouts of America. That gig brought Rockwell more opportunities in the burgeoning market of youth publishing, and he began establishing a successful freelance illustration career.

When Rockwell was twenty-one, his parents opted to move the family from New York City to New Rochelle, New York—a quiet town lauded for its community of creators, including well-known illustrators like the Leyendecker brothers and Howard Chandler Christy. Rockwell also became acquainted with a cartoonist named Clyde Forsythe, who happened to work for a little publication called *The Saturday Evening Post*. Under Forsythe's instruction and guidance, Rockwell sent in a proposal for a cover illustration to *The Post* at the tender age of twenty-two. It went over very well indeed, with his first *Post* cover published on May 20, 1916. *Mother's Day Off* (also known as *Boy with Baby Carriage*, oil version at the Norman Rockwell Museum, Stockbridge, MA) is considered quintessentially Rockwell: a young boy, bedecked in a suit, tie, and bowler hat, grumpily pushes a pram while two baseball-cap-wearing playmates tease him for his babysitting duties. It was just a small glimpse of what would come over the next half century of his career—kids, Americana, and humor: the perfect Rockwell trifecta. Though he would contribute to multiple publications of his day, including *McCall's*, *Ladies' Home Journal*, and others, it is these *Post*

images that most of us conjure in our minds when we hear the name Norman Rockwell.

Give Graphics a Go!

Graphic design and illustration sometimes get a bad rap within artistic circles—"it's not *fine* art," snooty critics claim, as they once growled about Norman Rockwell. But it proved to be a remarkable springboard for several twentieth-century art stars who got their start in magazines: Andy Warhol leaped to greatness via his charming illustrations of shoes for *Glamour*. Feminist artist Barbara Kruger honed her bold, graphic style as a magazine designer for *Mademoiselle*. And Edward Hopper, of *Nighthawks* fame, found full-time pay as an illustrator for magazines such as *Country Gentleman* and *Scribner's* and used his training there to great effect in his later artworks. Graphic design: it's art. And it can get you the jump your art career needs.

In 1963, Norman Rockwell quietly retired from work at *The Saturday Evening Post* at the gentle urging of his third wife, Molly. Rockwell was sixty-nine years old and had been completing cover illustrations for the *Post* for forty-seven years, since the publication of *Mother's Day Off* in 1916. Like that first cover, most Rockwell illustrations are striking in their sweetness and charm (art critic Sebastian Smee notes that Rockwell's famous works are like "adolescent crushes . . . so damned cute, they snatch any sentiment you may be holding in reserve for nearby [artistic] competitors and hog it all for themselves." That imagery is so perfect that I've got a crush on that sentence). To be fair, though, Rockwell's illustrations explicitly focused on the greener pastures of American life and shied away from much of the darkness: a scuffed shoe might hint that a figure was down-and-out, but there'd be no depictions of a Depression-era breadline or despondent gazes. While World War II preoccupied many of Rockwell's images from the first half of the 1940s—

including his iconic *Four Freedoms* series—they tell their own placid tales of support and sunny days, with sailors on leave lounging in hammocks, small boys straining to make themselves tall enough to enlist, and happy families gathering together to celebrate an abundant Thanksgiving. And that cheerfulness was the whole point, with Rockwell noting in his 1960 autobiography, *Norman Rockwell: My Adventures as an Illustrator* (Garden City, NY: Doubleday, 1960), "Maybe as I grew up and found the world wasn't the perfect place I had thought it to be, I unconsciously decided that if it wasn't an ideal world, it should be, and so painted only the ideal aspects of it." His *Saturday Evening Post* images, especially featuring children, were his most popular ones: wholesome enough to share with the whole family and apt to suffuse the viewer with warm nostalgia and happy memories. "I like to paint kids," he once noted. "People think of their own youth [when they see my work]." Rockwell's painted world was the American ideal.

Ideal, that is, in terms of *The Saturday Evening Post*'s rigid definition. One of the most noticeable traits of Rockwell's *Post* covers is the blatant whitewashing of American life—a vision of Caucasianness with nary a person of color to be seen. This was due, in fact, to a specific rule at the magazine: no person of color should be depicted unless in a servile position. To most of us today, this order is gross and despicable, but it was very much a product of its segregated times. According to the artist's granddaughter, Abigail Rockwell, this directive was a painful one for Rockwell, and so he attempted workarounds for it:

He would sneak African Americans and people of other ethnic backgrounds into his paintings where he could—*Statue of Liberty*, July 6, 1946 [cover of the *Saturday Evening Post*], for example. He cleverly turned this policy on its head in his December 7, 1946, cover, *New York Central Diner*. In it, a young boy in the train's dining car is trying to figure out the check. But it is an African American man, the waiter, who is the heart of this painting. The viewer's eye goes to him because his presence is so immediately felt; he radiates such kindness and amusement at the boy's dilemma.

By 1963, Rockwell was fed up with this "servility" directive, especially given the prominent nature of the civil rights movement. As an artist for *The Post*, it was his job to present readers with a vision of America, but as the decade progressed, Rockwell was keenly aware that his picture of the nation was one of myth, not reality. How could he expect to fully present American life if he was refused the opportunity to depict its challenges and most important issues?

"Times are changing now, and people are getting angry. I'm getting angry now too," he remarked to a newswire reporter in June 1965, and he intended to put more of that anger on display. With his third wife Molly at his side (she was liberal and politically active and had a great influence on her husband), Rockwell quietly stepped away from *The Post*.

Imagine the potential for terror here: the magazine had supported him for half a century! It made him famous and brought him great success and a reputation that continues to this day. But that willingness to step away ushered in for Rockwell a new and fruitful period in his life: that as an illustrator for *Look* magazine.

Look magazine's primary goal is right there in its name: look! Whereas *The Saturday Evening Post* featured articles, letters, editorials, poems, and short stories with the occasional illustration or cartoon (besides the cover art, of course), *Look* aimed to do the opposite: it was essentially a visual medium that made use of image mass production and camera technology to provide its audience with pictures and the occasional text. For Norman Rockwell, such a publication proved to be a great place to experiment with visual storytelling in a new and compelling manner. After all, the adage notes that a picture paints a thousand words, and no one could paint a picture the way Norman Rockwell could.

An additional reason that *Look* appealed to Rockwell was its willingness to tackle uncomfortable and important issues. This certainly stems from *Look*'s forward-thinking position as a product of the twentieth century, publishing its first issue in 1937. By contrast, *The Post*, which was created in 1821, still held on to its stubbornly blasé nineteenth-century roots,

which favored pacification over challenge. *Look* had already made history in January 1956, when it scandalized the public by presenting an article by William Bradford Huie titled "The Shocking Story of Approved Killing in Mississippi." In the article, Huie interviewed J. W. Milam and Roy Bryant, who confessed to killing fourteen-year-old Emmett Till, an African American boy from Chicago who was in Mississippi visiting family in August 1955. As one might expect, this article garnered very mixed reactions from a still very-segregated America. In a letter to the editor, Richard Lauchli of Collinsville, Illinois, wrote, "Roy Bryant and J. W. Milam did what had to be done, and their courage in taking the course they did is to be commended. To have followed any other course would have been unrealistic, cowardly and not in the best interest of their family or country." Many others still praised *Look* for its bravery. "You are to be complimented for your willingness to stick your neck out in this manner for the sake of justice," wrote Samuel H. Cassel of Fairview Baptist Church in Cleveland, Ohio. "Minorities all over the country are indebted to your stand on this brutal slaying," wrote Airman First Class Howard L. Austin of the U.S. Air Force, from Geneva, New York.

This was the divided environment—both at the magazine and in the country as a whole—that Norman Rockwell witnessed in his new position at *Look*.

For his first commission with *Look*, published on January 14, 1964, Rockwell packed an immediate punch and created one of his most indelible images. *The Problem We All Live With* (1963, Norman Rockwell Museum, Stockbridge, MA) depicts Ruby Bridges, a six-year-old African American girl who became the first nonwhite student to attend William Frantz Elementary School in New Orleans after the city was forced to desegregate its schools (six years after *Brown v. Board of Education*!). Bridges was one of six African American children who passed the Frantz Elementary entrance exam, but she was the only one who chose to attend the school and was the only nonwhite child to show up for class on her first day, November 14, 1960. *The Problem We All Live With* succinctly and magnificently

showcases the reality that little Ruby faced that day: she is dressed immaculately, wearing a pleated white dress, her tennis shoes barely scuffed, and her braided hair pulled back in a demure, girlish bow. She walks along with her head held high, as if oblivious to her surroundings—and is that a shadow of a proud smile on her lips? But her surroundings aren't wonderful. We can't see much, really, but what we see is bad enough: the letters "K.K.K." carved into the wall at the far left of the canvas; the racial slur "NIGGER" painted on the wall right above poor Ruby's head; the splattered remains of a rotten tomato streaking down to the ground, having barely missed the girl's pristine gown. Flanking her on both sides are four U.S. marshals, who were deputized to escort her safely to class, but we don't see their faces—and neither do we see the figures of the many who boycotted and ridiculed Ruby's presence that day. We see only *her* face—and to make it even more psychologically arresting, the viewer is brought down to her eye level, an effective and sympathetic framing mechanism on Rockwell's part.

Like the interview with Emmett Till's murderers several years prior, Rockwell's inaugural illustration for *Look* was met with decidedly mixed reviews. As Linda Szekely Pero, curator of Norman Rockwell Collections at the Norman Rockwell Museum, has noted:

One Florida reader wrote: "I am saving this issue for my children with the hope that by the time they become old enough to comprehend its meaning, the subject matter will have become history." Other readers objected to Rockwell's image. A man from Texas wrote, "Just where does Norman Rockwell live? Just where does your editor live? Probably both of these men live in all-white, highly expensive, highly exclusive neighborhoods. Oh, what hypocrites all of you are!" The most shocking letter came from a man in New Orleans who called Rockwell's work "just some more vicious, lying propaganda being used for the crime of racial integration by such black journals as *Look*, *Life*, etc."

The painting still strikes a strong emotional chord today, particularly for its unflinching use of language. As art historian William Kloss notes,

"The N-word there—it sure stops you. There's a realistic reason for having the graffiti as a slur, [but] it's also right in the middle of the painting." That sense of shock is exactly what Norman Rockwell wanted us to feel, alongside the empathy we experience when looking at Ruby walking bravely along. It is an iconic late-Rockwell image, and one of the most notable civil rights–era works of art.

Wonderful side note: in 2011, President Barack Obama quietly requested that the painting be loaned temporarily to the White House, where it hung in a hallway outside the Oval Office for four months in commemoration of the fiftieth anniversary of Bridges's historic first day of school. Weird side note: during the O. J. Simpson murder trial in 1995, Simpson's defense team, under the guidance of his lawyer Johnnie Cochran, hung a copy of this painting in Simpson's home in order to represent "something depicting African-American history" and gain support from the African Americans on the jury. This, according to authors Lawrence Schiller and James Willwerth in *American Tragedy: The Uncensored Story of the Simpson Defense* (New York: Random House, 1996), contributed to the defense's successful acquittal of Simpson.

Jacob Lawrence: Portraying Black Heroism

With paintings so suffused with color, vitality, and movement, it's no wonder that Jacob Lawrence was—and still is—a highly influential artist. In the midst of a seriously segregated midcentury America, Lawrence gently pushed for more positive representations of black people in visual art to fight against negative stereotyping. In the 1930s and into the early 1940s, Lawrence created pulsing, primary-colored scenes of heroes of the African diaspora, including Harriet Tubman, Toussaint L'Ouverture, Frederick Douglass, and others. It was a gamble with a huge payoff: in 1941, at the age of twenty-four (!), he became the first African American artist whose works were acquired by the Museum of Modern Art (MoMA) in New York. These works are among some of the most vibrant and stunning works of

Modern American art (even if they weren't immediately accepted by some art lovers: see chapter 2 for more on Lawrence's modernist "eyesores").

The Problem We All Live With begat a new era for Rockwell in terms of its subject matter, but its design is still fairly Rockwellian: a child-centered, child-height image with pops of bright reds and yellows. It still *looks* and *feels* like a Norman Rockwell painting, even though it lacks sentimentality, corniness, and the artist's signature touch of humor.

The same cannot be said about *Murder in Mississippi*.

Murder in Mississippi (1965, Norman Rockwell Museum, Stockbridge, MA) looks and feels almost *nothing* like a Norman Rockwell painting. And that's probably half the point. (When I viewed this work of art for the first time, I literally stopped in my tracks and said, "Oh my God," and quickly followed it up with an astonished, semiskeptical question: "*That* is Norman Rockwell?") Like *The Problem We All Live With*, *Murder in Mississippi* visually recounts a real-life event during the civil rights movement: the murder of three civil rights workers (two white, one black) in Philadelphia, Mississippi, in June 1964, an event that would later be fictionalized in the 1988 Gene Hackman–Willem Dafoe film *Mississippi Burning*, as well as a more truthful take in 1990's *Murder in Mississippi*, starring Tom Hulce and Blair Underwood. Rockwell's canvas depicts Michael Schwerner, James Chaney, and Andrew Goodman, three Congress of Racial Equality (CORE) volunteers assisting with black voter registration in Mississippi during Freedom Summer. Their grassroots efforts to support African American justice ran afoul of the Ku Klux Klan, who kidnapped the three workers and chain-whipped them before shooting them, point-blank, one by one. Their bodies were buried and remained undiscovered for forty-four days, and their murder became national news.

Murder in Mississippi was another commission for *Look*, meant to illustrate a brief story titled "Southern Justice" by Charles Morgan Jr. to be published on June 29, 1965 (Morgan's story lends its name as an alternate, unofficial title for *Murder in Mississippi*, possibly as a way to distinguish

the painting from the earlier *Look* magazine story of Emmett Till, "The Shocking Story of Approved Killing in Mississippi," because their titles are ridiculously similar). Multiple factors hint that this project was a very important—and indeed personal—one to the artist. According to Pero, Rockwell typically worked on numerous projects at once, filling his Stockbridge studio with five or six canvases in varying stages of development. But here, for the first time in his life, he broke with this jumbled, casual methodology and ceased working on anything other than what would become *Murder in Mississippi*.

Age-Old Protest Art

Think that the genre of protest art was born of the fire and fury of twentieth-century social revolutions? Think again. Many art movements began as a backlash to what had come before, but the seeds of artistic protest were sown in the sixteenth century, thanks to the Protestant Reformation against the Catholic Church. As the name implies, Protestant Reformation art grew directly from protests over Catholic excessiveness, and long-used traditions in Christian scenes—like an elaborate golden halo around a saint's head—were eschewed in favor of a more naturalistic presentation. As interest in the Church waned, so, too, did the fascination with Christian art, leading to a boom in production of landscapes, still lifes, and genre scenes (especially in northern countries like Germany, Flanders, and Holland). A major downside of the artistic protest, though, was a huge spike in iconoclasm, or the attack on works of art due to their subjects or style. Many Catholic treasures were destroyed or damaged during this time period. So remember this during your next rally: keep away from the art, and just chant and sing a little bit louder instead, OK?

For five feverish weeks, Rockwell took copious notes and produced multiple sketches and studies before completing his final oil-on-canvas iteration

in April 1965. Among Rockwell's reference materials for this painting, now in the collection of the Norman Rockwell Museum, was a press clipping from *The New York Times* on July 14, 1964, that referred to the three men, whose bodies had still not been located at that time. As Pero writes, "[This] establishes that he had the June 21, 1964, murders in mind long before beginning work on his painting in March 1965."

As he did with most of his projects, Rockwell relied on photography to support his preliminary drawings for *Murder*. A series of preparatory pictures from late March 1965 exist, presenting three men modeling in Rockwell's darkened studio for the figures of Chaney, Goodman, and Schwerner, all of whom can be identified—Oliver McCary posed as Chaney on March 20, as did Kit Hudson in the role of Andrew Goodman. Striking a more personal, walloping chord is the model for Schwerner, who can be considered the primary figure in Rockwell's composition: Norman Rockwell's eldest son, Jarvis. For a painting so important, it makes sense that Rockwell would request the participation of trusted models and that he'd maybe look within his immediate family for help, even if simply to approximate a figure's proportions and pose. But imagine the psychic toll that this request might hold: a parent asking his son to pose as a man about to be brutally killed.

Perhaps this experience fueled another one of Rockwell's preparatory decisions: the choice to use *himself* as a model for an additional photographic study about the visual effects of blood smeared on a shirt. Intending to present Schwerner wearing a crisp, white button-down soiled by Chaney's hands, Rockwell apparently insisted on using human blood ("from a concealed source," Pero notes) to garner the intended effect, dousing his hands in it and dragging it down his own sleeve. Yikes.

Rockwell looked to history as inspiration too. Early sketches of the central Schwerner/Chaney grouping show Rockwell's consideration of Michelangelo's famous *Pietà* (1498–99, St. Peter's Basilica, Museo del Vaticano, Vatican City) as a foundation for the manner in which Schwerner holds Chaney up, which isn't a surprise—Rockwell greatly admired Michelangelo and even based his famous *Rosie the Riveter*, illustrated on the cover of *The Post* in 1943, on the Renaissance painter's portrayal of the prophet Isaiah on the Sistine Chapel ceiling. Ultimately, though, he ended up using

a far newer source as the model for his composition: a Pulitzer Prize–winning image by photojournalist Héctor Rondón Lovera titled *Aid from the Padre*, presenting a chaplain grasping a soldier mortally wounded in a 1962 Venezuelan military uprising. We can see a direct correlation between Rockwell's illustration and Lovera's documentary image, which makes good sense: by using a photojournalistic image as his base, Rockwell's own image becomes less fantastical (in the sense that it is an imagined rendition of the trio's final moments) and acts instead as a reminder that this terrible event wasn't one of Rockwell's American myths but was an actual occurrence.

All these obsessive preparations and toil paid off in the final canvas, completed on April 13, 1965, and measuring approximately 4 ½ feet tall by 3 ½ feet wide—a sizable piece. In the scene that Rockwell created, there are only three figures, starkly lit as if by car headlights. Michael Schwerner, standing just to the left of center, stares off to the right side of the canvas while holding a struggling, dying James Chaney off the rocky ground as Chaney's grave injuries threaten to level him. Chaney's grasping hands clutch his friend and colleague and leave that appalling smear of blood on his shirt. Lying on the rocky ground at the feet of the two figures is a third: the crumpled body of Andrew Goodman. Is he still alive? Is he dead? It's hard to tell. But if he hasn't been killed yet, we know he is about to be. And we also know that Schwerner and Chaney's time is limited too.

Rockwell's composition is disquieting in its minimalism. We see none of the Klansmen who rallied to torture and kill the CORE volunteers, though early color sketches do exist showing that the artist had originally intended to paint a horizontal spread and include a larger cast of characters. But boiling down the scene to its essentials makes it even more urgent. Instead of distracting viewers with the presence of others, Rockwell only hints at the mob with forbidding, elongated shadows that creep ever so closely toward the three men and serve to further highlight their impending doom.

Such minimalism also extends to the color palette. *Murder* is almost completely devoid of color, presented in varying ranges of brown, cream, and black. The effect is similar to that of a black-and-white photo, making it even more reminiscent of Lovera's *Aid from the Padre*. But there's one

break with this documentary-inspired color scheme: bloody red paint highlighting gaping, bleeding bullet wounds on James Chaney's right shoulder and the stained smears left by his hands on Michael Schwerner's sleeve. That red paint is horrific and startling, and yet absolutely right: it shakes the viewer in a visceral way. This ain't your mother's Norman Rockwell. This is Norman Rockwell for a new America and a new era, and neither is necessarily pretty.

When it came to the ultimate publication of the artwork as part of the "Southern Justice" story in *Look*, the outcome surprised Rockwell. Instead of accepting his newly completed, impeccably painted work, the editors of the magazine opted instead to reproduce an earlier oil sketch that Rockwell had mailed in as a conceptual example. It shares the same basic construction as the refined, completed painting, but it was completed in a hastier, faster manner. This made its appearance more emotionally jarring and disturbing: Schwerner, for example, is a hollow-eyed figure with a skull-like visage, and Goodman is a mass of squiggly lines at his feet, looking more like a Honoré Daumier or a Francisco de Goya than a Norman Rockwell creation. *Look*'s art directors found it more arresting and meaningful than the cleaner final canvas, and Rockwell himself eventually agreed, noting three years later that "all the anger that was in the sketch had gone out of [the final canvas during its reworking]."

That being said, I humbly disagree. For me, the realistic precision of the final canvas and Rockwell's evident technical prowess (and don't forget those splotches of blood red, which don't read as clearly in the oil sketch) make it *more* unsettling. They are the only things that hint of Rockwell's hand here—otherwise, such an expressionistic work, like the oil sketch, might have truly come from another artist. That Norman Rockwell—depicter of freckle-faced skinny-dippers and scrappy-sweet girls, of twinkly-eyed Santas and brave Boy Scouts—would actively choose to present the horrors of his world so strongly and clearly is enough of a wondrous surprise in and of itself.

As with *The Problem We All Live With*, the response to the oil sketch

published alongside "Southern Justice" received much attention—but this time, most of it was glowing. "I was deeply moved by Norman Rockwell's beautiful and compassionate painting of the murder of the three civil rights workers," a reader named Mary Allison wrote in to *Look*'s editorial team. "It should forever be a reminder to the conscience of mankind of the results of hate and ignorance."

In the last decade of his life, Rockwell looked back upon his civil rights–inspired works of art with pride, but also with humility, shrugging off excessive praise by noting that it was the subject, not his presentation of it, that was meaningful: "I just wanted to do something important," he said.

And these works are important, even today. Combined, three paintings—*The Problem We All Live With*, *Murder in Mississippi*, and a 1967 work titled *New Kids in the Neighborhood* (Norman Rockwell Museum, Stockbridge, MA) that gingerly touches on suburban integration—form a trinity of Rockwell's activist artwork that still stirs and sobers. *The Problem We All Live With* typically gets most of the attention, as the artist's first foray into racial justice, and *New Kids in the Neighborhood* treads that same child-centered, optimistic road. But not *Murder in Mississippi*: it surprises and disturbs us. Those sensations, opposite from Sebastian Smee's delicious "crushes," are so foreign to us viewers of conventional Rockwell images. In *Murder*, there's no hope, no victory, no understanding to come—just blood and the knowledge of waiting death.

It's hard to fathom that Norman Rockwell would want to up the ante and create a work of art *more* stunningly disturbing than *Murder in Mississippi*, but in the midst of turbulent 1968, he did just that. *Blood Brothers* (1968, current location unknown) began its life as a commission for *Look* magazine, just as *Murder* had, but whereas *Look* agreed to publish a version of *Murder*, it rejected *Blood Brothers* for publication outright. And I get it. It's graphic in a way that *Murder* isn't—google it and you'll see what I mean. In *Blood Brothers*, Rockwell presents a scene of two men—one white, one black—killed side by side, their blood pooling and mingling brightly on the ground beneath them. Rockwell was said to have drawn inspiration for

this image from the dangerous riots following the assassination of Martin Luther King Jr., and the Norman Rockwell Museum helpfully notes that the artist's intention was to "show the superficiality of racial differences—that the blood of all men was the same." But perhaps it is a failing of Rockwell's painting that we can't easily get to that why-can't-we-all-just-get-along core. He did *too good* a job at bringing the terror of the times to his audience.

It was too much for *Look* to handle. Early on, a compromise was suggested to Rockwell by *Look*'s art directors—how about shifting the focus of the work from scarred, segregated America to war-torn Vietnam?—but even with this redesign, *Blood Brothers* was over-the-top grisly. *Look* refused it, and at some point, Rockwell opted instead to donate it to CORE—an interesting decision that also brings his racially motivated works full circle and right back to the murders of James Chaney, Michael Schwerner, and Andrew Goodman, CORE workers all. It was a noble idea—to provide the work of art to CORE to support its mission—but unfortunately, the fate of the finished painting is unknown, as it seems to have disappeared from CORE's collections. We now know of it mainly from studies and sketches housed at the Norman Rockwell Museum.

When considering Norman Rockwell only from the perspective of his winning saccharine covers for *The Saturday Evening Post*, it feels like the seventy-something *should* have been all wrong for this job of shocking the American public out of complacency. In actuality, though, Rockwell's lauded position as America's greatest living illustrator made him exactly right for it. Trusted and beloved, he stepped into the role of the country's wise, gentle, and firm grandfather, using his images to guide and mold our beliefs—sometimes hopefully (as in *The Problem We All Live With*), sometimes bluntly (as in *Blood Brothers*). If a younger, fresher artist had jumped in to create a challenging series of racially motivated paintings, the effect wouldn't have been the same: after all, the "shocking" part usually comes easily, but provoking more traditional and conservative audiences out of their complacency is much harder. But in *Murder in Mississippi*, Norman Rockwell does both.

The
Slightly Odd

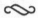

Leonardo da Vinci, *Mona Lisa* (*La Joconde*), c. 1503–1506 (with possible later additions)

CHAPTER 5

The Lady Vanishes: The (Multiple) Thefts and Forgeries of the *Mona Lisa*

> [*Mona Lisa*'s] eyes had that lustre and watery sheen which is always seen in real life, and around them were those touches of red and the lashes which cannot be represented without the greatest subtlety.... The nose, with its beautiful nostrils, rosy and tender, seemed to be alive. The opening of the mouth, united by the red of the lips to the flesh tones of the face, seemed not to be coloured but to be living flesh.
>
> GIORGIO VASARI, ARTIST AND HISTORIAN

> With all due respect, the *Mona Lisa* is overrated.
>
> PAULO COELHO, AUTHOR

When I was an undergraduate in college, I took an entry-level art history survey course, wherein I learned all the basics of terminology and methodology: the meaning of the word *chiaroscuro*, how to identify the three types of capitals on ancient Greco-Roman columns, and what made the Impressionists different from the Postimpressionists (despite the obvious fact that the Postimpressionists came later, *duh*). In an overcrowded lecture one afternoon, I learned something rather shocking about the most famous work of art on the planet. My smart, level-headed professor covered the artist's revolutionary use of perspective, the theories about the identity of the sitter, and—naturally—the obsession over her mysterious smile. She said, "You can see her yourself if you visit the Louvre Museum in Paris." But then she paused, and after a breath, she whispered, "But, of course, the *Mona Lisa* on display is a fake."

• • •

Nearly twenty years have passed since I heard that admission—and I'm still haunted by it. What is it about Leonardo da Vinci's iconic *Mona Lisa* (c. 1503, Musée du Louvre, Paris) that would lead my mentor to feel so strongly about its authenticity, or lack thereof?

This question swirled around in my mind on a recent business trip to France, wherein I had the good fortune to make a pilgrimage to see Leonardo's masterpiece in person for the first time in a decade. Not that it was actually easy to *see* the work, because standing in front of *Mona Lisa* today is a maddening experience. At the Louvre, the painting—which is smaller than most of us imagine, at 30 inches high by 20 inches wide—hangs in an acclimatized compartment that keeps its temperature steady at a cool 43 degrees Fahrenheit and a perfect 50 percent humidity, and behind bullet-proof glass that is 1 ½ inches thick. Beyond that, visitors are kept behind a railing, itself set back from the work of art by several feet. Finally, our modern age dictates that if we don't snap a selfie in front of something, we never saw or experienced it—so add in hundreds of iPhones held above heads.

Herein lies the truth of the matter: you can't really see *Mona* very well. But this fact doesn't stop the millions of visitors—literally *millions!*—who brave the labyrinthine corridors of the Louvre to attempt to see it. The *Museum Index*, an annual report prepared by the Themed Entertainment Association (TEA), noted that the Louvre is the world's most visited museum, welcoming 10.2 million visitors in 2018 *alone*, and that number is constantly growing, with 2018's stats representing a staggering 25 percent increase over 2017. And of those visitors, roughly 80 percent come to the Louvre specifically to see the *Mona Lisa* (known in France as *La Joconde*). So if the Louvre is the world's top museum, the *Mona Lisa*, then, is the most visited work of art on the planet.

Why the infatuation with *Mona*? What's so great about this small wooden panel of a fairly homely lady with an extra-large forehead, nonexistent eyebrows, and a slight smirk? Most viewers do not really consider her importance, simply using her as a visual check on their Parisian to-do list.

However, the *Mona Lisa* is not only a cultural touchstone for us today (even my five-year-old knows her by name). There is evidence that it was also of strong importance to its creator, who kept it in his possession for decades.

Leonardo da Vinci (1452–1519) is the truest embodiment of the Renaissance man if there ever was one. Not only did he actually live during the Renaissance, that European golden age, but his interests were vast and ran deep. He excelled and experimented in many different arenas, fully interdisciplinary before such a catchphrase became cool. Leonardo was aces in painting, sculpture, architecture, music, engineering, literature, math, botany, and astronomy, to name just a selection of his hobbies. On top of all that, he was an inventor, credited with coming up with the first plausible concepts for human-powered flight, scuba gear, and armored cars. You know, this is the kind of thing you do in your spare time when you're not producing the world's most recognizable portrait (for more on Leonardo, see chapter 8).

Leonardo da Vinci: Painter, Poet, and Paleontologist?!

Leonardo da Vinci, the truest of Renaissance men, was outrageously curious about the world around him, and frequently recorded his observations in a variety of notebooks (among the most famous: *The Codex Leicester*, 1504–8, now owned by none other than Bill Gates). Among his most interesting discoveries: fossils and fossilization, making him one of the fathers of paleontology more than two hundred years before the founding of the discipline. According to Andrea Baucon, a paleontologist (and a visual artist too!), Leonardo was way ahead of the curve in terms of his contemporaries: most sixteenth-century scientists considered fossils to be "the products of forces inside the earth that were trying to reproduce life within rock"—not the remains of life, but life attempting to be born in an

otherwise inhabitable product, as Baucon notes. Leonardo, though, was a smarty-pants who put it all together by studying both "body fossils"—the remains of long-ago creatures, such as teeth and bone fragments—and "trace fossils"—footprints or other impressions. Jotting his thoughts down in *The Codex Leicester*, Leonardo correctly theorized that these fossils—hundreds of years before the term would be coined—were indeed the products left behind by living things long gone. Is there anything that Leonardo couldn't do?!

The quickie version of his life reads something like this: Leonardo da Vinci was born in 1452 in the Vinci region of Italy, near Florence—hence, his name, which literally means Leonardo of Vinci. (Want to know a quick way to piss off an Italian Renaissance specialist? Refer to Leonardo as "da Vinci." It's *not* a surname, you guys. It's like saying, "Of Poughkeepsie is coming to dinner tomorrow," and it *drives them nuts!*) Leonardo's early interest in art led him to apprentice in the studio of the Florentine painter Andrea del Verrocchio, who, as legend has it, decided never to paint again after witnessing his student's talent, which was far superior to his own. This legend probably isn't 100 percent true, but boy, it sure makes a great origin story.

After he left Verocchio's studio in 1478, Leonardo spent a few years working on artistic commissions for rich and famous Florentines, including the powerful Medici family, before traveling onward to Milan, where he stayed through the end of the fifteenth century. Here he continued to pattern his time as he had in Florence—completing projects of various natures for wealthy clients, such as Ludovico Sforza, the Duke of Milan. The reality of the economics of European art at this time dictated that only the rich could afford to commission or purchase artwork. So Leonardo did what he had to do and sought patrons to support his creations. He worked for dukes, popes, and finally, kings, and in the process he produced some of his best works of art: *The Last Supper* (1498, Santa Maria delle Grazie, Milan); *The Virgin of the Rocks* (1483–86, Musée du Louvre, Paris); *The Virgin and Child with Saint Anne* (c. 1503, Musée du Louvre, Paris).

But of course there is one painting that stands far above the others in our contemporary imagination.

It is believed that Leonardo began painting the *Mona Lisa* in either 1503 or 1504, after transitioning to Florence. Throughout the years there have been various arguments as to the identity of the subject—my personal favorite, by the way, is that it is a self-portrait of Leonardo in drag: a possible, but not probable, identification. The generally accepted theory is that it is a portrait of Lisa Gherardini, the wife of a wealthy Florentine merchant named Francesco del Giocondo—hence the *Mona Lisa*'s Italianate name, *La Gioconda*, and doubly hence, the French translation to *La Joconde*. Most of the painting was probably completed prior to 1507. According to Giorgio Vasari, a contemporary of Leonardo's who's known primarily today as a somewhat inaccurate scholar and artistic biographer (see chapter 6), Leonardo "lingered over it for four years, and then left it unfinished." Interestingly, the painting never left the artist's possession during his lifetime—a strange situation, but particularly so if it was commissioned specifically for a wealthy Florentine family. And yet records exist noting its presence among Leonardo's possessions, even after he relocated to France to work under King Francis I in 1516. Some art historians even claim that Leonardo may have tinkered with *Mona Lisa* all the way through 1517, a full decade and a half after he began it. Upon Leonardo's death in 1519, the piece, along with Leonardo's other possessions, was inherited by one of the artist's pupils, before King Francis ultimately purchased it for his royal collection in Fontainebleau. It remained in the king's residence at Fontainebleau until King Louis XIV transferred it to the famed Palace of Versailles in the late seventeenth century. Luckily, *Mona* survived the violence of the French Revolution, and she was briefly given a place of honor in Napoleon's bedroom until she was finally relocated to her current home, the Louvre, in 1804. Originally yet another regal palace, the Louvre was converted to the state museum of France in 1793, and in her hallowed halls the *Mona Lisa* has hung peacefully since that time.

Peaceful, that is, until a century later, when, suddenly, it was gone.

• • •

On the morning of Tuesday, August 22, 1911, a painter named Louis Béroud walked into the Louvre to study the masterworks and to seek artistic inspiration. Like his colleagues, he sought permission from the museum to copy paintings in its permanent collection, an activity that the museum encouraged (the Louvre was perhaps a little *too* permissive, letting artists clutter up their storage closets and galleries with paint and easels if their copies were not completed by nightfall). And in terms of copying the masterworks, there was hardly any oversight. The only rule was that the artist's reproduction could not be the same size as the original. This single guideline was the only real step the museum took to prevent art forgery (foreshadowing alert!).

Louis Béroud intended to copy Leonardo's little painting, sure, but there wasn't any reason to prioritize this selection. The *Mona Lisa* was famous, especially within France, but her reputation was nowhere near the international superstar status that we have assigned to her today. In fact, the painting received little attention until the second half of the nineteenth century, when the Romantics—those artists who sought feeling and emotion over Realism—became enamored with *Mona*'s oh-so-seductive smile. Only then did the work begin to receive significant acclaim and praise. Prior to that point, it was a Renaissance masterpiece, but only one among many. By the dawn of the twentieth century, *Mona* had grown popular enough that she received her own fan mail from admirers around France. As her fame increased, suitors brought her flowers, and some even proposed marriage to the painting (further adding frustration for meddling mothers everywhere who just wanted their sons to *settle down already*). But after a woman slashed a nearby painting by the Neoclassical artist Jean-Auguste-Dominique Ingres in 1907, officials determined that *Mona*, as well as other priceless works, was far too accessible, and that greater measures needed to be taken in order to protect her. And so a specially formulated glass box and custom frame were fitted around the painting. But this preparation was apparently not enough to keep her safe.

What's with That Smile?
Medical Interpretations of Mona

Since the nineteenth century, the curious facial expression of the *Mona Lisa* has been a major topic of discussion among art historians and laypeople alike: what's she really smiling about? Or more important, why isn't she smiling *more*? Millions have assumed that something must be going on behind that mysterious expression— something *wrong*. At the forefront of postulators today? Medical doctors. In recent years, Leonardo da Vinci's *Mona Lisa* has been the subject of intense scrutiny as doctors and researchers have attempted to pinpoint her problems. Since 1989, teams of researchers the world over have noted that Mona's strange expression mirrors that of patients who experience Bell's palsy, a type of temporary facial paralysis that makes one's face appear slightly droopy on one side. Interestingly enough, pregnant or postpartum women are three times more likely to experience Bell's palsy than any other group—and historians have noted that Leonardo's famed portrait may have been commissioned in celebration of the birth of Lisa del Giocondo's son, Andrea, in 1502 or 1503. Could this explain why Mona's lips are turned up more on her left side than on her right? It certainly makes sense.

Others still have taken a deeper look at Mona's overall wellness, or lack thereof. The newest theory on the block, posited in fall 2018, points to a disorder that is still common today (and, thankfully, very treatable): hypothyroidism. Dr. Mandeep R. Mehra, of Boston's Heart and Vascular Center at Brigham and Women's Hospital, found himself stunned during a recent Parisian vacation when he witnessed Ms. Mona's condition at the Louvre: a thinning hairline, lackluster and yellowing skin, nearly nonexistent eyebrows, and a variety of lumps and bumps—even the beginnings of a goiter. Naturally, all of this would have an effect on one's sunny outlook, and Mehra noted, "When you have hypothyroidism you're a little depressed, and your facial muscles are puffy and weak. You can't even bring yourself

to a full smile." Possibly bringing it all together? The fact that, as with Bell's palsy, this disorder is frequently triggered by pregnancy. Mystery (possibly) solved!

When Louis Béroud entered the gallery known as the Salon Carré that August morning, he noticed something rather odd. *Mona Lisa* was missing, and in its place were only four iron pegs—the backing where the wooden panel was typically hung. Béroud was surprised and sought clarification from museum employees. *Where was Mona today?* he asked. Their responses—shrugs and claims of ignorance—surely did not bode well for the safety of the Louvre's treasures at that time. Even the museum's head of security waved off Béroud's concern, noting that he believed the work had simply been removed in order to be photographed for museum publications. This, as you might guess, turned out to be an incorrect assumption, and I can only hope that that man was very quickly relieved of his security position. After it was confirmed that no one in the Louvre knew of the painting's whereabouts, the realization dawned: the *Mona Lisa* was gone, and its whereabouts were unknown.

At first, museum officials assumed a path of least resistance, harboring the naive hope that the panel had simply been removed and left lying in a nearby gallery. To confirm their suspicions, the Louvre closed its doors to the public to undertake an interior search, calling in a sizable corps of policemen to comb the galleries for the painting, or at the very least, to find some clues to its disappearance. The closure that Tuesday stretched into a full week of intense scrutiny, and only then did the extent of the situation make itself known.

The interior search of the Louvre failed to turn up the painting, but it did produce something intriguing: a protective glass box and a discarded frame emblazoned with the painting's title, languishing in a stairwell. The worst was then confirmed: the *Mona Lisa* had been removed from her frame and then removed from the Louvre, and the thief, or thieves, had had enough of a head start that *Mona* could now be anywhere in the world.

Throughout the Louvre's closure, museum employees were alerted to

stay calm and, *for God's sake, don't alert the newspapers.* The Louvre didn't want to alarm the public, but just as important, it didn't want to face the embarrassment of the shocking revelation that its security measures were unbelievably lax. Of course people quickly took notice of the closure, and the public indeed began clamoring for the reasons behind the barricading of the greatest museum in the world. The cat was out of the bag, and the news was trumpeted across the Western world: *Mona Missing! Detectives Seek Stolen Painting! No Clues Yet Uncovered!*

What kinds of leads did the police have about the whereabouts of *Mona Lisa*? At the beginning, they had too many. As soon as word got out that the painting was gone, all of Paris went full-on Sherlock. Local police stations were flooded with tips—most contradicting one another, many possibly falsified, some paranoid—regarding purported sightings of the *Mona Lisa*: the painting was found on a train in Belgium, hustled across into Holland, and assumed to be on a steamer bound for America. Naturally, conspiracy theories abounded too. My preferred tale is that the "theft" of *Mona* was a vast cover-up instigated by the Louvre's curators due to a botched conservation effort. To hide their embarrassment over the destruction of a Renaissance masterpiece, the curators supposedly hid the original in the basement of the Louvre, claiming it had been stolen. This, some said, was only a temporary solution, as *"Mona Lisa"* would be miraculously found—but only when curators were able to produce and replace the original by a suitably believable copy (what sneaky creatures we curators are).

Ultimately, Louvre officials and Parisian police came to a conclusion that narrowed down their list of suspects. Upon studying the discarded frame and glass box that once held *Mona Lisa*, it became clear that whoever stole the painting knew art—how to hold it, how to separate a panel from its frame and backing, how to protect it, and how to secret it away without being noticed. Such deductions reduced their long list of suspects to those with art world knowledge, finally zeroing in on a particular group of friends—an artsy gang led by the poet, writer, and art critic Guillaume

Apollinaire and his close pal: a short, swarthy, and moody Catalan painter named Pablo Picasso.

Apollinaire and Picasso were no strangers to scandal involving art theft. Around this same period, both were questioned regarding a robbery of several small statuettes, also from the Louvre's collections. The theft was undertaken by an acquaintance of Apollinaire's who occasionally nicked artworks as a means of pure entertainment—*ugh, I've got ennui. Hey, I know! How about a little light larceny?* But when it was discovered that Picasso was harboring a few of the stolen figurines in his studio, it seemed like only a small step further to indict him of masterminding the theft of dear *Mona*. Picasso did come into possession of the statuettes by purchasing them from Apollinaire's associate, but he also clearly turned a blind eye to the inscriptions on the bottom of each sculpture that baldly proclaimed, "Propriété du Musée du Louvre." Let's be honest—that is some truly sketchy behavior, so it isn't shocking to understand how officials would give Picasso some serious side-eye.

Parisian police detained Picasso and Apollinaire for questioning—Apollinaire was even briefly arrested—and under the stress of the situation, they did what many do in similar interrogation situations: they metaphorically threw each other under the bus. Apollinaire claimed Picasso knew of the painting's location; Picasso balked, and blamed Apollinaire as the criminal mastermind. However, it soon became obvious that their claims were unsubstantiated fabrications, and neither man could be connected to the missing Leonardo panel in any way. They were quickly released from custody, but as you might imagine, Apollinaire and Picasso's friendship was never the same again.

If there was an upside to the terrible theft, it was this: the Louvre experienced a massive uptick in the number of visitors, as thousands crowded the Salon Carré to get a look at the spot where *Mona Lisa* used to be displayed. Waves of tourists rubberneck to see her today, and more than a hundred years ago, people did the same thing in order to glimpse . . . *nothing*, literally. Eventually, of course, the novelty of this nothingness wore off for both the crowds and the museum, and *Mona*'s former post was quickly

filled in with Raphael's portrait of the Renaissance writer Baldassare Castiglione—a fitting choice because Raphael's composition of the Castiglione portrait was modeled directly after that of the *Mona Lisa*. Of course *Mona* was far from forgotten, but as the months passed without sign of her or her captors, the situation grew dire. In late 1912, France's deputy minister of fine arts reported, "There is no ground to hope that *Mona Lisa* will ever resume her place in the Louvre." With a sad air of finality, the investigation into the disappearance was officially closed.

Leonardo da Vinci's striking masterpiece had been gone for nearly two and a half years and the subsequent investigation deemed a failure for more than a year when, in December of 1913, a strange letter arrived at the shop of Alfredo Geri, an art and antiques dealer in Florence. Geri had recently put an ad in local newspapers to drum up business, and he was not surprised to receive an offer letter for the sale of a previously unknown artistic masterpiece. What was surprising in this case was that the envelope bore a postmark from Paris, when he didn't advertise there—and even more surprising were its contents. The note was from a person calling himself Leonardo, and it read as follows:

> The stolen work of Leonardo da Vinci is in my possession. It seems to belong to Italy since its painter was an Italian. My dream is to give back this masterpiece to the land from which it came and to the country that inspired it.

Geri was, understandably, cautious and disbelieving of the note, but he performed his due diligence. He sought the advice of the director of Florence's famed Uffizi Gallery, a man named Giovanni Poggi, who suggested that Geri respond to this so-called Leonardo and arrange for a rendezvous to examine the work being offered. Both men figured that Leonardo's claim was dubious at best, and surely a request for an in-person meeting would be of little interest to someone peddling a worthless forgery. Geri and Poggi

both assumed that Leonardo would simply vanish—which made the quick reply they received even more startling. *Yes, yes, I'll gladly bring the painting to you*, Leonardo wrote.

Such enthusiasm won over Geri and Poggi, which is why on Thursday, December 11, 1913, these two experts found themselves walking warily behind a somewhat dodgy-looking man who introduced himself as Leonardo Vicenzo. Together they meandered through the streets of Florence to a nearby hotel where Leonardo insisted *Mona Lisa* was safely waiting for them. *Yeah, right*, you can imagine Geri and Poggi thinking, but they played along, with the art dealer agreeing to Leonardo's requests for hundreds of thousands of Italian lire should Geri be interested in purchasing the painting. What they saw in the hotel room, though, was what they never actually expected to see: the *real Mona Lisa*—undamaged, intact, and marvelously preserved, nestled like a newborn baby in a wrap of red silk inside a secret compartment built into the bottom of an unassuming suitcase.

Geri and Poggi were dumbfounded. Somehow, miraculously, they pulled themselves together just enough to persuade Leonardo Vicenzo to let them remove the painting from the hotel in order to take it to the Uffizi for authentication and examination. Geri gently but urgently tucked the silk-wrapped painting under his arm and carried it away, and once out of earshot of Leonardo's hotel, Poggi notified the local police. Shortly after, when the police entered "Leonardo's" hotel room, they discovered that the thief was in the midst of an afternoon catnap and that he seemed unruffled and unsurprised to find them there. How could someone who, until moments earlier, had held the world's most sought-after work of art in his hands be so cool and calm, enough to snooze the day away? Who *was* this guy?

It didn't take long for the truth to come out. Leonardo's actual name was Vincenzo Peruggia, an Italian national who was formerly employed at the Louvre as a glazier, a workman who fits panes of glass into windows and doors. In fact, he was the one who had built the protective frame and glass box–frame for *Mona Lisa*—which would explain how he was able to release the painting from its hold so easily, and perhaps why the frame was

discarded gently, instead of haphazardly. Under investigation by Italian po-
lice, Peruggia flatly confessed the details of his crime. He noted that he
entered the museum on the morning of Monday, August 21, 1911, sliding
in behind other custodial employees and repairmen who performed many
of their duties on Mondays while the museum was closed to the public. It
was an ideal time to undergo a great theft, considering that the number of
employees on site on Mondays was greatly limited, even in terms of secu-
rity staff. And, of course, having worked at the Louvre, Peruggia had the
advantage of (a) being familiar with the museum's layout, and (b) having a
familiar and therefore unthreatening face to other Louvre employees. This
meant that the crime was surprisingly easy for Peruggia to pull off. When
he discovered a moment when the Salon Carré was empty, he lifted *Mona
Lisa* off the four iron pegs that secured it to the wall and took it to a nearby
service staircase, where he quickly removed the panel from its protective
glazing and frame. He then wrapped his worker's smock around the paint-
ing, cradled it gently, and left the Louvre through the same door by which
he'd entered.

Peruggia confessed that after the theft, he chose to conceal the famous
painting in his Paris apartment, in that same shoddy suitcase he had used
to transport *Mona* to Florence—an admission that would later astonish
and embarrass the police. At the beginning of the investigation, Parisian
officials had questioned Peruggia as they had done with all Louvre employ-
ees current and former, and many in their own homes. Shamefaced, the
police had to admit that the painting had been in Paris, right under their
noses, for nearly two years, languishing in Peruggia's hovel. After that pe-
riod, however, Peruggia grew anxious and developed a high-minded solu-
tion: he sought to repatriate *Mona Lisa* to Italy, her "home country," mainly
due to a misconception that she had originally been stolen from Italy, when
in reality she had been a citizen of France for nearly her entire existence.
No matter—the most important part was that the masterpiece was redis-
covered.

All the world was ecstatic to hear the news that *Mona Lisa* had been
found against all odds. As they did when she was abducted, newspapers
around the globe trumpeted her return. She was a sensational headline

and front-page news, and after a groundbreaking two-week solo exhibition at the Uffizi Gallery in Florence, *Mona* was returned to the Louvre with the greatest fanfare on January 4, 1914. And as they had done when she was missing, hundreds of thousands of people stormed the Louvre in order to see their icon safely back on display. *Mona Lisa* was finally home, and she was more popular than ever before.

In retrospect, the story of the theft of the *Mona Lisa* seems like a fairy tale, almost Hollywood-like in its redemptive arc. A masterpiece stolen, presumed lost, then returned unharmed. But something also seems a little bit *off.* Remember how calm and relaxed Peruggia was, enough to take a nap after Geri and Poggi removed *Mona Lisa* from his possession? It's almost as if it weren't a shock that he had gotten caught—had he expected it all along? And how about the patriotic claim he made in his note to Geri as Leonardo, where he stated that his motive was as simple as wanting to return an Italian painting to Italy? But then why wait more than two years before bringing it to Florence, if that was his ultimate goal? Perhaps Peruggia had been waiting for money (it was later discovered that he had written home to his family, bragging that he was about to become very rich). But what if he was waiting for something else—what if he was waiting for instructions from the *real* mastermind of the theft?

In June of 1932, nearly twenty years after the Louvre regained its star attraction, a story appeared in *The Saturday Evening Post*, of all places, that reported an entirely different set of details. The article, titled "Why and How the *Mona Lisa* Was Stolen," was written by a reporter named Karl Decker, who claimed to have met a mysterious man in 1914 who revealed the "true" story to him while sitting in a café in Casablanca. This man introduced himself to Decker as Eduardo de Valfierno, a marquis from Argentina who proudly boasted of his long career as a very successful con man whose business specialty was art forgery. His literal partner in crime was a French artist, art restorer, and forger named Yves Chaudron, who,

together with Valfierno, had supposedly made a killing in South America creating fake Bartolomé Esteban Murillo paintings for unsuspecting tourists. Such work was all well and good, but Valfierno wanted to make things a little more *interesting* (go big or go home, right?). He formulated an idea to take advantage of the latest craze in the world of the ultra rich. Newly minted millionaires and billionaires, particularly Americans, were fighting tooth and nail to outdo one another for the greatest private art collections—and a side effect of this was that not only did the art market grow increasingly robust, but so did the market for very, *very* good forgeries. Naturally, collectors either didn't know, or didn't want to know, whether they were being offered forgeries, so they were especially vulnerable to sales of them. Why not go all in, thought Valfierno, and pretend to offer them the very best artwork in the entire world?

The plan to offer the fake *Mona Lisa* to the wealthiest of potential buyers was not simple, but Valfierno intended to make the most cash out of his concept. He allegedly hired Yves Chaudron to create not one copy of the Leonardo da Vinci panel, but *six* identical copies, which Valfierno would then sell to six clients, spread across the globe. But in order for each collector to believe that he or she was holding the *real* deal, one thing had to happen: the actual *Mona Lisa* had to disappear from the Louvre, and *everyone* had to know it.

Of course Eduardo de Valfierno wasn't going to do the dirty work himself. What if something went wrong, and he was caught red-handed? Plus, he didn't know the ins and outs of the Louvre. It became clear that he needed an insider to get the job done. Enter Vincenzo Peruggia, a former Louvre employee who was not only familiar with the museum's layout, but one who could be easily manipulated with cash, and a little bit of nationalist pride, to steal *Mona*.

The Most Infamous Art Theft in History:
The Isabella Stewart Gardner Museum, 1990

In 1990, thieves unknown broke into Boston's famed Isabella Stewart Gardner Museum and made off with thirteen works of art—including rare works by Rembrandt van Rijn and Johannes Vermeer—with a combined value of more than $500 million. The kicker? Thirty years later, this case, the most infamous art theft in modern history, is still unsolved. Though many suspects have been named over the years—notorious mobster James "Whitey" Bulger; a corrupt security guard performing an inside job; a California screenwriter with a shady past—the question of the identity of the perpetrators is less important than the *real* question: Will the thirteen artworks ever be seen again? The folks at the ISGM are hopeful that their long-lost treasures will come home—so much so that they doubled their reward in 2017 from $5 million to $10 million. And the good news is that cold hard facts do support them: approximately 80 percent of stolen art is eventually returned. But that positivity is tempered by concerns about the condition of these works. Even if they're found, what if they're damaged or practically destroyed. Even worse, what if they have been lost over these past few decades? It's terrifying to consider, but all we can do now is hope for a safe return—and keep our eyes wide open for any clues to their current location.

While Valfierno prepped Peruggia for his crime, Chaudron set up his easel at the Louvre in front of the Leonardo—just as Louis Béroud would later do—and meticulously copied every single detail of the little painting, essentially creating a template that he could later reproduce to exact scale and on aged wood panels. He left nothing to chance, and even formulated a method of producing the surface cracking endemic to old paint and varnish, called *craquelure*, via the use of a high-powered electric fan pointed closely to the copy's surface as it dried. Chaudron attempted to re-create every centimeter as best as he could in order to keep any suspicious

collectors off his back, including using only painting methods and materials that would have been available during the Renaissance. In Valfierno's eyes, though, such meticulousness was virtuous but unnecessary: the beauty of their crime was that a collector would never have access to the real *Mona Lisa* in order to compare its intricate details. Each collector could then assume that he or she was offered the authentic painting. And because he or she could not advertise ownership lest the item be repatriated to the Louvre, how would anyone know whether there happened to be five other similar *Mona Lisa*s swirling about the world?

After the news broke that Peruggia had performed his duties and *Mona* was gone, Valfierno jumped into action. According to his statements in Karl Decker's article, he was able to quickly sell all six *Mona Lisa*s, netting the equivalent of nearly $90 million for himself and for Chaudron. But there was a problem, and that problem's name was Vincenzo Peruggia. Peruggia was undoubtedly paid handsomely for his efforts, and the ridiculous plan could have never succeeded without his insider knowledge and technical skill. However, he quickly breezed through his funds and needed another infusion of cash. So he made a rash decision. For some reason—probably to keep himself distanced from the Leonardo, just in case it was discovered by the authorities—Eduardo de Valfierno had allowed Peruggia to maintain a physical hold on *Mona*, with the intention of returning to the thief with instructions on how to handle and dispose of the stolen painting when the time was right. But Peruggia just couldn't wait any longer, and he made the natural conclusion that the sale of the *Mona Lisa* would net him even more than the theft itself did. And so, in December 1913, he contacted art dealer Alfredo Geri in Florence with what he assumed was an ingenious get-rich-quick scheme.

Ah, the best laid plans.

Valfierno was dismissive of Peruggia in his statements to Decker, declaring, like a *Scooby-Doo* villain, "We would have returned the painting voluntarily to the Louvre in due time, had not a minor member of the cast idiotically run away with it." Indeed, the most important aspect, to Valfierno, was being able to pawn off six fakes in the time period that the original painting was missing in action. But are we really to believe Valfierno at

his word that his intention was to reinstate *Mona Lisa* back in the Salon
Carré? She had become the world's most valuable painting, and he had di-
rect access to her. I doubt that he'd want to give that up. Also, wouldn't re-
turning the authentic work anger his patrons, who would surely realize that
they had been swindled? Valfierno was admittedly a crook and a liar—so
it's plausible that his assurance of *Mona*'s reinstatement to Decker was
bogus, and simply said to save face. But here's the big question: If he was
successfully able to sell six fakes, who's to say that he wouldn't have asked
Yves Chaudron to create *just one more*, swap it with Peruggia's stolen origi-
nal, and deposit that *copy* back at the Louvre? It would have been a win-win:
he could confidently admit to his collectors that the Louvre possessed a
copy, but *not them, no, never!* And even more important, Eduardo de Val-
fierno could keep the world's most coveted work of art for himself.

Okay—let's get to the bottom of this. If Peruggia's nationalistic claims and
motivation didn't seem plausible enough, then does Valfierno's six-copy
ruse? No, not really. If anything, it's even more far-fetched and cinema ready.
I'll admit that it is super sexy to think about criminal masterminds and se-
cret art forgeries in the hands of furtive billionaires. But there are also some
serious issues with the Valfierno tale. First, there are no records anywhere
verifying Valfierno's existence, other than Karl Decker's *Saturday Evening
Post* article. Sure, it could have been a pseudonym, with Valfierno opting to
hide his true identity, but no evidence remains of this supposed criminal
genius. Additionally, there's the fact that the Valfierno tale didn't break until
1932, nearly twenty years after the painting's return to the Louvre—why
wait so long to tell the story? Last, others have noted that Karl Decker wasn't
the most truthful author around, and he often liked to spice up his prose
with sensational stories of derring-do. What's more audacious than a swash-
buckling story centered around the greatest art theft of all time?

One element that gives me pause, however, is the tidbit about the six (or
more?) forgeries that Yves Chaudron supposedly created. To the best of our
collective art-historical knowledge, none of these replicas have ever sur-
faced. *Or have they?* We must contend with the fact that versions or copies

of Leonardo's panel *are* famously in existence. Some historians have even posited that Leonardo himself painted at least one variation on *Mona Lisa*, though whether or not the master actually painted it—instead of an assistant or student—will be a matter of debate for decades to come (and is one of several current debates surrounding Leonardo's *Salvator Mundi*, see chapter 8). One example is the so-called *Isleworth Mona Lisa*, a panel whose existence was only confirmed in late 2012, after being locked away in a Swiss bank vault for upward of forty years. The unveiling of a possible twin to the Louvre's *Mona* caused a great stir among the artistic community, who have argued its merits and flaws ad nauseam. However, there is some evidence that, if not painted by Leonardo specifically, the *Isleworth Mona Lisa* was most likely produced by a close follower or apprentice of Leonardo's. Carbon dating and dendrochronology, or tree ring dating, have confirmed the age of the *Isleworth* panel as concurrent with Leonardo's lifetime, and an expert in so-called "sacred geometry"—wherein adherents propose that specific geometric forms and connections bring harmony, beauty, and (hence the name) sacred effects in works of art—verified that the drawing and line structure of the *Isleworth* panel matches Leonardo's personal take on sacred geometry. Fascinatingly, nearly identical claims have been made about several other paintings: one located in Madrid's Museo Nacional del Prado, another in a private collection known today as the *Vernon Mona Lisa*, and a third, previously owned by the British upper-crust painter Sir Joshua Reynolds, held today in another private collection and last exhibited to the public in 2006. So are these paintings truly by Leonardo da Vinci, or an assistant working closely with the artist under his guidance? Or is it possible that any, if not all, of these paintings are forgeries skillfully created by Yves Chaudron using his aged and time-appropriate methods and materials?

As fun as it would be to believe that Karl Decker's story of lies and intrigue is true, I personally believe that it isn't. So if there aren't six secret fake *Mona*s, that also means that any suspicion that Yves Chaudron and Eduardo de Valfierno may have stashed *another* fake *Mona* for return to the Louvre is equally ridiculous. The takeaway is that the facts point to the *Mona Lisa* at the Louvre as the real deal. As much as Chaudron may have

attempted to copy every nook and cranny of Leonardo's masterpiece, you just can't fake the hand of an artist completely. And then there's that *craquelure* that he supposedly re-created. You can try your best to reproduce it, but ultimately it acts like fingerprints. Each painting's *craquelure* is unique, and any conservator or curator with a magnifying glass would be able to exactly match the lines across a painting with those seen in detailed photographs of the original. And upon her return, *Mona Lisa* was scoured and examined, not only for damage but for verification of authenticity—which the Louvre confirmed and announced to the public.

For me, then, another mystery remains. Even if we assume that Leonardo da Vinci's *Mona Lisa* is truly located at the Louvre today, some niggling detail still convinced my college professor of its inauthenticity. I found myself perplexed: my mentor, a hugely intelligent, highly educated brilliant historian—and one who was inclined to neither the rumor mill nor myth—was sure the work was a skilled forgery. I recall that in her brief explanation of her theory, she leaned a bit too much on the Valfierno fable, but she also noted that the *Mona Lisa* had been stolen *twice*.

Twice? When was the second time? Most books and articles point to the 1911 case, but very little is mentioned of any second supposed heist. However, it is possible that she was stolen again—this time, during World War II, when those ne'er-do-well Nazis coveted the most important painting in the world.

Chances are good that this twist in the tale isn't all that surprising to you. After all, many of us are already familiar with the Monuments Men, a group of Allies who were charged with protecting the great art that it was feared were potential targets for looting and endangerment during World War II. Art was expressly vulnerable during this period for two reasons: first, art needed to be shielded from any bombing or outright destruction from the war itself. But there was also another plan being hatched that equally imperiled Europe's greatest pieces of art. One of Hitler's bold ideas

was to build an incredible museum in his hometown of Linz, Austria, with the intention of stocking it with the very best art in the known world. The easiest way to do that, he figured, was to steal it—and unfortunately, the Nazis were all too successful at following these commands. Art historian Noah Charney estimates that about five million objects were stolen during World War II. Was *Mona Lisa* one of them? As Charney narrates in his book *The Thefts of the Mona Lisa: On Stealing the World's Most Famous Painting* (New York: ARCA, 2011), the answer is both yes and no: the Nazis *thought* that they had stolen *Mona*, but they actually hadn't. Let me explain.

During the war, the Nazis, under the watchful eye of a fierce SS commander named August Eigruber, began stashing the spoils destined for the Linz museum in an abandoned salt mine in a picturesque area known as Altaussee, about eighty kilometers east of Salzburg. Charney writes that there's a certain amount of confusion about the *Mona Lisa*'s inclusion in the Altaussee stash because while two primary source documents include the *Mona Lisa* as part of the loot, others—including American postwar inventories of the mine—make no mention of it. It's a confusing question: Was *Mona* looted and hidden by the Nazis at Altaussee or not?

Unfortunately, it's almost impossible to say with complete certainty whether the Nazis confiscated *Mona*. And as Charney describes, the Louvre itself has historically been rather tight-lipped on the sensitive subject. The only surviving Louvre documents confirm that the Leonardo painting had been crated up on August 27, 1939, to be shipped to one of five French châteaux identified for safe keeping from invading Axis troops. And then it's metaphorical crickets for any and all information about *Mona*, with no mention made of her until a 1945 document attests to the panel's safe return to the Louvre via the Monuments Men's labors. Nothing exists to document the in-between times. Charney, however, offers a very intriguing explanation for this. He writes that Louvre officials later revealed the existence of an "identical copy of the *Mona Lisa*" dating from the sixteenth century—in other words, created at approximately the same time as the Leonardo original. Red flag alert: take a note of Charney's use of the word *identical*—the Louvre doesn't describe this painting as "a semiclose match," but instead says that it is so authentic that it is hardly possible for a nonspecialist to

identify it as a copy. This reproduction was one of thousands of works gathered after the war in what became known as the Musées Nationaux de Récupération (National Recovery Museum), a temporary home for works of art whose owners could not be located in the immediate aftermath of the war. The copy was marked with the inventory number MNR 265, and it languished in storage for five years, unclaimed, until authorities transferred it to the Louvre for permanent safekeeping. (Funnily enough, from 1950 until the very recent past, this copy hung on a wall outside the private office of the Louvre's museum director. That's a nice career perk.) By sorting through this evidence, Charney, whose own expertise lies in the examination of famous art thefts, has come to the following conclusion: yes, a painting was indeed crated away in 1939, but the Louvre crated up the *copy*, not the original, and sent it outward into the unknown. Assuming that the *Mona Lisa* would be a prime target for Nazi looters, the Louvre may have kept the original hidden in Paris, while allowing the copy to be taken. As Charney says, "This would explain why the *Mona Lisa* did return from Altaussee, but why it may also be that the *Mona Lisa* never left Paris. It was the copy that was stolen, hidden at Altaussee, and recovered." Charney makes no mention of why it took five years before the Louvre was able to access the copy from Altaussee, but to be fair, if they had the actual *Mona* hidden away the entire time, they probably weren't in a hurry to reclaim a replica.

Leonardo da Vinci's *Mona Lisa* has not left her home at the Louvre in more than four decades, even though she was met with clamoring crowds on tours in the United States in 1963 and in Japan in 1974. In 2011, the museum's head of painting, Vincent Pomarèd, declared that it was absolutely unthinkable that its most popular painting would ever travel again, mainly due to the fragile state of the five-hundred-year-old panel. But think, too, of the riotous response that tourists to the Louvre might have in *Mona*'s absence, particularly given that many make the pilgrimage to the museum specifically to lay eyes on it. Certainly, the Louvre would not want to deal with such a headache if it wasn't necessary. These reasons for keeping *Mona Lisa* at the Louvre in perpetuity are legitimate and totally reasonable—but

if you are a conspiracy-minded person, they might also be read as convenient spins to hide "the truth" from an unsuspecting public. Without the opportunity to borrow the work and see it in another institution, art experts from all over the world rarely have the ability to closely examine the painting with their own eyes and scientific instruments. Insiders, too, have noted that the Louvre typically sources conservators and inspectors internally, and does not allow outsider access to the painting, and that many outside requests to scrutinize and conserve the work have been denied flat out. And though *Mona Lisa* has twice been attacked in the past, some might deem her current level of protection a little *intense*. Bulletproof glass, a crowd-deflecting cordon, two full-time security guards—and let's not forget the ever-present security cameras. In reality, it is *not* overkill: the painting is literally invaluable, and it makes sense to protect it within an inch of its life. But it does also keep each and every person at an extreme distance. So who's to really notice whether or not the *Mona Lisa* on display at the Louvre is authentic or not? And seriously, given the iconic and symbolic status the panel has undertaken over the past century, should we even care?

For the record, I choose to believe that the *Mona Lisa* on view is indeed the real painting created by Leonardo da Vinci in the sixteenth century. So much of a work of art's power and value lies in being seen, so it makes sense to me to have a masterpiece like this one available to the masses. But I don't have solid proof that the painting isn't a copy. I simply accept the information provided to me by the Louvre's experts as like-minded museum colleagues. But even I must admit that if I really, *really* wanted to keep the world's most priceless work of art safe and secure, it sure makes a lot of sense to put a nearly identical version—dare we say *fake*?—on display in its stead. If I were in charge at the Louvre, I could lock the original away in the vaults of the institution and keep everyone—scientists, historians, and tourists alike—at enough of a distance that its veracity could not be verified. To top it all off, the daily crowd of thousands of tourists would inadvertently aid and abet my covert mission by making it even harder to view the painting at all, let alone up close to note any discrepancies in a forgery.

But honestly, if you were entrusted with *Mona Lisa*, wouldn't you be tempted to do the same?

Antonio del Pollaiuolo, *Battle of Nude Men* (or *Battle of Ten Nudes*), c. 1490

A Corpse Cornucopia:
Renaissance Artists, Anatomy,
and the Myth of Body Trafficking

Through dissection Michelangelo studied every known animal, and did so many human dissections that it outnumbers that of those who are professional in that field. This is a considerable influence that shows in his mastery in anatomy that is not matched by other painters.

ASCANIO CONDIVI, ARTIST AND BIOGRAPHER

In the middle of the night, surrounded by several imposing Swiss Guardsmen, the pope burst through the door to Leonardo's private palace chambers. [H]e was horrified to find Leonardo wide awake, with a pair of grave robbers, in the midst of dissecting a freshly stolen corpse—right under the pope's own roof.

BENJAMIN BLECH, RABBI AND AUTHOR

L et's talk about naked people.

Learning to draw the nude human form is a total necessity for burgeoning artists. The catch is that it's not that easy to accurately depict the body, because the body is so varied—the shapes of the features, the proportions of assorted extremities (entire master classes are offered on how to draw hands alone!), the appearance of veins, muscles and bones creating every curve and contour of the skin. And that's not even taking into consideration the complexity of body positioning and contortions. Getting it all accurate and naturalistic is a serious feat, and many instructors have claimed that in order to get it right, you must have a solid understanding of what makes up the human body from the inside out.

Today, we take for granted that the hidden structures of the body have been well studied for centuries, and that skeletal and muscular diagrams are but a quick Google search away. And one glance at Michelangelo's iconic and awe-inspiring *David* (c. 1501–4, Galleria dell'Accademia, Florence) reminds us that the artist *knew* the human form and its underlying elements. But life drawing courses—art classes designed around the study of the human body, up close and personal—didn't exist back in Michelangelo's day because in some spheres it was deemed inappropriate at best, and morally reprehensible at worst, for an individual—especially, God forbid, a woman!—to model nude for an artist. So how did he—and other artists like him—learn about the body's internal structure in order to accurately depict its many nuances?

For a long time, the answer was believed to be corpse trafficking. Imagine your favorite Italian Renaissance artists stalking the streets of Florence and Rome under the dark of night, trafficking in dead bodies with hopes of performing furtive dissections for the purposes of artistic improvement, all while trying to avoid the censure of the Catholic Church. Dramatic, right?

But as intriguing as the theory is, corpse trafficking is most definitely a myth. And interestingly enough, the reality behind anatomical study and art is pretty intriguing in its own right, especially when you consider that artists worked with dead bodies legally *and* with the blessing of the Church.

Like many great art-related myths (*Van Gogh never sold one work of art during his lifetime!* Nope—see chapter 7. And *Michelangelo worked all by himself on the Sistine Chapel ceiling and painted it while lying down!* False. Charlton Heston's film counterpart did in the 1965 film *The Agony and the Ecstasy*, but the artist himself patently did not), it has been rather difficult to rebut the legend of clandestine body snatching by the likes of Leonardo or Michelangelo. And I can see why: these crazy myths and stories are more fun! (No one wants to listen to that little art historian in the corner who says, "Well, actually . . ." *Great job being a buzzkill, Jen.*) Even sources like Ranker continue to create listicles promoting these grave-robbing antics because they grab our attention.

But carrying on such myths not only inaccurately diminishes artistic process and medical advancements of the Middle Ages and the early Renaissance, but it also places science and religion at an artificial divide at an unnecessary moment—when it turns out that the Church actually *supported* such explorations.

The Church-centered autopsy myth, often considered a long-held fact, actually began in the nineteenth century—a time rife with scientific myth-making as a by-product of an us-versus-them mentality. *We modern folk know so much about science!* seems to have been a chest-puffing common refrain during the years following the advances of the industrial age (see chapter 9), and nineteenth-century theorists made sweeping declarations about the beliefs of previous generations. Prime among these was this assertion regarding the human body: in the past, dissection couldn't possibly have been allowed . . . because of God.

The (Protestant) Christian revivals of the nineteenth century—especially in the United States—embraced the idea that dissection, in Renaissance times, must have been totally taboo due to the presumed sanctity of the human body. Yet theorists didn't actually have facts to support their beliefs—instead, they adopted Old Testament verses as basis for their claims. Genesis 1:27 states, "So God created mankind in his own image, in the image of God he created them; male and female he created them." The bottom line was that if you were to dissect a corpse, *then you'd effectually be dissecting God, you horrible heathen.* Similarly, New Testament verse was claimed as further evidence of the notion. First Corinthians 6:19–20, purportedly written by Saint Paul, proclaims, "Do you not know that your bodies are temples of the Holy Spirit, who is in you, whom you have received from God? . . . Therefore honor God with your bodies." While these verses have been interpreted for different means throughout the years (*don't drink alcohol, ever! No sex before marriage! Organic vegetables are the best!*), nineteenth-century antidissectionists used it for their causes, arguing that the "temple of the Holy Spirit" should not be desecrated through autopsy or any other medical so-called "openings of the body"—and that it must have always been this way throughout history.

What these staunch believers were missing, though, is that there had

been a long precedent of religiously motivated dissections, particularly in Europe. Katharine Park, the Samuel Zemurray Jr. and Doris Zemurray Stone Radcliffe Research Professor of the History of Science at Harvard University, has built a career on debunking myths surrounding the development of medical methodology. Park, like many of us historians, came of age hearing those nineteenth-century tales of dissection censure, and was flummoxed when historical archives produced materials that forced her to question her long-held belief—autopsies, in fact, were not infrequent in the premodern era, nor were they disallowed by the Church. In fact, many wealthy families requested medically led dissections as a way to cope with grief and—as we do today—to understand the likely cause of death. Fascinatingly, there exists evidence that the bodies of women—especially holy women—were most frequently dissected, a fact that really turns that whole the-Church-forbids-it myth on its head. If a nun or another revered woman passed away, doctors would perform autopsies with the hope of finding something—anything—in a person's body to "prove" their holiness, thereby making an easier case for sainthood.

The Anatomical Anomalies of Michelangelo's Women

Michelangelo Buonarroti (1475–1564), master of the male form (hi, *David!*) . . . but *not so great* at depicting women? The Virgin Mary in his Vatican *Pietà* (1498–99, St. Peter's Basilica, Museo del Vaticano, Vatican City) is oversized. His female personifications of *Dawn* and *Night* for the Medici Chapel (c. 1526–31, Florence) are even worse. With intense six-pack abs and breasts that seem like a haphazard afterthought rather than an integral part of these figures' anatomies, there's almost nothing traditionally feminine about them. What's going on here? Was Michelangelo really just a *bad* artist?

Of course not. There's a good theory about why Michelangelo's women are so strong and mighty. Art historian Yael Even identified two basic types of Michelangelo women: the humble, pious type and

the victorious, heroic type. How best to visually represent a larger-than-life heroine? Easy: you give her the physical attributes of any traditional hero. Bulging muscles, tight abs, and a massive frame—all that's missing is a cape—and you've got yourself a Michelangelo masterpiece of girl power, even if that girl is given characteristics traditionally read as masculine.

In retrospect, that the Catholic Church could have ever been against the dissection of bodies seems ridiculous to anyone who has ever visited a European cathedral or church. Such spaces typically house at least one reliquary, or a container made for housing a sacred relic. Though some reliquaries hold objects associated with a holy figure—a piece of clothing, or in the case of Jesus himself, thorns from the crown of thorns—many house parts of the holy figures themselves: bones, hair, internal organs, and even, in some cases, the person's preserved body. Dissection was necessary to establish these reliquaries, which would then produce centers of veneration and, in theory, greater devotion from churchgoers. Dissection, then, would have been sanctioned, if not promoted, by the Catholic Church.

Not that *everything* was allowed by the Church, though. A papal bull issued by Pope Boniface VII in 1299, intriguingly titled *Detestande feritatis* ("Of Detestable Cruelty"), forbade the act of boiling flesh to separate it from bone—a more expedient, if not papally favorable, method of preparing bodies (and their reliquary "objects"!), rendering them easier to transport to churches far and wide. But even this declaration has been subject to misinterpretation over the centuries, being cited more than once as proof that the Catholic Church "forbade" autopsies and dissection.

A closer reading of the papal bull isn't the only item that shows a permissiveness toward dissection and autopsy—there were also anatomy lessons featuring dissections at the University of Bologna, the world's oldest university, at the dawn of the fourteenth century, just a year or so after Boniface's declaration. This same time period produced the world's first anatomical "textbook," *Anathomia corporis humani*, written by Mondino de Luzzi (1275–1326), a professor of surgery in Bologna. His book

essentially functioned as a how-to guide for dissection practices and even includes some rudimentary descriptions (if no illustrations) of internal organs. This text was so influential that it became required reading—not only in Bologna, but all over Europe—for medical students until the 1600s. If dissection was so religiously forbidden, it seems strange that this book had such wide-ranging effects on medicine for more than three centuries.

However, to say that there was *no* pushback against autopsies and dissections would be dishonest. While the criticism didn't come from the Church, it did come from Italian families. Concern arose from the worrisome idea of a family member being "opened up" in public at anatomical lectures and surgery theaters—*what if Uncle Jacopo is recognized!?* (Private postmortem examinations, it should be noted, had no stigma.) The dual motivators of shame and fear, in these cases, produced at least one official proclamation around 1388, where Florentine officials decreed that "only unknown and ignoble bodies can be sought for dissection, from distant regions without injury to neighbors and relatives," according to the late fifteenth-century anatomist Alessandro Benedetti.

This decree is compelling for two reasons: first, it set a geographical boundary—typically a thirty-mile radius—upon the procurement of corpses in most cases. It also asserted that the best bodies were those of criminals, vagrants, or the otherwise unidentifiable (that is, the poor and unfortunate—if you happened to live on the margins of society, you were the first to go). For the record, Katharine Park does mention a report of at least one corpse theft during these early years. "In 1319, four medical students of Master Alberto of Bologna were prosecuted for robbing a grave and bringing the corpse to the house where he lectured 'so that the said Master Albert could teach them to see what is to be seen in the human body,'" she writes. Such an event was isolated, however, because the University of Bologna began holding school-sponsored dissections and incorporated anatomical lessons into its curriculum.

Artists became involved in the whole autopsy/dissection kerfuffle as the sixteenth century approached. By this point, the University of Bologna had

been holding anatomy lessons for almost two hundred years, and both students and the general public alike clamored to attend public dissections and associated lectures. To meet the demand, physicians and university professors perfected a tripartite method of corpse procurement: first, a private appeal to family members of an ill or recently deceased individual. Considering the whole "thirty-mile radius" at work in many Italian city-states, though, this didn't always go so well. Next, they went to prisons and jails to seek the bodies of executed criminals—which, believe it or not, wasn't as profitable as one would imagine. Contrary to what many of us may imagine, executions in Italy weren't a frequent occasion; Florence, for example, held about six or seven public executions per year, and only a small portion of these criminals were so-called foreigners from at least thirty miles away. Where, then, were most corpses found for medical research? Hospitals.

Now, Renaissance hospitals weren't the kinds of places we're used to today—where we all go for everything from a sprained wrist to cancer surgery. Back then, those of means remained at home for diagnosis, treatment, and convalescence. Instead, hospitals were charity-driven institutions meant to provide care to the poor and those without family to provide such care. Conveniently, those served by hospitals were the ideal candidates for dissection, typically being both of low means and potentially of geographical distance—if you have no money and no family, chances are good that no one would scoff at your dissection! Most Renaissance artists began working with corpses not through grave robbing or secretive means, but through the legit assistance of hospital personnel.

When Your Corpse Is Played by a Sex Worker: Caravaggio's *Death of the Virgin*

In the first years of the seventeenth century, revolutionary artist (and famous ne'er-do-well) Caravaggio (1571–1610) received a prestigious commission from a wealthy patron of the church of Santa Maria

della Scala in the Trastevere district of Rome, to create a devotional painting dedicated to the Virgin Mary, representing the adoration of her body upon death. But Caravaggio's final product didn't jibe well with religious and artistic expectations. For starters, this Virgin Mary looks nothing like she typically did in painted representations: all rosy, glowing, and sacred, as befitting the mother of Jesus. Here she just looks . . . *dead*. With gray skin and swollen feet, Mary lacks a sacred vibe—the holiest of all holy women, brought down to the lowest common denominator. That was shocking enough. But then word spread that the wily Caravaggio used his own mistress—a known sex worker!—as the model for the Virgin. To put it lightly, this did not go over well with the Catholic Church or the artwork's patron. The work was rejected outright, and the commission granted to another artist. But it's Caravaggio who gets the last laugh: *Death of the Virgin* (1601–1605/06, Musée du Louvre, Paris) is now considered a masterpiece of Baroque painting, one of the best in the world.

The connection between medicine and art, as we've established, isn't such an oddity: the keen observation of the makings of the human body was considered necessary for artistic training during the Renaissance as much as it was a requirement for medical training. In their quest to achieve the most lifelike renderings, many artists—as members of the general public— would watch physicians perform dissections to learn about the bone and muscle structures within the human body.

Artists quickly realized, however, that *they* had a very special bargaining chip: a mutually beneficial relationship wherein they could provide anatomical drawings as illustrations for textbooks and other educational materials. In other words, it was a win-win situation for both doctor and artist. Flemish-born anatomist Andreas Vesalius (1514–64), a professor at the University of Padua, even claimed that he had made a deal with the great Venetian painter Titian (c. 1488/90–1576), allowing the artist to assist in dissections in return for medical illustrations that would feature prominently in Vesalius's books. This, however, seems highly unlikely, and

there is no evidence that Titian—a hugely important and sought-after artist—participated in this "deal." It's far more likely that a student or another member of his studio assisted Vesalius, and that the proximity allowed Titian reciprocal access to the medical drawings themselves, further improving his own designs.

Though Titian's involvement in medical illustration is probably a myth, the association of other important visual artists with dissections isn't. Antonio del Pollaiuolo (c. 1429/33-1498), another Renaissance biggie trained in sculpture, painting, goldsmithing, and printmaking, was, according to the Granddaddy of Art History, Giorgio Vasari (1511–74), "the first master to skin many human bodies in order to investigate the muscles and understand the nude in a more modern way." Vasari's classic collection of artist biographies, *Lives of the Most Excellent Painters, Sculptors, and Architects* (typically known today as *The Lives* or *The Lives of the Artists*), has a reputation for being a teeny bit overdramatic and at times untruthful—he knew when to embellish a story to make it more appealing. But Pollaiuolo's own artwork bears out his in-depth study of the appearance and inner workings of the human body, particularly its musculature. His most famous print, *Battle of Nude Men* (also known as *Battle of Ten Nudes*, c. 1490; surviving print impressions found in Cleveland, New York, London, Vienna, and elsewhere), lives up to its name, presenting ten naked men fighting, contorted in various standing, leaning, and reclining poses that clearly delineates the muscles flexing throughout their (very, very toned) bodies.

Pollaiuolo's *Battle* shows a clear understanding of the body's internal mechanisms, especially musculature, as applied to an illustration of the human figure. Oftentimes such drawings—or prints, in this case—were designed with the help of *écorchés*—precise renderings of the body's muscular structure without the covering of skin. *Écorchés* were created by artists to hone their skills for portions of a larger artwork they were working on—as was probably the case for Pollaiuolo—but they also may have been drawn or painted by students studying the body's structure. The most famous of these *écorchés* were produced by the greatest artistic anatomist of the Renaissance: Leonardo da Vinci.

Leonardo's many anatomical illustrations litter his *Codices*—the various

notebooks he maintained during his lifetime—and these sketches were revolutionary for their time. Like an architect, Leonardo's drawings provide different perspectives of the human body, breaking it down in sections, elevations, and even perspective studies. These in-depth renderings speak not to a quick examination, but to ongoing study and even collaboration: Carmen Bambach, curator of Drawings and Prints at the Metropolitan Museum of Art, suggests that Leonardo's most thorough drawings were made under the direction and assistance of a young professor named Marcantonio della Torre (1481–1511) from the University of Pavia. Through Della Torre, Leonardo received his best access to corpses, and worked with Della Torre to produce his works. What's interesting is that Leonardo's medical images were not published during his lifetime; it's unclear whether or not Della Torre commissioned or requested their use from the artist, as his premature death from the plague cut short his ambitions. For his part, Leonardo did not attempt to broadcast his anatomical studies after Della Torre's death. The very fact, too, that these illustrations were produced within his notebooks attests to their personal usage, as ways of quelling his irresistible knowledge and curiosity and as attempts to improve his own artistic designs (not that it stayed private forever, though: his sketches were eventually discovered and essentially copied by none other than Andreas Vesalius, who created the first illustrated anatomical text, *De humani corporis fabrica* [*On the Fabric of the Human Body*], in 1543).

Leonardo da Vinci didn't simply explore the human body through dissection. He began, like most artists, by sketching from live nude models where possible, and only moved on to autopsies and dissections in order to understand the body's inner workings—bones, muscles, and internal organs, focusing especially on the brain, heart, and lungs. Like a scientist, he sought to figure out every detail and function of the body, even if it didn't necessarily have a direct correlation to one of his current projects. Example A: Leonardo was fascinated by the human heart and wondered how it moved blood through the body after being propelled by the pumping of the heart. As early as the 1490s, he began using the hearts of farm animals to determine their functions, and in Milan during the 1510s, he continued his research thanks to his cadaver connections, creating incredibly detailed drawings of hearts

(Windsor Folios, Royal Collection, Windsor, UK). While not all of Leonardo's assumptions—or illustrations—are technically correct (his drawings of a fetus in the womb, from the same collection, are to be lauded for their ambition but not their accuracy), he was still hundreds of years ahead of his time in his understanding and artistic exploration of the body.

Like many others, Leonardo couldn't necessarily wait around for Marcantonio della Torre or other doctors to make time for him; while the professors undoubtedly threw the artist a bone every now and then, on rare occasions, Leonardo needed to take matters into his own hands. Thus an artist undertaking an autopsy or dissection on his own, extraordinarily uncommon though it might be, *did* happen. Like the leading medical professors today, Leonardo sought assistance from various charity hospitals throughout Italy—seeking access especially from hospitals in Rome, Milan, and Florence. By making connections with the caregivers therein, he could score cadavers for his own artsy research-driven purposes. And the hospital employees weren't the only ones sympathetic to Leonardo's needs: in his notebooks, Leonardo described befriending patients within hospitals who allowed their bodies, post death, to be used for his purposes. About one incident, Leonardo wrote:

> [An] old man, a few hours before his death, told me that he was over a hundred years old, and that he felt nothing wrong with his body other than weakness. And thus, while sitting on a bed in the hospital of Santa Maria Nuova in Florence, without any movement or other sign of any mishap, he passed from this life. And I dissected him to see the cause of so sweet a death.

By the end of his life, Leonardo recorded that he had personally undertaken around thirty dissections—and it can be assumed that all of them stemmed from cadavers sourced with the same care and methodology.

Despite historical documentation that attests to the frequency and acceptance of artists using cadavers as the basis for their anatomical studies, the

myth of the illegal trafficking of corpses has been difficult to shake. Part of the problem is that the fable was perpetrated fairly early on in contemporaneous literature. A big offender here is Giorgio Vasari, who apparently found a special thrill in noting "the very strangest caprice" in the life of Silvio Cosini, a relatively middling sculptor who was employed, at one point, by Michelangelo. Of Cosini, Vasari notes:

> One night he took out of the grave the body of one who had been hanged the day before; and, after having dissected it for the purposes of his art, being a whimsical fellow, and perhaps a wizard, and ready to believe in enchantments and suchlike follies, he flayed it completely, and with the skin, prepared after a method that he had been taught, he made a jerkin [vest], which he wore for some time over his shirt, believing that it had some great virtue, without anyone ever knowing of it. But having once been upbraided by a good Father to whom he had confessed the matter, he pulled off the jerkin and laid it to rest in a grave, as the monk had urged him to do. Many other similar stories could be told of this man, but, since they have nothing to do with our history, I will pass them over in silence.

Who knew that Buffalo Bill from *The Silence of the Lambs* had an art-historical connection?

As mentioned previously, Vasari's main goal wasn't necessarily to document the veracity of an event; he was a known gossip who frequently embellished stories to make sure that readers got the biggest bang for their buck (and thus ensuring better sales of his books). I love that Vasari's snippet about Cosini ends with the dismissal of similar stories as not relevant to the artist's biography—was the skin vest a high point in the artist's career, then?

Body Snatching Throughout the Ages!

Need a fast influx of cash, and jewelry theft isn't cutting it? Try steal-
ing dead bodies! Whereas grave robbers focused predominantly on
purloining the goods buried with a corpse, body snatchers (also
called resurrectionists at the height of their nineteenth-century no-
toriety) took the corpses themselves. Why do such dirty (and stinky)
work? As noted in this chapter, many of these crimes were commit-
ted in order to provide bodies for anatomy discussions or dissections
in medical schools and laboratories, a habit that has been docu-
mented around the world since the thirteenth century. But that's not
the only reason for body snatching. In the late eighteenth and early
nineteenth centuries, body snatching from African American and
Native American cemeteries escalated, as dodgy anthropologists
clamored to use anatomical "findings" to prove their often racist and
bigoted agendas.

Even today, corpse robbery isn't such a rare thing. In 2007, Indian
police raided the hideout of a gang of bone traders, who snatched
bodies in order to provide "hollow human thigh bones in great de-
mand in monasteries [for use] as blow-horns, and skulls as vessels to
drink from at religious ceremonies," according to a Reuters report.
And in 2006, a staggering number of young female corpses in rural
China were stolen for burial next to similarly deceased, single young
men. These so-called ghost marriages are illegal and weird, but also
kinda sweet, if you think about it. Ol' cousin George and little Van-
essa are no longer alone in the afterlife! Now they have each other! So
even if body snatching wasn't a thing for Renaissance artists, it *was*
(and *is*) a thing for many, many others throughout time.

Cosini's one-time employer Michelangelo didn't escape the corpse-
procurement rumors either. In "Michelangelo, Giotto, and Murder," art
historian Norman E. Land traces gossip that transformed the artist's
much-reputed tetchy personality into something truly pathological. By the
mid-seventeenth century, a rather obscure Englishman (with a flair for the

dramatic) named Richard D. Carpenter concocted a tale about the artist, one meant not only to highlight the general "deceptive nature" of artists, but also to promote Carpenter's own anti-Catholic sentiments. In his 1642 treatise *Experience, Historie, and Divinitie*, Carpenter writes:

> *Michael Angelo* [*sic*], a Painter of Rome, having enticed a young man into his house, under the smooth pretence [*sic*] of drawing a picture by the sight of him; bound him to a great woodden Crosse [*sic*], and having stabbed him to the heart with a Penknife . . . drew Christ hanging, and dying upon the Crosse [*sic*], after his resemblance & yet escaped without punishment. And this picture, because it sets forth Christ dying, as if the picture itself were dying, and with a shew [*sic*] of motion in every part; and because it gives the death of Christ to the life; is had in great veneration amongst [Catholics].

This isn't body snatching, but Carpenter's story instead ups the ante from grotesque theft to outright homicide—that's some serious escalation (and, if true, would have proclaimed a *really* intense devotion to one's craft, it must be noted). Though several historians were quick to come to Michelangelo's defense, Land notes that the rumor of the artist's bloodlust persisted until at least the end of the eighteenth century, with even the Marquis de Sade evoking Michelangelo's supposed crimes in his early novel *Justine* (1791).

However, one person did purportedly rob graves for his own medical means: Andreas Vesalius, the anatomy professor from the University of Padua. According to Park:

> One of the most surprising aspects of his great treatise *On the Fabric of the Human Body* . . . is his lack of respect for persons and his candid pride in the acts of daring and deception required to obtain what he considered an adequate supply of cadavers. He and his students forged keys, rifled tombs and gibbets, and stole in and out of ossuaries in a series of nighttime escapades that he recounts with evident relish and amusement, particularly when female bodies were involved.

Some might be a little uneasy knowing that incredible artworks have been inspired or aided by the dissection of a dead body. Was a visual rendition of the body's interior *really* necessary to produce a compelling image of a saint, for example? I'll leave you with one very unique example to consider. In Milan, the city's famous duomo (cathedral) houses an arresting sculpture of Saint Bartholomew, one of Jesus's twelve apostles. But his appearance isn't standard. Instead of being clothed in a toga or robe (or whatever you'd traditionally expect a saint to wear), Bartholomew is flayed down to his muscles, and has *his own skin draped across his shoulders*. Horrific! And yet so very cool. This sculpture, completed in 1562 by Marco d'Agrate, is the Italian artist's masterwork, the piece that has cemented his status as a well-studied, anatomically versed maker. His Bartholomew is wide-eyed and calm, just standing there with all his muscles in full view, with every ripple of sinew impeccably defined, and his skin hanging off his back—a typical way to present this saint, who met his demise while being skinned alive. It's utterly realistic *and* memorable (it is one of the artworks most photographed at the duomo today). Even d'Agrate was proud of his efforts, signing the sculpture with the line, "I was not made by Praxiteles [the most famous sculptor of Ancient Greece] but by Marco d'Agrate." D'Agrate's understanding of musculature via his close study of the dissected human body has made all the difference here. His attention to anatomical detail is what makes this a *killer* work of art (groan!).

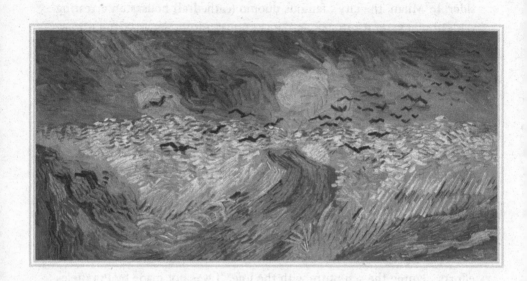

Vincent van Gogh, *Wheatfield with Crows*, 1890

CHAPTER 7

The (Possible) Murder
of Vincent van Gogh

What am I in the eyes of most people—a nonentity, an eccentric, or an
unpleasant person—somebody who has no position in society and will never
have; in short, the lowest of the low.

VINCENT VAN GOGH, ARTIST

Look what that intensity did to poor great Van Gogh!

JOHN TAGLIABUE, POET AND PLAYWRIGHT

When I was a college freshman, I played hooky from chemistry labs and anthropology lectures to wait in a long, *long* line on an uncharacteristically chilly morning in Los Angeles. I was waiting for an exhibition: *Van Gogh's Van Goghs* at the Los Angeles County Museum of Art, a show that featured numerous works from the Van Gogh Museum in Amsterdam. At that point in my life, I had never seen one Vincent van Gogh (1853–90) painting in person, let alone many, so I just *had* to go. Of course many others had made similar plans, and together we swarmed, hive-minded, past paintings filled with shimmering colors and exuberant brushstrokes. I immersed myself in bright sunflowers, swirling self-portraits, and lovingly painted landscapes. But when I turned in to the final gallery, I stopped in my tracks.

I stood in front of a horizontal painting, divided nearly in half by tones of cobalt and ochre, with the darkness of the blue tones representing a gloomy sky, almost a shock in contrast to so many of the more vibrant paintings I had admired in the previous galleries. The artist's hasty brushstrokes

reveal a dash of greenery, turbulent swathes of wheat, and a red-brown dirt path disappearing toward the horizon. Above, in the churning sky, is a flock of blackbirds. This was *Wheatfield with Crows* (1890, Van Gogh Museum, Amsterdam), a showpiece created just prior to Van Gogh's untimely death in late July 1890. For more than one hundred years, viewers have been as struck by this painting as I have been, and interpretations of it have been many and varied. But the one that seems to stick—whether or not it is accurate—is that it visually presents Van Gogh's growing depression and hopelessness. As such, many read it as a preview of his upcoming death—a suicide note completed in paint instead of ink.

Van Gogh's suicide is as much a part of his story as the famous tale of his cutoff ear is. He's been called the perfect embodiment of the tortured genius, a creature so agonized by life and failure that he sought his own death as the only solution. But in 2011, two Pulitzer Prize–winning authors published a book titled *Van Gogh: The Life* (New York: Random House) that stunned the art world. In their book, authors Gregory White Smith and Stephen Naifeh state that the artist didn't commit suicide. No, they say, he was actually murdered.

It's nearly impossible for us to separate Vincent van Gogh from the *idea* of Vincent van Gogh. From Irving Stone's 1934 blockbuster novel *Lust for Life* (50th anniversary ed., 1984, Plume, New York), to the 1956 movie of the same name starring Kirk Douglas, even to "American Pie" songwriter Don McLean's superschmaltzy single "Vincent," Van Gogh is embedded in our popular culture. And because of this, we think we *know* him. But the truth is that much of what we've been taught about this agonized virtuoso is the sincerest exercise in mythmaking. Like so many others gone before their time—think John Lennon, Janis Joplin, Kurt Cobain, David Foster Wallace, and others—an artist's unexpected death becomes the perfect catalyst for the elevation of a cultural icon to the status of saint, hero, or god. By and large, this apotheosis leaves us with a romanticized, aggrandized view of someone's life and work. We love stories—and even if the juiciest parts

of a story aren't true, we don't care. It's so much more pleasurable for us to collectively think of Van Gogh, for example, and to sigh wistfully with the lament, "What a poor man. And to think he never sold one work during his lifetime." Even if we are wrong—and we are!—we want to believe the myth.

It turns out that the myth of Van Gogh as a distressed genius began incredibly soon after his death. Art historian Nathalie Heinich notes that less than two years after his passing, the term *genius* was already being assigned to Van Gogh by art critics. Drawn to the facts of his mostly solitary existence and his suicide, it was easy for experts and the general public alike to appoint various adjectives to describe him: *disturbed*, *forsaken*, *tragic*, *mad*, and *tortured*. Once these descriptions began to take hold in the public imagination, there was no stopping it.

But as early as the 1930s, some historians began to push back against the mythologizing of Van Gogh. In a 1936 article in the *American Magazine of Art*, Gertrude R. Benson proclaimed that most of the information circulating about Van Gogh was

a kind of unscrupulous muckraking that sensationalizes the frustration, the tragedy, and not the achievements, in a life that was obstinately dogged by misfortune. . . . At best, the emphasis was on the "poor fighter, the poor, poor sufferer"; at worst, literary hacksters spun a Poe-like tale of horror from the melodrama in his life or shed crocodile tears over a Christ-like hero who moved stumblingly but inevitably toward his crucifixion.

Those are fightin' words from Benson for sure, and it is helpful to note that Irving Stone's sentimental embellishment of Van Gogh, *Lust for Life*, had been published only two years prior—and he's undoubtedly the "literary hackster" to whom Benson refers—so Benson is probably reacting directly to Stone's book in her article. But regardless of the circumstances, she was right. If there ever was an artist whose story was subjected to such hyperbole, it's Vincent van Gogh. But how much of the information about his life is true? How much of it is romanticized fiction?

Vincent Willem van Gogh was born in the village of Zundert in the Netherlands on March 30, 1853. His youth was fairly uneventful, and family noted that while he drew pictures from time to time, there was never any real indication of solid artistic talent or tendency. Indeed, his decision to become a professional artist came "late" in his life at the age of twenty-seven, after first pursuing careers as a teacher, a clergyman, and an art dealer. Until roughly 1880, Vincent ping-ponged around England, Holland, France, and Belgium in pursuit of his various career endeavors. It seems, like many of us, that he just didn't know what to do with his life. Ultimately, his conundrum was solved by his younger brother, Theo, who often acted as his confidant, financial backer, supporter, and all-around metaphorical guardian angel. Vincent and Theo were lifelong pen pals, and in his letters, Vincent would sneak in little sketches or drawings of places he visited or people he had seen. These illustrations charmed Theo, and in 1880, he wrote Vincent and advised him to pursue art as a full-time career. Luckily for us, Vincent heeded that advice, and spent the next few years traveling around Europe again in search of artistic inspiration and training.

Most art historians consider Van Gogh's first real achievement in painting to be an 1885 canvas called *The Potato Eaters* (Van Gogh Museum, Amsterdam), which is a clear representation of Vincent's interest in being what he called "a painter of peasant life." He found everyday people—especially the working class—to be an inspiration, an embodiment of the kind of Christly ideals that he had proselytized during his early attempts at being a preacher. These initial peasant scenes are dark, shadowy, and full of earth tones, surprisingly dark for those who only know Van Gogh through works like a little painting called *The Starry Night* (1889, Museum of Modern Art, New York).

The canvases that many of us think of as "quintessentially Van Gogh" didn't come into being until after 1886, when Vincent moved to Paris to live with Theo and to dig deeply into the Parisian avant-garde of the Impressionists and Postimpressionists. Suddenly, Vincent was thrust into the worlds of Henri de Toulouse-Lautrec, Paul Gauguin, Paul Signac, and

Claude Monet. These artists—some of whom became good friends of Van Gogh's—dramatically affected him. Under their influence, his works became bolder, brighter, more expressive, more spontaneous. His brushstrokes became shorter, livelier, and more prominent. Van Gogh, as we know him, really began to come into his own. But it wasn't until he made the momentous decision to move to southern France that his work sprang into full bloom.

In early 1888, Van Gogh found himself exhausted and burned out by Parisian life. Always a bit sensitive, he was stressed by both the city's urban vitality and the manic art scene and was thrilled by the idea of a simpler life—and probably of warmer weather too. He relocated first to the small Provençal town of Arles, where he settled into a life of extreme productivity—according to estimates, he created more than two hundred paintings in the short span of only fifteen months. He was exhilarated by the southern light and the luscious colors of the natural world around him, and the steadily good weather in Arles allowed him to spend full days painting outdoors, or *en plein air*, to practice his craft. Though life for Vincent improved immensely, he yearned for another element: camaraderie. He dreamed of forming an artists' colony in a big yellow house nearby, where creative folks could spend days obsessing over color theory and the latest developments in artistic technology. In a fit of joyful inspiration, he invited artist friends from Paris and beyond to join him in this endeavor. Only one—Paul Gauguin, a fascinating and problematic character in his own right—answered the call.

For a few bright months, Van Gogh and Gauguin were the closest of friends, working together and sharing their artistic goals and generally living the good life—that is, until the two men began to disagree and ceased collaborating. Coincidentally, it was also around this time that the first real signs of Van Gogh's mental instability began to surface, and late that year he experienced his first breakdown—possibly related to epilepsy, though the precise nature of his condition is still unknown. His physical and mental ailments, combined with his despair at the failure of his artists' colony

and his terrible fracture with Gauguin, led to its apex: his legendary ear mutilation incident, wherein he sliced off most of his left ear (and then presented it as a token of affection to a maid at a local brothel, which is, um, sweet?). Quickly after the ear cutting, in May of 1889, Van Gogh had himself voluntarily committed to a mental asylum in the small town of Saint-Rémy-de-Provence, a development he lamented in a letter to Theo, writing, "I put my heart and my soul into my work, and have lost my mind in the process."

An Ear en Garde

We all know that Van Gogh chopped off his own ear . . . *or do we*? While tradition holds that Vincent did the dirty work of self-mutilation in a fit of madness, two German historians, Hans Kaufmann and Rita Wildegans, published a book in 2008 theorizing that it was actually *Paul Gauguin*—fellow artist, fair-weather friend, and an accomplished fencer—who cut off Vincent's ear with a rapier in late December 1888 after an altercation. This is in direct contrast to what Gauguin himself reported—though he was the only eyewitness to the encounter. But this fact doesn't faze Kaufmann and Wildegans, who find Gauguin's tale inconsistent, and they note that Van Gogh's letters to his brother, Theo, contain hints of Gauguin's violence: "Luckily Gauguin . . . is not yet armed with machine guns and other dangerous war weapons," Van Gogh quipped.

At the time, shutting himself away in a mental asylum may have been necessary for the artist's safety, but luckily, it did little to curb his creativity. Once he was sufficiently healed physically, Vincent found himself longing for emotional restoration in the only way he knew—through a continual devotion to art. He painted the hospital's garden, olive trees, bouquets of flowers, mountains, and towering cypresses with as much vigor as he always had, and it was during this period that some of his most memorable works, like *The Starry Night*, were created. Yet his yearlong stay at the

asylum in Saint-Rémy wasn't all sunshine and daisies: while staying there, he experienced several more fits and breakdowns, with some so intensely debilitating that he could not paint for weeks at a time. At one point, Vincent's pain grew so acute that he attempted suicide via poisoning, ingesting paint and kerosene before he was discovered by his medical aides. And things only became worse: the longer he stayed locked up at the asylum, the more he became convinced that the hospital was actively causing his mental disintegration. In May of 1890, Vincent persuaded his doctors to allow him to leave Saint-Rémy-de-Provence, and he returned to Paris and to the comfortable support of his brother, Theo.

Starry Night's Epileptic Inspiration

Vincent van Gogh was certainly not the healthiest man ever, but his ailments may have had one very positive unintended side effect: they may have inspired his most famous work, *The Starry Night* (1889, Museum of Modern Art, New York). One doctor believes that the iconic yellow coronas of Van Gogh's stars may be representative of the artist's tendency toward self-medication with digitalis, a powerful drug based on extracts from foxglove plants and used as a treatment for epilepsy, specifically epileptic seizures. Such dosing—probably recommended by his doctor, Paul Gachet—could have altered the artist's perception, causing him to experience a visual haziness frequently tinged with yellow, a condition today known as xanthopsia. Though the digitalis may have done little to assist Van Gogh's seizures, it had a glorious byproduct—the ability to perceive an ordinary evening as a spectacular sight, informing one of the most famous works of art of all time.

If there's one thing we know for sure about Vincent van Gogh, it's that he didn't stay anywhere for a long period of time. Only days after returning to Theo's happy home, he left Paris and moved to the town of Auvers-sur-Oise, about thirty kilometers north of Paris—close enough to his brother

but far enough from the city that he could seek the authentically simple life for which he yearned. He carried on painting, producing multiple landscapes, including *Wheatfield with Crows*, but the countryside did not have as much healing power as he had originally hoped. His depression continued, and his mysterious illnesses worsened. It hit a crescendo on July 27, 1890, when Vincent van Gogh walked into the middle of one of the wheat fields he had so lovingly rendered in oil paint and shot himself in the stomach with a revolver. He died two days later, on July 29. He was just thirty-seven years old.

Vincent van Gogh's life was turbulent, and his early demise is most certainly heartbreaking. But much of the collective image of him as a misunderstood and unloved genius is nevertheless highly mythologized. Take, for example, the often-repeated nugget that Van Gogh's art was completely unappreciated during his lifetime and that he never sold one work of art. Untrue. As noted in the Van Gogh Museum's wonderful web series, *125 Questions*:

> We don't know exactly how many paintings Van Gogh sold during this lifetime, but in any case, it was more than a couple. Vincent sold his first painting to the Parisian paint and art dealer Julien Tanguy, and his brother, Theo, successfully sold another work to a gallery in London. *The Red Vineyard* [the Pushkin Museum of Fine Arts, Moscow], which Vincent painted in 1888, was bought by Anna Boch, the sister of Vincent's friend Eugène Boch. Van Gogh often traded work with other artists—in his younger years, often in exchange for some food or drawing and painting supplies. In this sense, Vincent actually "sold" quite a lot of work during his lifetime.

Within the artistic community, then, his art was exhibited, seen, and appreciated. In fact, during the period that he committed himself to the asylum in Saint-Rémy, his works were exhibited multiple times in both Brussels and Paris. He was shown alongside contemporaries like Camille

Pissarro, Paul Cézanne, and Pierre-Auguste Renoir. Even Claude Monet vocally celebrated his works during Van Gogh's lifetime (learn more about Monet's own career struggles in chapter 1). In terms of the public interest in Van Gogh's work? OK, yes, things were a bit slower on the uptake than the artist himself would have liked. But we must consider Vincent's biographical timeline in this scenario: he made the choice to pursue art as a full-time endeavor only in the last decade of his life, half of which was spent learning, working, and perfecting his techniques. Naturally, there was not a lot of time left over to purposefully market himself or his artwork. And it's common for many artists to go years—even decades or lifetimes—before finding recognition or admiration (instant overnight success, in the age of Instagram and Twitter, isn't even a guarantee for artists today, though the possibility of fame is far greater now than ever before).

Finally, we must consider the art market and Vincent van Gogh's place in it at the end of the nineteenth century. His art fit squarely into the world of the avant-garde, which meant that many collectors considered his works too strange or radical—*too unrealistic!*—for their tastes. Van Gogh was certainly not alone in this—so many of the Impressionists and Postimpressionists had the same problems. So while it may be unfortunate that Van Gogh didn't sell more paintings in art galleries during his lifetime, it certainly isn't as mournful or pitiable a situation as popular culture may have led you to believe. Sadly, it was all too common.

There is, however, one part of the Van Gogh mythology that seems to stick: his tragic suicide in 1890. Historians, doctors, and casual connoisseurs alike can only speculate as to the reasons behind it, but a few supposed eyewitness accounts give us a hint at the narrative.

When Van Gogh moved to Auvers-sur-Oise in the weeks before his death, he rented a room at a local inn in the center of town called the Auberge Ravoux. The innkeeper's teenage daughter, Adeline, had been a gentle observer of Monsieur Vincent, as her family called him, and the events of late July 1890 would become a significant part of her family's legend.

When she was in her midseventies, in 1953, Adeline committed her memories of Vincent to paper. In her account, she wrote that on the morning of July 27, Van Gogh had left the inn for his usual daily painting sessions, loaded down with his easel, canvases, paints, and miscellaneous artistic accoutrements. But he deviated from his normal schedule when he did not return before sunset. This, she said, was unusual, and did not follow the artist's typical habits and behavior. When he did eventually arrive back at the inn, it was after nine p.m.—darkness had fallen more than an hour prior, so there was no remaining light for painting *en plein air*—and he was without his equipment: no thickly painted landscapes or portraits with still-wet brush strokes, ready to dry overnight in his small bedroom at the Auberge. Even stranger, Adeline's mother noticed that the man was walking haltingly, with his hands delicately holding his stomach. Adeline's document describes what happened next:

> Mother asked him: "M. Vincent, have you had a problem?" He replied in a suffering voice: "No, but I have . . ." He did not finish, crossed the hall, took the staircase and climbed to his bedroom. I was witness to this scene. Vincent made such a strange impression on us that Father got up and went to the staircase to see if he could hear anything. He thought he could hear groans, went up quickly and found Vincent on his bed, moaning loudly: "What's the matter," said Father, "are you ill?" Vincent then lifted his shirt and showed him a small wound in the region of the heart. Father cried: "Unhappy man, what have you done?"
>
> "I have tried to kill myself," replied Van Gogh.

Shooting oneself in the chest or stomach—and accounts vary as to the exact location of Van Gogh's wound—is surely an insanely painful way to go. And it has the dubious distinction of prolonging death in a way that a shot to the temple or forehead does not (and my apologies for the morbidity of this discussion). Vincent's injury wasn't immediately fatal, then, so he spent the following two days in and out of consciousness with the occasional ability to speak to Adeline's family, the local police, and a couple of friends, including his primary physician, Dr. Paul Gachet. According to

Adeline, during those final hours he revealed the story behind his injury: he had gone to a nearby wheat field, shot himself with a revolver, and passed out from the searing pain. Later that evening, he was revived by the cooler temperatures of nightfall and awoke in search of the revolver to finish the job. When he was unable to locate the gun, he then opted to return to his room at the Auberge Ravoux.

Van Gogh was the first person to actively spread this story about his death. He even reiterated his tale to the local police, declaring, fascinatingly, "My body is mine and I am free to do what I want with it. Do not accuse anybody, it is I that wished to commit suicide." Theo was alerted of Vincent's condition via telegram and quickly arrived by train with enough time to hold vigil over his dying brother, watching solemnly as his brother fell into a coma and died at approximately 1:30 a.m. on July 29.

This is the narrative we know about Vincent van Gogh. It's part of the lore, part of the legend. But is it really the true story of how he died?

Authors Gregory White Smith and Stephen Naifeh spent more than ten years researching and writing *Van Gogh: The Life*, which they intended to become the definitive biography of Vincent van Gogh. During their research period, they were given rare access to the archival vaults of the Van Gogh Museum in Amsterdam, which held everything from the artist's preparatory sketches to hundreds of his handwritten letters. While sorting methodically through this treasure trove of information, the authors noticed strange or conflicting information in the various reports of the artist's suicide.

The first bit of intriguing information was the final letter that Van Gogh ever wrote, posted to Theo on the day he shot himself. According to Smith and Naifeh, the tone of the letter was joyful and energetic, with Vincent discussing his future hopefully, mentioning to Theo that he had placed a large order for new paint, so he was clearly thinking of his work and seemingly as engaged in his livelihood as ever. This obviously conflicts with the idea that he was despondent and suicidal.

Additional elements that struck the authors as odd were the early first-

hand accounts of Vincent's death. No one ever called it suicide—or even an *attempted* suicide—with most referring to the events as Vincent having "wounded himself." Tellingly, too, no one at that time had been able to locate the revolver with which he supposedly shot himself—though there was an extensive search in the days following the "accident"—and no one came forward as a witness to the shooting.

All of this doesn't seem too suspicious to me upon first read, but it planted in Smith and Naifeh a seed of conspiratorial doubt. It seemed, they reckoned, that perhaps Van Gogh didn't intend to kill himself at all—and that a tall tale about suicide became the accepted narrative.

So where did the talk of suicide actually begin, then? Though Van Gogh recounted his suicidal intentions to the Ravoux family and local police, Smith and Naifeh point to one particular loose-lipped suspect—Émile Bernard, a fellow artist and (supposed) friend of Vincent's, who reported the suicide story to an art critic whom he desperately hoped to impress. Bernard proclaimed that Vincent went out into the wheat fields that evening and "left his easel against a haystack . . . and fired a revolver shot at himself." We should note that Bernard is getting this information secondhand—or he may very well have made it all up!—because while he attended Vincent's funeral, he most certainly was not in Auvers prior to that time. Bernard, too, was known to be a fan of heightened drama, and he had already used his friend Vincent as a subject of a histrionic recollection a couple of years prior, when he relayed the tale of Van Gogh's cutoff ear—spiced up with lots of extra emotion—to the very same art critic (what nerve!).

In their recounting of this traditional take on Van Gogh's death, Smith and Naifeh returned to that other eyewitness account—Adeline Ravoux's 1953 recollection—and they began to view it hypercritically, using every weapon in their arsenal to debunk the tale: she was old when she recorded her testimony; she relied too heavily on her father's recounting of the event, which certainly had morphed over the years; and that her own version of the story had changed in its retelling as well, possibly to become even more dramatic—so that mythmaking machine was hard at work again. A final, possibly damning piece of evidence surrounding Adeline Ravoux's tale was

that 1953 marked the hundredth anniversary of Van Gogh's birth, and celebrations, press, and exhibitions abounded around the world, bringing the artist back into the spotlight. She may very well have been capitalizing on a grand opportunity and good timing.

Between Ravoux's conveniently timed tell-all and Émile Bernard's dramatic recounting, there was little in the way of hard evidence to support the long-assumed tale of Van Gogh's suicide, and this made Smith and Naifeh rather nervous. There were no eyewitnesses to the actual shooting, nor any evidence—no *literal* smoking gun! No firmly identified wheat field of death!—of the event. It occurred to the authors that the story bordered more on legend than truth. Could it all be a falsehood, a tall tale? Smith and Naifeh wondered, though they kept their hypothesis to themselves.

And then the most bizarre thing happened. Their hypothesis gained credence with the discovery of another supposed firsthand account of Vincent van Gogh's death that had mysteriously been overlooked or forgotten for many years.

In 1956, a frail man in his eighties named René Secrétan stepped forward to give a series of interviews to French journalist Victor Doiteau. Like Adeline Ravoux three years earlier, he claimed to have a firsthand recollection of the famous Vincent van Gogh, and provided a long, detailed narrative to Doiteau about his run-ins with the artist in Auvers during the summer of 1890.

René Secrétan grew up in a prosperous Parisian family, and every summer the whole Secrétan crew would decamp to Auvers-sur-Oise to enjoy the relaxed surroundings of their vacation villa. In 1890, René was a troublemaking sixteen-year-old who spent his time hunting, fishing, and generally causing all kinds of outdoorsy mischief with a group of like-minded Auvers pals. Their hero was Buffalo Bill Cody, the American hunter and showman whose *Buffalo Bill's Wild West* had performed to massive sold-out crowds in Paris just the year before, during 1889's Exposition Universelle. Cody's presentation at the exposition included full-scale reenactments of horse races and rodeos, Native American attacks on stagecoaches, and

pistol-shooting demonstrations featuring the likes of Annie Oakley. René Secrétan saw the *Wild West* show—and fell utterly under the spell of all things cowboy. (Incidentally, Vincent, Theo, and their pals attended the exposition that year too, but most of them were far more intrigued by the exotic aesthetics of the Japanese Pavilion to take the time to see Buffalo Bill's popular extravaganza.)

Like many teenagers, Secrétan took his obsessions to the extreme. When his family moved to Auvers for the summer of 1890, René brought with him a much-prized costume consisting of a buckskin tunic, boots, and a cowboy hat, all purchased at great expense in Paris. But he felt the need to add a little more authenticity to his getup, so he supplemented with one additional element: a 38-caliber pistol, which, according to René, was a *real* gun, but one that worked erratically. He used it to shoot birds and squirrels in the countryside, but it also did double duty as a fairly convincing intimidation apparatus. You see, René wasn't the nicest kid in town. In fact, some of his favorite activities were to play pranks on the locals and to cause mayhem throughout the countryside. And in the summer of 1890, there was one particular person whom he especially enjoyed terrorizing. I'll give you one guess who.

René Secrétan had an older brother, Gaston, who was the opposite of René. Whereas the younger Secrétan boy was a loud, brutish punk, Gaston was quiet, kinder, and more interested in art, culture, and music. So it is unsurprising that Gaston fell in with a solitary Dutch painter who yearned to spend his time drinking and talking shop with a like-minded aesthete. On occasion, René would tag along with Gaston and listen in on his conversations with Vincent van Gogh at the local bar. Mostly, though, he just wanted the opportunity to torment this man who seemed to be an easy target for his mockery and practical jokes—like putting salt in his coffee or hiding a garden snake in his paint box. At first, Vincent seemed to take the teasing in stride—after all, René was just a teenager, and if you have ever known a teenage boy, then you know that they are prone to all kinds of generalized idiocy. But then something shifted: René's pranks escalated,

and Vincent grew more wrathful at his mistreatment. As Smith and Naifeh recount, by July of 1890, the atmosphere between the teen and the Dutchman had grown poisonous.

For Smith and Naifeh, little things about this story began adding up: an antagonistic, moody teenager, a malicious relationship, a revolver that seemed literally trigger-happy. Ultimately, they came to an alternative explanation of Vincent van Gogh's death, one that had never before been presented.

René Secrétan, they say, shot Van Gogh—either on purpose or accidentally.

In explaining their theory, Smith and Naifeh write:

> René had a history of teasing Vincent in a way intended to provoke him to anger. Vincent had a history of violent outbursts, especially when under the influence of alcohol. Once the gun in René's rucksack was produced, anything could have happened—intentional or accidental— between a reckless teenager with fantasies of the Wild West, an inebriated artist who knew nothing about guns, and an antiquated pistol with a tendency to malfunction.

If René Secrétan indeed shot Vincent, it would be fairly easy for us to extrapolate what happened next: Vincent, possibly unaware of the extent of his injury, may have felt that his best option was to travel back to his room at the Ravoux Inn to tend to his wounds. And René, terrified of his actions, may have cleaned up the crime scene as best he could, collecting Vincent's art supplies—and the gun—and abandoning any evidence of their final encounter.

In *Van Gogh: The Life*, Smith and Naifeh do a fine job of breaking down this theory element by element, even adding a series of explanatory bullet points to demonstrate how their reconstruction fills in the gaps in the original narrative and eliminates areas of contradiction and doubt. It explains

the lack of a weapon, as well as the inability to locate any of Van Gogh's art supplies from that day. It also takes the supposed inconsistencies of the bullet wound into consideration. Though no autopsy was done on the artist, the doctors who attended his deathbed—Dr. Gachet, as well as a man named Dr. Joseph Mazery—both noted that the angle at which the bullet had entered Vincent's body was oblique (or angled) and not straight on, as one would expect from a suicide or a shot from an extremely close range. Finally, there's that lack of a suicide note. Van Gogh was undoubtedly close to his brother, Theo—wouldn't he have said goodbye to the person who loved him most in the world?

The only caveat to the theory, according to the biographers, is Van Gogh's assurance to the innkeeper Ravoux and to the police that *he* had committed the shooting and had done so with the express desire of bringing death upon himself. But Smith and Naifeh naturally have a response to this conundrum. Vincent, they say, welcomed the opportunity to die.

Considering his depression and mental illness, life wasn't a bunch of roses for him, and so perhaps the idea of it coming to a quick end was a type of bittersweet consolation, as well as a convenient way to eliminate his presumed burdensome presence in his brother's life. Indeed, the artist had once written and underlined the following statement in a letter written to Theo: "I would not expressly seek death . . . but I would not try to evade it if it happened." If René Secrétan accidentally did the artist a favor, then, why would Vincent sully René's name, as well as that of his prominent family, by calling him a killer?

The takeaway: Vincent van Gogh didn't commit suicide: instead, he actively covered up his own murder.

Now, let me take the opportunity to step in here and say that my thoughts, upon reading Smith and Naifeh's hypothesis for the first time, were that the timing of René Secrétan's story seemed rather suspicious. As with Adeline Ravoux's oh-so-favorable timing, Secrétan may have capitalized upon yet another Van Gogh milestone: 1956, the year of his interview, coincided with the much-anticipated release of the film version of *Lust for Life*, so

Van Gogh was once again on everyone's minds. This time, though, he was romanticized by a movie idol whose portrayal was so lauded that actor Kirk Douglas would eventually win the Golden Globe for best actor and would be nominated for an Academy Award in the same category for the role. This irked René, who bitterly proclaimed that Douglas's characterization of Van Gogh was too heroic and handsomely honorable. The real Van Gogh was, in fact, a total mess—prone to getting staggeringly drunk, occasionally belligerent, and all-around ragged. René Secrétan wanted to take some of the shine off the apple, and all the attention surrounding *Lust for Life* provided the opportune moment.

But does this opportunism really explain away Secrétan's story? Or could it still hold kernels of truth?

In his narrative to journalist Doiteau, René Secrétan was clear and lucid, and much of what he reported is verifiable by other accounts and witnesses. Interestingly, he was jarringly upfront about his own shortcomings, especially regarding his repeated bullying of Vincent. However, there was one part of the story that seemed not to fit: his ultra-brief discussion of Vincent's death. It is here, Smith and Naifeh say, that René Secrétan turns nondescript and his verbose recollections grind to a halt, noting only to Doiteau that he knew nothing of Van Gogh's death, as his parents had opted to return the family to Paris prior to that infamous July day. Secrétan stated that he later learned about Vincent's death in a Paris newspaper, but he couldn't remember which paper he read—and Smith and Naifeh go out of their way to note that no such report has ever been found. The only point that René conceded was this: yes, Vincent had used *his* pistol to commit suicide—that part was true. But René balked at any implication that he had pulled the trigger, claiming instead that Vincent had obviously stolen it from René's rucksack, and René only realized it was missing after he returned to Paris.

Here again, Smith and Naifeh shed doubt on Secrétan's narrative. Two things in particular struck them as odd: first, we must recall that René so loved having that pistol around for its intimidation and coolness factor that

it seems very strange that he wouldn't have noticed it was missing from his rucksack, particularly when he supposedly carried it with him everywhere. But his insistence that he wasn't around when the shooting occurred is even sketchier, as others claimed to have seen members of the Secrétan family lingering in town on the day of the incident. But here's the stinger: Smith and Naifeh report that during the brief police inspection after the shooting, officials performed a town-wide inventory of all revolvers, which were rarely found in Auvers-sur-Oise. Only one, apparently, was missing— the one that had been last in the possession of René Secrétan. And where was René during this investigation? The police noted that he, along with his brother, Gaston, had been mysteriously spirited away from Auvers by their father in the middle of the night only hours after the shooting.

When *Van Gogh: The Life* was published in 2011, this alternate theory of the artist's death made quite an impression. It was the ultimate in art-historical clickbait, with headlines screeching WAS VAN GOGH MURDERED? in bold type. What's curious to me is that such attention came as a bit of a surprise to Smith and Naifeh, because their hypothesis was not a major revelation in the book. It is, in fact, buried in the very back, in an appendix to their nearly thousand-page volume. The information's location didn't much matter, though—the "revelation" spread like wildfire, and all around the world, art historians, curators, and critics jumped to the forefront to give their opinions on the demise of a man gone for more than 120 years. Dismissal was harsh and fast, but there were many who seized onto the hypothesis as a verifiable—and juicier—explanation for Van Gogh's death.

In the July 2013 issue of the eminent art journal *The Burlington Magazine*, Louis van Tilborgh and Teio Meedendorp—two senior researchers from the Van Gogh Museum—aimed to refute the biography's claims in an article titled "The Life and Death of Vincent Van Gogh." Van Tilborgh and Meedendorp's discussion is painstaking and thorough, dissecting Smith and Naifeh's hypothesis bit by bit to prove its falsity. They note that in certain circumstances, much of the biographers' hypotheses are assumptions

made based on the *tone* of René Secrétan's statements and not the *statements* themselves. And to be fair, Smith and Naifeh are doing an awful lot of reading between the lines. For example, Secrétan's assurance that he knew nothing of Van Gogh's death is viewed by Smith and Naifeh as an outright lie—but for all we know, it could actually be a true statement, which is how Van Tilborgh and Meedendorp read it. Perhaps Secrétan *really* had no idea about when and how Van Gogh died—but verifying this statement for veracity is nearly impossible.

This point—about differing interpretations—also plays into how the scientific or medical evidence can be read. For Smith and Naifeh, the details of Vincent's wounds—the angle of the bullet entry, the fact that the bullet never exited the body, and the types of powder residue and bruising around the wound—point to a determination that the revolver was shot by another individual (not Vincent himself) and from a distance. The biographers sought assistance from ballistics and medical professionals, who concurred that the injuries sustained by the artist were consistent with Secrétan's revolver type and were *not* consistent with typical suicidal wounds. The medical evidence, they say, is clear: Van Gogh was murdered.

But Van Tilborgh and Meedendorp declared that their medical experts noted opposite possibilities—for example, that the gunpowder residue present around the wound would have been found on the skin only if Vincent had lifted his shirt to put the barrel to his own chest—and would a teenaged René Secrétan have done such an odd thing? And while Smith and Naifeh make the case that Vincent was morally opposed to suicide, referring to multiple passages in his letters to Theo, Van Tilborgh and Meedendorp trace Van Gogh's shifting opinions on this matter, particularly after his mental health started deteriorating and he committed himself to the asylum at Saint-Rémy. Consider, too, that Vincent was all too aware that he was both an emotional and a financial albatross around his brother's neck, especially toward the end of Vincent's life—and he made this opinion clear to Theo. In fact, Van Tilborgh and Meedendorp reference a draft of a letter to Theo that was found *on Vincent van Gogh's body* at the time of the shooting, one which shows Vincent's awareness of his

brother's financial responsibility—they had had a recent argument—and difficulties in managing his artistic career:

> My word, there's probably a long way to go before there's a chance of talking business with rested minds. That's the only thing I can say at the moment, and that for my part I realized it with a certain horror, I haven't hidden it yet, but that really is all . . . Ah well, I risk my life for my own work and my reason has half foundered in it—very well—but you're not one of the dealers in men; as far as I know and can judge I think you really act with humanity, but what can you do.

At that point, Vincent's letter ends abruptly.

This wasn't Vincent van Gogh's final letter, mind you—it was actually a draft of an earlier one. Regardless, he chose to include this letter, in its incomplete form, on his person on the day of his apparent suicide attempt. Knowing that he and Theo had experienced recent difficulties, in addition to his feelings of failure, sheds a clearer light onto the situation.

Smith and Naifeh make no reference to this letter in their telling of Van Gogh's death.

Between these two sets of authors, it essentially comes down to a battle of the evidence and the *interpretation* of that evidence. Which one is right?

The fact of the matter is . . . we don't know. We don't have a clear direction that lets us know, fully, that Van Gogh killed himself, or was killed by another person (either purposefully or accidentally). We are left with multiple narratives, mostly written far after the event.

Smith and Naifeh's murder hypothesis became popular again in late 2018, when it went more mainstream thanks to a new biopic about Vincent van Gogh released that year, directed by the artist and filmmaker Julian Schnabel. *At Eternity's Gate*, featuring the awesome Willem Dafoe as our main man Vincent, takes the fairly direct position that it was indeed Secrétan who pulled the trigger. But in an interview with *The Hollywood Reporter*, Schnabel sidestepped questions and criticism about his depiction of

Vincent's death, perhaps as a way to stave off any assertions that he took too many liberties with Van Gogh's biography. About the ending of *At Eternity's Gate*, Schnabel brusquely noted, "If he killed himself or if he didn't is irrelevant to me . . . I think, all history is a lie. If you watch the movie *Rashomon* [1950], you've got five different stories of the same event, so I would not get hung up on [what actually happened to cause Van Gogh's death]."

In my humble opinion, I find the tale spun by Smith and Naifeh in *Van Gogh: The Life* to be very intriguing, and the authors make a pretty convincing case. But it's really hard for me to buy it. I concur with Van Tilborgh and Meedendorp's statements about Van Gogh's fluctuating psychological state, particularly when you consider his long battle with depression. Depression is an utterly terrible condition and can make people consider things that they might have previously confirmed that they were morally opposed to. There's also the fact that he had attempted suicide before, during his stay at the asylum in Saint-Rémy. Given this knowledge, it doesn't seem like a stretch that he might have attempted it again.

All this being said, there's one more piece of information to tackle. In July of 2016, the Van Gogh Museum in Amsterdam held an exhibition called *On the Verge of Insanity*, which profiled the artist and his work through the lens of his purported madness and mental instability. As part of this show, curators included several artifacts central to the artist's life—and death.

The item that has received the most interest in the show? A small, rusted revolver. Was this the actual gun that killed Vincent van Gogh?

Maybe, maybe not. Nienke Bakker, the museum's curator of paintings, tackled this controversial inclusion in a press release, noting, "It [the gun] was found in 1960 in the field where Van Gogh shot himself and has since been in private care. Forensic experts studied the amount of corrosion, ultimately declaring the gun to have been buried underground between 1880 and 1910, fitting the range of when the artist took his life." Bakker similarly confirmed that the small size of the gun easily explains one of the strange facts of Van Gogh's medical examination: the lack of the exit wound. The handgun, he notes, was too small and too ineffective to properly kill a

human being, and any wound it would inflict, while eventually fatal, would not be so instantaneously.

Even this curatorial note still leaves me asking at least one more question. Bakker confirms that the gun was buried in a field in Auvers-sur-Oise. *But who buried it?* Was it simply covered up by ravaging elements, hidden through the eventual accumulation of dirt and debris? Or did the injured and suffering artist perform this as one of his final acts before trudging back to the inn? Or—of course—did someone else bury the gun?

That gun, incidentally? It went up for sale at a Parisian auction house in June 2019, where it sold for a whopping $183,000, more than $100,000 over its original estimate. And the "private care" in which the gun had been held for decades? It was confirmed to have been kept by the Ravoux family.

Ultimately, it really doesn't matter how Van Gogh died (and I'll rightfully admit that my writings here, well-meaning though they may be, may possibly add fuel to the fire of the "poor Van Gogh" myth). Murder, accident, or suicide—this isn't the most important facet of Van Gogh's life.

What *is* important is that this artist lived.

Though he passed away too early, Vincent van Gogh's flame burned amazingly bright, and he left behind many hundreds of incredible works of art that have not only inspired generations, but also changed the course of art history. His paintings combined his interests in nature with his deeply emotional and spiritual life, leading to works of art that are more expressive and psychologically profound than the subjects they illustrate. His style, too, has influenced some of the most important painters who came after him—his use of bright colors would later become a hallmark of the works of Fauvists like Henri Matisse; the flatness and abstraction of his landscapes would anticipate the German Expressionists; and his impulsive, thick application of paint would inspire the works of midcentury Abstract Expressionists like Jackson Pollock.

So much of twentieth-century art—and beyond—owes a great debt to Vincent van Gogh, and many, *many* books have been written extolling him

and his art, placing him in a hallowed (and heroic, and mythic) position. I think he would probably get a kick out of all the attention today. When he was alive, such discussion and fervor were still a dream fueled by hopes and passions. As he wrote, "By working hard, I hope to make something good one day. I haven't yet, but I am pursuing it and fighting for it."

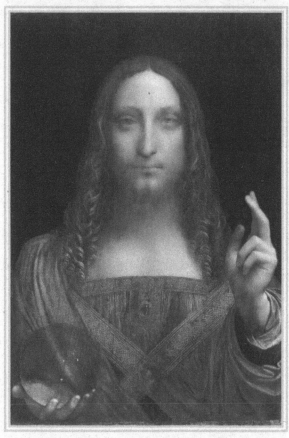

(Attributed to) Leonardo da Vinci, *Salvator Mundi*, c. 1500

CHAPTER 8

The Odyssey of an Oddity,
or the Many Adventures
of *Salvator Mundi*

Leonardo is the hamlet of art history whom each of us must recreate for himself.

KENNETH CLARK, HISTORIAN

If it really is a Leonardo painting, it has been incredibly unlucky. And if it isn't a Leonardo it's been incredibly lucky.

BEN LEWIS, CRITIC AND AUTHOR

In fall 2017, while browsing through my daily trove of art email newsletters at the North Carolina Museum of Art, I saw a headline that stopped me cold (and caused a near collision of my steaming mug of coffee with my lap). It proclaimed, "The Last Leonardo Comes to Auction," with the painting trumpeted by auction house Christie's as "the greatest and most unexpected artistic rediscovery of the 21st century." It was a revelation, a stunner, a surprise: sales of old master paintings of this caliber—especially works completed by high-profile, big-name artists from the Renaissance, like Leonardo da Vinci (1452–1519)—are exceedingly rare, as the artist is no longer alive to make more paintings (duh), and most of the works that have withstood the ravages of time—less than two dozen!—have long been relegated to private and public collections around the world. This was the art sale of a lifetime. My heart raced and my fingers fumbled over my computer's keys as I scrolled to read more.

A moment later, the atmosphere at my desk changed subtly. I squinted

at the screen, attempting to reconcile the odd sensation of disconnect between my eyes and the monitor, because the words Leonardo da Vinci did not seem to match up with the image paired with it: a hazy, bust-length image of Jesus Christ as *Salvator Mundi*, or the savior of the world, pictured head-on, with his left hand cradling a crystalline orb and his right elevated in a gesture of benediction. I couldn't explain why, exactly, but the image looked *off*, wrong, an approximation of a Leonardo da Vinci masterwork. Still, I shrugged off my discomfort—though a scholar of art history, it's not within my realm of qualifications to attribute authorship of old master paintings. I closed my browser and shook *Salvator Mundi* out of my head, turning back toward the realm of contemporary art, my day job playground.

Little did I know that this small painting was about to initiate an art-historical firestorm, and that concerns over its credibility would only be the beginning of this painting's bizarre (and ongoing) cultural journey.

Salvator Mundi wasn't always believed to be a Leonardo. *Salvator*'s provenance—its record of ownership through time—practically begs for a family tree–like diagram (my eyes boggled as I read its collection lineage, but Christie's provides a helpful timeline on its website, which makes things a bit easier). According to the auction house's experts, who obviously assert the painting's authenticity, "strong circumstantial evidence" points to the likely commissioner of this odd panel to have been King Louis XII of France in association with his consort, Anne of Brittany (though many are still unconvinced by the painting's possible royal lineage). Together, the couple targeted a painter—presumably Leonardo da Vinci—to realize their artistic vision. The exact date of the work is unknown, but most scholars ascribe its making to around 1500—slightly after Leonardo's Milan fresco of *The Last Supper* (1498, Santa Maria delle Grazie, Milan, Italy), and a few years before he began working on *Mona Lisa* (see chapter 5 for lots of goodies on Leonardo's most well-known painting). *Salvator Mundi* doesn't reappear in the history books for more than a century, until the 1625 marriage of French princess Henrietta Maria to King Charles I of England,

when the princess probably brought her family's painting to England as part of her dowry. In the mid-seventeenth century, England was embroiled in a civil war, and Henrietta Maria fled the country, leaving the painting behind to languish in her absence.

By 1651, *Salvator Mundi* had officially switched hands as part of a sale of royal property to repay the English monarchy's many debts. The sale's inventory called the work "a peece [*sic*] of Christ done by Leonardo" and noted its value as £30 (when adjusting for hundreds of years of inflation, the modern equivalent is approximately $5,800). After the ascent of Charles II to the English throne a decade later, the royal art collection—including *Salvator Mundi*—returned to the monarchy via parliamentary decree. It then remained in or adjacent to English royal collections for the next century, until a 1763 sale records its precipitous fall from the good graces of art history: though deemed "L. Da. Vinci A head of our Saviour" [*sic*] in sale documentation, its realized price was a mere £2.10 (the equivalent of $437 today) and it was sold to a commoner named John Prestage (what a travesty!). Its value had reached an all-time low, but its demotion was not yet finished.

When *Salvator* resurfaced in the early twentieth century, it was no longer a Leonardo. Sold to a country squire around 1900, it had been massively reworked and overpainted in order to "restore" it from poor health. Such subpar attempts at conservation had transformed the panel into a complete mess (examples of this early reworking can be viewed online, and oh man, they are *bad*. Okay, not *Beast Jesus* bad—see chapter 10 for more on that lovely painting—but terrible enough). Consequently, it was deemed the work of a follower of Leonardo named Bernardino Luini. A 1958 sale through a Sotheby's auction in London illustrates yet another reattribution, swapping in a second apprentice of Leonardo's studio—a man named Giovanni Antonio Boltraffio—as *Salvator*'s creator. It is sold for £45, or approximately $1,400 today, and as a beauty-challenged minor work by a middling artist, it fell out of the limelight yet again.

Art Attribution Angst

Attributing a work of art to a particular artist is not an exact science. Though it relies on meticulous research and historical documentation for support, a final appointment of authorship is often subjective, a choice sometimes based on emotion or gut reaction (for an interesting case of attribution and a timely fight for reattribution, see chapter 11). Historians and scholars are frequently left making their best educated guesses about artwork authenticity, and the results can be a real bummer to collectors or museums stuck in the middle. One of the most fascinating examples is the evaluations performed by the Rembrandt Research Project, a Dutch artistic and scientific collective tasked with confirming genuine works by the Dutch Golden Age painter Rembrandt van Rijn (1606–69). Since the project's kickoff in 1968, half of the Rembrandt paintings in the world— *half*, you guys!—have been demoted in attribution, now cited as works by students or followers of the master. This tragic yet common downgrading even occurred within my own institution: when *Young Man with a Sword* (c. 1633–45, North Carolina Museum of Art, Raleigh) first entered the museum's permanent collection in 1960, it was assigned to Rembrandt himself; now its ID label reads "Circle of Rembrandt van Rijn." This is an all-too-common fate for collections of Northern European art, but it still stings, and we curators die a little inside when we walk past our newly cheapened paintings, remembering what heights we had once attained. *Sigh.*

With the dawn of a new millennium came a reconsideration. Christie's catalog claims that *Salvator* was "discovered—masquerading as a copy—in a regional auction in the United States" in 2005 (a potentially leading statement if there ever was one), and its new owners, who purchased the piece for $10,000, "move[d] forward with care and deliberation in cleaning and restoring the painting, researching and thoroughly documenting it, and cautiously vetting its authenticity." The new owners were later revealed as a consortium of art dealers who worked in tandem with a who's who of

Italian Renaissance art historians, Leonardo specialists, and senior-level conservators to validate the work of art through historical research and scientific analysis.

Their meager investment and six years of toil really, *really* paid off.

With its inclusion in the blockbuster exhibition *Leonardo da Vinci: Painter at the Court of Milan* at London's National Gallery in London in 2011, *Salvator Mundi's* (final?) transformation was complete. Heralded as a long-lost masterpiece by Leonardo and the biggest revelation in art, its mere existence was met with a breathlessness and fervor that art dealer and Leonardo scholar Robert Simon, one of the work's co-owners, likened to winning "the art history equivalent of a gold medal." After a series of ultra-secret, high-dollar sales (first to art dealer Yves Bouvier for around $75 to $80 million, then to Russian oligarch Dmitry Rybolovlev for $127.5 million—the latter provoking a criminal complaint of price gouging, which seems almost laughable now), Christie's gleefully offered it up for its 2017 auction with a "pomp and circumstance surrounding the announcement [that is] a display of chutzpah rarely seen from Christie's—the auction house said it had not staged such an unveiling before," according to *ART-News*. This was an understatement, by the way: as Artnet.com reporter Timothy Schneider noted acerbically, "Christie's attempted to sex up the Jesus by installing *Salvator Mundi* behind a set of gleaming metallic doors, slid away by guards for a dramatic debut at the press conference." The effect must have been mesmerizing, though, and the press fell under the painting's strange, mystical spell as it hung alone on black-painted walls, as beautifully lit as a precious jewel in a display case. Through a flood of snapping camera shutters and the jostling of reporters, an artist who died five hundred years prior and his funky, murky Jesus became international front-page news.

Almost immediately after Christie's announced the impending sale of *Salvator Mundi* on October 10, 2017, the art world split into two warring camps: Leonardo versus Not Leonardo. A team of top conservators, curators, and scholars took to the press to praise the small panel (measuring 25

7/8 inches x 18 inches) as the last great work in private hands by the Renaissance master, with many recalling their intuitive knowledge of the painting's authenticity. University of Oxford professor emeritus Martin Kemp, a foremost expert on Leonardo da Vinci, described his first look at the work of art and his certainty of its attribution:

> [I]t was sitting on an easel, [a]nd I looked at it and thought, "Fantastic." . . .
> It was quite clear [that it was a Leonardo painting]. It had that kind of
> presence that Leonardos have. The *Mona Lisa* has a presence. So after
> that initial reaction, which is kind of almost inside your body . . . you
> look at it and you think, well, the handling of the better-preserved parts,
> like the hair and so on, is just incredibly good.

Kemp's physical reaction to the painting was matched by a practically religious wonderment in other commentators. In a brief 2017 video, art critic and broadcaster Alastair Sooke peers closely at the work's surface, his historical commentary broken by moments where a nearly spiritual sense of awe flits across his face. "It's really quite humbling," Sooke reveals to the camera. "I'm not remotely religious, but I find looking at this genuinely quite a moving thing."

Such a feeling of reverence was exploited by Christie's in their truly impressive marketing scheme. While the auction house did pursue traditional promotional methods (including the publication of a 174-page collector's edition catalog with academic analyses of the work's every nook and cranny, and close-up comparisons between *Salvator Mundi* and other Leonardo paintings that bear close similarities), it is their promotional video, titled "The Last Leonardo," that captures the rapturous effect of a work of art on an audience and makes a stunning impression. This four-minute advertisement—worthy of comparison to contemporary video art masters like Bill Viola—captures dimly lit people of diverse races and ages staring rhapsodically at *something* while accompanied by a soundtrack of swelling strings. Mesmerized, they gape, blink in slow motion, nuzzle babies, wring their hands, and hold back tears.

And you *never* see the painting, you guys. Not once.

(And in case you watch the video and do a double take: Yes, that *is* Leonardo DiCaprio in the mix, which is a sublime little in-joke. Plus, celebrity endorsement of any kind only adds to a brand's cachet, right?)

But even this near-religious level of veneration and expert-level credence couldn't drown out the dissenting din. It turns out that I wasn't alone in my initial discomfort and uncertainty about *Salvator Mundi's* authenticity. In response to the Christie's marketing assault, the internet was flooded with think pieces about whether or not the painting was a *real* Leonardo da Vinci. Museum curators and art historians came out of the woodwork the world over, calling the work problematic and dubious, citing the painting's oddly blurry appearance and Christ's awkward frontal posture—an atypical design choice for Leonardo, who patently favored a twisting motion in his figures. Even Jerry Saltz, the revered Pulitzer Prize-winning senior arts critic for *New York Magazine*, submitted his opinion on Vulture.com, unsubtly titling his editorial "Christie's Is Selling This Painting for $100 Million. They Say It's by Leonardo. I Have Doubts. Big Doubts." In one of the best segments of his wonderfully catty yet very serious critique, Saltz writes:

I'm no art historian or any kind of expert in old masters. But I've looked at art for almost 50 years and one look at this painting tells me it's no Leonardo. The painting is absolutely dead. Its surface is inert, varnished, lurid, scrubbed over, and repainted so many times that it looks simultaneously new and old. This explains why Christie's pitches it with vague terms like "mysterious," filled with "aura," and something that "could go viral." Go viral? As a poster, maybe. A two-dimensional ersatz dashboard Jesus.

Jason Farago, an art critic for *The New York Times*, felt similarly, and recorded his observations in a postsale, head-shaking screed:

Authentication is a serious but subjective business. I'm not the man to affirm or reject its attribution; it is accepted as a Leonardo by many serious scholars, though not all. I can say, however, what I felt I was looking

at when I took my place among the crowds who'd queued an hour or more to behold and endlessly photograph "Salvator Mundi": a proficient but not especially distinguished religious picture from turn-of-the-16th-century Lombardy, put through a wringer of restorations.

It didn't take long for the entirety of the planned auction of *Salvator Mundi* to achieve critical dissention. Soon *everything* was castigated, not just its potentially flawed attribution to Leonardo. Christie's flashy marketing tactics for what it deemed "the male *Mona Lisa*"—how gauche! The painting's proposed $100 million value—a price that high would automatically exclude any museum or public institution from attempting an acquisition, meaning the historic piece was destined to remain in private hands. The absolutely bonkers decision to include a Renaissance painting alongside twentieth-century works by the likes of Isamu Noguchi, Andy Warhol, Ellsworth Kelly, and Eva Hesse for a sale of postwar and contemporary art, or works dated from approximately 1945 up to the present! ("We felt that offering this painting within the context of our *Post-War and Contemporary Evening Sale* is a testament to the enduring relevance of this picture," explained Loïc Gouzer, then the chairman of Post-War and Contemporary Art at Christie's—a totally bizarre statement, considering that the painting was little known or lost for long periods of time, and was only reattributed to Leonardo recently. *How relevant could such a painting be, in terms of its effect on contemporary art and artists?* The real reason, in all likelihood? The contemporary art market is hotter than hell, and the sales of old master paintings aren't sexy enough to attract the attention of truly big spenders.)

And then an even crazier thing happened. In an action-packed bidding session that lasted an unheard-of nineteen minutes (almost the length of a standard sitcom episode, sans commercials), the November 15, 2017, sale of *Salvator Mundi* smashed the world record for the most expensive painting *ever* sold at auction, handily topping the price paid just two years prior for the newly declared runner-up: Pablo Picasso's *Les Femmes d'Alger (Version "O")* (1955, private collection), bought for $179.4 million. The final price paid by the anonymous winning bidder, including auction house

fees, was more than $450 million—far above that original $100 million estimate—and for a brief moment, all of us in the art world were shocked into silence.

That Other Famous Art Auction Moment: The Shredded Banksy

Notorious graffiti artist/art world renegade Banksy grabbed the biggest headlines in his career when, on October 8, 2018, he remotely triggered a shredder hidden inside a framed canvas version of his iconic stencil *Girl with Balloon* (2002). Just seconds after the work sold at Sotheby's for $1.4 million—a record price for the artist—half of the canvas was sucked into the shredder, appearing moments later in strips below its ornate frame. It was the ultimate Banksy ruse, and many people *loved* it—while others shook their heads, wondering, Why would an artist destroy his own creation? To make a point, of course. Banksy has maintained a complicated relationship with the commodification of his street art, benefiting from his rising visibility and marketability but also bemoaning that his creations now add fuel to the ever-skyrocketing contemporary art bubble. By destroying his artwork moments after it scored a major win for Sotheby's, Banksy seemed to say, *See? None of this—especially not money!— matters.* But the last laugh may be on Banksy. By intentionally destroying his work—and in such a public, meme-able way—Banksy raised the status of the work, now humorously retitled *Love is in the Bin*, from cool to totally seminal, most likely increasing its value for its new owner.

The silence didn't last long, though.

Our pal Jerry Saltz sprang into action on Twitter, declaring, "Christie's fishy da Vinci sold to a sucker for $450,000,000. Insiders have been emailing me saying 'Congratulations, you cost those crooks at Christie's $500,000,000.' Boom!! Christie's a hostel [sic] witness to art." Former

director of the Metropolitan Museum of Art Thomas P. Campbell posted his thoughts on Instagram, writing, "450 million dollars?! Hope the buyer understands conservation issues." And art adviser Todd Levin commented, "This was a thumping epic triumph of branding and desire over connoisseurship and reality."

All of this is enough to catapult *Salvator Mundi* into the world record books, as it is unlikely that its ridiculously high sale price will ever be beaten (unless another long-lost masterpiece surfaces. Which, I guess, is technically possible because it happened here, but is this a probable reoccurrence? Doubtful). And all of this is enough to maintain it as a controversial addition to the art-historical canon. But it's not the full story, or even the trickiest element.

What's even stranger is that we're no longer sure of the painting's location—nor who is truly responsible for its purchase and its reasons—as it hasn't been seen publicly since it was sold on that fateful November night in 2017.

Like a good therapist or human resources representative, auction houses like Christie's are dead serious about confidentiality. After the *Salvator Mundi* sale, the Christie's team confirmed the sale price but refused to provide the name of the individual or institution involved in its acquisition. This was not a surprise—such a lucrative sale would automatically thrust the bidder into an insanely bright spotlight, and a very critical one, given the ongoing Leonardo versus Not Leonardo debates. Hence, a second controversy was born: Who bought the work? Admittedly, it was fun to speculate from the sidelines: *Jeff Bezos used some of that sweet, sweet Amazon money to get it! A Chinese billionaire most definitely bought it! The National Gallery probably went halfsies with another American institution to make sure the work stays in a U.S. collection!*

Scarcely three weeks after the sale, though, a deceptively simple tweet dropped that revealed the artwork's expected destination, though not its purchaser: "Da Vinci's Salvator Mundi is coming to #LouvreAbuDhabi." This tweet, courtesy of the newly opened United Arab Emirates outpost of

France's famed Louvre Museum, was then parroted by the channel in two other languages—French and Arabic. Christie's tweeted its own congratulatory message, declaring that it was "delighted that the work will again be on public view," but that it had no further details to share with enquiring minds. So did the Louvre itself purchase *Salvator Mundi*? It seemed like a good fit, considering that it already housed Leonardo's iconic *Mona Lisa*, and holding its divine twin at its sister institution would provide a beautiful symmetry (and Leonardo loved symmetry!). Yet two weeks later, this rumor was dispelled by the Louvre's director, Jean-Luc Martinez. "Should we have tried to acquire it? The answer was no," Martinez asserted—though he eagerly revealed that he was already diligently pursuing the loan of the work of art for a planned 2019 exhibition commemorating the five hundredth anniversary of Leonardo da Vinci's death.

On December 6, 2017, *The New York Times* announced it had reviewed confidential documents that confirmed the *real* buyer: an obscure Saudi prince named Bader bin Abdullah bin Mohammed bin Farhan al-Saud. According to *The Times*, Prince Bader's interest in acquiring the painting almost felt spur-of-the-moment and strangely nonstrategic:

> Prince Bader did not present him[self] as a bidder until the day before the sale. He was such an unknown figure that executives at Christie's were scrambling to establish his identity and his financial means. And even after he had provided a $100 million deposit to qualify for the auction, the Christie's lawyers conducting due diligence on potential bidders pressed him with [a] pointed question: where did he get the money? Real estate, Prince Bader replied, without elaborating.

It was all played a little too cool, and Prince Bader—though undoubtedly grossly wealthy—was too much of a nobody to have pulled off such a cultural coup. On December 7, *The Times* again returned to the *Salvator* front, noting that both American and Saudi representatives confirmed that Prince Bader was really a stand-in for none other than Saudi Arabia's crown prince, Mohammed bin Salman. *Now* it was all starting to come together. As journalists David D. Kirkpatrick and Eric Schmitt asserted:

[Prince Bader] has no publicly known history as a major art collector, and no publicly known source of great wealth. But he is a contemporary, longtime friend and close associate of the crown prince, and prominent Saudi royals have been known to make high-profile purchases through straw buyers.

But even after this convincing confirmation, the back-and-forth mystery of *Salvator Mundi*'s ownership continued, much to everyone/no one's surprise. One day later, on December 8, 2017, the Saudi embassy in Washington released an official statement on its website denying the crown prince's involvement and providing an alternate explanation:

[T]he Embassy learned through information conveyed by His Highness's office that the art work [*sic*] was acquired by the Abu Dhabi Department of Culture and Tourism for display at the Louvre Abu Dhabi in the United Arab Emirates and that HH Prince Bader, as a friendly supporter of the Louvre Abu Dhabi, attended its opening ceremony on November 8th and was subsequently asked by the Abu Dhabi Department of Culture and Tourism to act as an intermediary purchaser for the piece.

Did it really matter, though, who owned the work of art? It was already being heralded—even if in a really, *really* low-key manner—by the Louvre Abu Dhabi as the feather in its cap. In June 2018, the museum amped up its enthusiasm with a splashier media takeover, confirming what had been awaited breathlessly: the painting's debut date. MASTERPIECE REVEALED: SALVATOR MUNDI 18-09-2018 screamed a specially created social media graphic, accompanied by a link to a press release announcing the long-awaited exhibition. In an interview with an Abu Dhabi English-language publication, the chairman of Abu Dhabi's Department of Culture and Tourism gushed, "This is a very important and exciting moment for Abu Dhabi as we witness a masterpiece by one of the most important artists in history coming to our city. Having spent so long undiscovered, this masterpiece is now our gift to the world and we look forward to welcoming

people from near and far to witness its beauty." Abu Dhabi was already fast-tracked to become an art mecca (even the Guggenheim is planning to open a collection there), set to rival Dubai. With the announcement of *Salvator*'s due date, though, it was about to explode into the cultural stratosphere.

And then it didn't. In September 2018—just two weeks before it was scheduled to debut the famous/infamous painting—yet another restrained announcement was made via social media: "The Department of Culture and Tourism—Abu Dhabi announces the postponement of the unveiling of Leonardo da Vinci's Salvator Mundi. More details will be announced soon."

If you thought that the announcement of the Abu Dhabi acquisition of *Salvator Mundi* was gigantic news, *this* one was even bigger. To cancel one of the most important and public art unveilings in recent memory—and a scant two weeks beforehand, no less!—was disastrous. It was a tough look for the museum, an embarrassment when the museum was already garnering plenty of negative attention for reported workers' rights violations during its construction. And providing no further details only made matters worse, because this signaled something peculiar—even nefarious!—was afoot. The art world, a large swath of which was already predisposed toward *Salvator* suspicion, got ultra nervous. And when neither the Louvre Abu Dhabi nor the Louvre proper answered repeated press inquiries regarding an updated timeline for *Salvator Mundi*'s unveiling, the situation got the full-on international conspiracy upgrade. *Why would Abu Dhabi delay its most valuable purported acquisition? Because it's totally fake, that's why!* declared the hordes of Not Leonardo advocates. *It's better that it is canceled now before exhibiting a knockoff Leonardo on its walls and generating even more embarrassment!*

Even as of the writing of this book, visitors can find no reference to *Salvator Mundi* on the Louvre Abu Dhabi's website. Curiously, the site doesn't seem to have an integrated search function, which means that tracking down details about *Salvator* isn't an option—and more tellingly, the museum has scrubbed the original press release from its pages. Following the release's link as originally posted on the Louvre Abu Dhabi's social media

channels produces a rather ominous-seeming 404 redirect. If you didn't know any better, you might never have known that there was any connection between the Leonardo and the Louvre Abu Dhabi.

It was almost as if *Salvator* had vanished. And to the general public, that's exactly how it looked. The main story surrounding *Salvator Mundi* shifted from "Is it a Leonardo or not?" to "Where did it go?"—and just as important, "Why did it disappear?"

Even amid the myriad controversies surrounding *Salvator*, France's Louvre Museum still wanted to play the Leonardo game, ever hopeful to include it as a crown jewel of their fall 2019 Leonardo anniversary exhibition. After a February 2019 article in the UK's *Telegraph* reported that the Louvre officially canceled its loan request amid authenticity concerns, a Louvre spokeswoman asserted, "I confirm the Musée du Louvre has asked for the loan of the Salvator Mundi for its October exhibition and truly wishes to exhibit the artwork. . . . The owner has not given his answer yet." That hope remained alive throughout the run of the show. Perhaps unsurprisingly, though, the painting never did appear during the much-publicized Louvre exhibition.

But did you catch that teeny-tiny little word from the spokeswoman? "*His* answer," she commented (emphasis mine). This turn of phrase ignited a firestorm yet again, as it seemingly confirmed that the Abu Dhabi Department of Culture and Tourism/Louvre Abu Dhabi had been shut out of the picture entirely, if they were ever really, truly involved to begin with. Suddenly ownership was shuffled back to a single individual, and all eyes turned back toward Saudi Arabia and Crown Prince Mohammed bin Salman. Yet almost two years after *The New York Times* first scooped the crown prince's involvement, bin Salman's name and interests no longer seemed so benign, particularly in the face of CIA allegations in 2018 that the prince himself ordered the assassination of Saudi dissident and *Washington Post* journalist Jamal Khashoggi. Combined with a slew of high-profile corruption arrests of senior Saudi officials purportedly commanded

by bin Salman, as well as a nationwide austerity edict, the crown prince has transformed into an autocrat who is derided both nationally and internationally. His alleged acquisition of the maybe-Leonardo panel is yet another strange show of might, this time led by the heft of the prince's wallet.

Don't Show His Face: Aniconic Traditions in Islamic Art (and a Possible *Salvator Mundi* Oops)

Amid the hullabaloo surrounding *Salvator Mundi*, there is another issue that's seldom discussed: the potentially offensive purchase of a painting of Christ by the figurehead of an Islamic nation. For an artistic rendition of Christ's face to make its home in a Muslim country is a solid taboo to many, especially ultraconservative followers of Islam, which teaches that visual representation of *any* god or prophet is akin to sacrilege. This *aniconic* tradition—the opposition, or even forbiddance, of idols or icons—lies at the heart of Islamic art, a tradition that values decorative and even symbolic elements over outright figural representation. While Muslims don't believe in Jesus as "the savior of the world," as the painting's title and subject matter assert— a subject already a point of contention for Muslims—Christ is nevertheless considered a prophet in the Muslim faith, and deserving of that same nonvisual respect. To exhibit a painting of his face *in* the face of a Muslim majority in Saudi Arabia, then, is considered bad news, and reports suggest that Mohammed bin Salman has ticked off the conservative elite of his home country via his pricey, blasphemous purchase.

In retrospect, the answer for Mohammed bin Salman's Leonardo acquisition is obvious. It's the same reasoning for Christie's marketing of *Salvator Mundi* during its Post-War and Contemporary Art sale, and the real motivation behind the ceaseless Leonardo versus Not Leonardo questioning.

It's not about public fascination with a work of art, or the enduring power of Leonardo da Vinci, or even the rarity of the reappearance of a high-caliber Renaissance painting. In fact, it's not about art at all.

It's really all about money.

Like the attribution of art, the valuation of a work—how much it is worth—can fluctuate, and can also be subjective, though some concrete factors may play into it: the fame of the artist; the rarity of the type of work; its subject matter and the like; as well as the size of the object itself and the value of similar pieces in the art market. Based on several of these elements, *Salvator Mundi* was already in a value class all its own, but the furious bidding that far outstripped the $100 million sale estimate catapulted it into superstardom at a new estimate of $450 million. By paying the priciest amount ever spent on a work of art—*overpaying*, actually—Mohammed bin Salman, by all accounts an art novice with little collecting experience, could prove his worth and his power. Leonardo's painting is merely a pawn, a symbol of the Saudi's ability to control the art market, long one of the hottest playgrounds for the global elite—and likewise, his ability to sway the global elite for his own purposes.

In an increasingly connected yet confusing world, it is easy—and fun!—to go all conspiracy-theory on the *Salvator*/Mohammed bin Salman connection. As recently as early 2019, some journalists—led by Zev Shalev of the independent news site Narativ.org—have placed *Salvator Mundi*, the Saudis, and Emirati royalty in the middle of the purported Russian conspiracy to rig the 2016 U.S. election in favor of Donald Trump (never mind the fact that the *Salvator Mundi* sale occurred more than a year after the election). But such connivances complicate the bottom line, as well as any probable reasons for the artwork's disappearance from public view. Today (as always), art is money, and money is freedom—if Mohammed bin Salman is indeed the owner of the costly panel, he would have been free to renege on his offer to lend it to the Louvre Abu Dhabi for any reason. Perhaps he thought it looked nice on his living room wall and wanted to keep it there. Perhaps—as indicated in rogue reports in summer 2019—he needed something to spruce up his 440-foot-long super yacht, the *Serene*, and has opted to store it there in what would be a concerning move (you're housing a

fragile painting on *water*, for goodness sake—what insurance company in their right mind would cover that?). Or perhaps he, too, had concerns about his purchase's authenticity and decided to squirrel it away—but probably not.

If I am to allow myself any conspiracy theory at all, it's one that is purely financially motivated. Pulling *Salvator Mundi* off view was a strange move, but most likely wasn't due to any lingering or growing concerns over its authenticity. In fact, I would even assert that the Leonardo versus Not Leonardo scandal may have been a red herring all along, as its final purchase price effectively renders the point moot: *It doesn't matter if the painting is really a Leonardo; it is being valued as one nonetheless.* Its disappearance, though, has done something amazing: it's kept *Salvator* in the news years after its record-breaking sale. As art historian Bendor Grosvenor mused in *The Art Newspaper*, "The value of a Leonardo . . . is best measured in column inches. And what better way to boost the star power of *Salvator Mundi* than by making it 'disappear' for a few months?" And he's right. Keeping the work of art in the papers, websites, periodicals, and scholarly journals only ups its credibility and fame—and therefore its financial worth.

When *Salvator Mundi* resurfaces into the public eye once again—and I'm sure it will—it may or may not be attributed to Leonardo da Vinci, continuing the same roller-coaster ride that it has survived for the last five hundred years. But it will be marketed, with the greatest of fanfare, as the most expensive work of art to ever grace the world, recently "lost" after its lucrative sale and now available (I hope!) for all to see.

Just don't forget to buy a souvenir postcard on your way out, in case it disappears again.

The
Strangely
Wonderful

Hilma af Klint, *The Swan, No. 12, Group IX SUW*, 1915

Séances and Surprises:
The Spiritualist Women Who
Invented Modern Art

The true work of art is born from the "artist": a mysterious, enigmatic, and
mystical creation. It detaches itself from him, it acquired an autonomous
life, becomes a personality, an independent subject, animated with a
spiritual breath, the living subject of a real existence of being.

WASSILY KANDINSKY, ARTIST

But there is . . . a record showing that she [Hilma af Klint] is making these
amazing canvases before all the other artists even though they're all steeped
in the same ideas moving around society.

TRACEY BASHKOFF, CURATOR

There's almost nothing more that art historians love to do (besides
looking at art) than to argue about art and artists. It plays out at every
university and conference worldwide: who was the so-called father of
modern art, Gustave Courbet or Édouard Manet? (Tough call, I say—can
we crown them as cofathers?) Who was the more important artist, Pablo
Picasso or Henri Matisse? (I like Matisse better personally but understand
Picasso's groundbreaking significance.) But many of these arguments pale
in comparison to one of the biggest questions in the art world: Who was
the artist who created the world's first piece of abstract art—a work dedi-
cated solely to color, or pattern, or shape, or gesture (or all the above!) in-
stead of a recognizable subject matter drawn from life? Who invented
abstract art, which begat Modernism as we know it?

An early adopter of both abstraction *and* arguing about the founder of abstraction was Wassily Kandinsky (1866–1944), who was so invested in proving *himself* as the pioneer of the form that he wrote a letter to his art dealer in 1936 to stake his claim about a painting created twenty-five years earlier called *Komposition V* (*Composition V*, 1911, private collection). About this painting, Kandinsky wrote to his Berlin-based dealer, J. B. Neumann, "It really is the very first abstract painting in the world because in those days there was no other artist who painted abstract pictures. Therefore it is an 'historic painting.'"

Komposition V is a monumental achievement, a huge work (6 feet x 9 feet!) filled with thick black lines and swirling colors. There are moments where a Rorschachian need to find a recognizable image takes over—*Is that a person standing in profile in the lower-right corner?* I ask myself. *And over there—is that a bird?* But for all my questioning and squinting, the answer is always the same: there's no subject, or object. The painting is what it is—a thrilling blast of color and line so vivacious that your eyes can't possibly stay still long enough to focus on any single detail. It's amazing. And Kandinsky is right: if it was the world's first abstract picture, it would indeed be "an historic painting," and for decades it was celebrated as such by many art historians.

But what if it isn't the world's first totally abstract painting? And what if Kandinsky wasn't the first abstract artist?

Let the arguments begin.

This question of the birth of abstraction seems small—perhaps even pointless—at the outset, but it has big consequences. First, it would have been a ballsy move for an artist to paint for the sake of painting, not for representation or storytelling purposes. So consider how freeing this must have been, too, for artists in the early twentieth century: *You want to paint a canvas with a blob of red paint in the center? Go for it! You don't need to pretend the blob is a flower or a face anymore!* And it's not an exaggeration to note that the move toward pure abstraction at the beginning of the century paved the way for the likes of Mark Rothko, Jackson Pollock, Helen

Frankenthaler, Agnes Martin, Gerhard Richter, and thousands more of the biggest names in art over the past century. Just as the invention of oil paint revolutionized the medium centuries ago, the development of abstract art changed the course of art history though our contemporary era.

Although abstraction might be considered a hallmark of twentieth-century aesthetics, its roots took hold in the nineteenth century. In the last decades of the 1800s, many notable artists were preoccupied with experimentations aimed squarely at challenging the tried-and-true traditions associated with painting—think Paul Cézanne's flattened landscapes that distort space, or Claude Monet's myriad works detailing the effects of light (see chapter 1). Though these artists didn't create abstract art per se, with these experimentations they established a visual precedent for tweaking the appearance of a subject in order to progress beyond the limits of Realism. As such, their images were *abstracted*. No longer was it necessary to paint a mountain exactly as it was seen with the naked eye; instead you could represent it based on your emotions or your personal perception of it. "Painting from nature is not copying the object; it is realizing one's sensations," Cézanne once famously said. The irresistible siren calls toward total abstraction had begun, though it would take a generation to fully blossom.

A fascination with moving beyond the limitations of sight was not only in vogue in the art world in the late nineteenth century, it also infused other realms of Western society, buoyed by the optimism and the massive change brought on by the Industrial Revolution. Imagine the promise and the excitement of this period, where *anything* could happen. Indeed, the world felt new, jazzed up by scientific discoveries and dazzling inventions of the era and the decades that followed. Fossils! The electric light! Photography! X-rays! The *atom*, for goodness sake! The invisible was suddenly made visible thanks to these developments, and such previously unfathomable achievements brought more questions to the surface: *What else might we not be seeing? What lies beyond the scope of our vision?*

These questions, to be fair, have always been asked, regardless of scientific advances—but until the nineteenth century, their answers were typically only guessed at, or asked within a particular context: religion. Some

might think it odd that the same half century that begat a great rush
of scientific advancement also produced a resurgence in religious—
particularly Protestant—evangelism. When viewed through a capacity of
curiosity, however—*what lies beyond the scope of our vision?*—it doesn't
feel like such a stretch. In fact, this mode of questioning had long been the
purview of religious faith. And as many nineteenth-century societies
shifted in ways previously unimaginable—with the dissolution of tradi-
tional communities at the behest of urbanization, for example—people
were undoubtedly uneasy. They needed something to assuage their fears,
something bigger to believe in. Hence there was a notable uptick in reli-
gious fervor during this era.

In the mid-1800s, however, an all-new belief system—some even called
it a religion, though others balked at the term—combined fascination with
the spirit world and in the "proof" of its existence via communication with
the dead: Spiritualism. Spiritualism, a popular movement whose followers
believed in the ability to communicate with otherworldly beings, began in
the 1840s with the table rappings of the infamous Fox Sisters, who claimed
a direct line of contact with ghosts in their purportedly haunted home in
Hydesville, New York. As their fame grew, so did the concept of Spiritual-
ism as a whole—Spiritualism provided a tempting link between science
and religion, adopting aspects of both to create a hybrid doctrine combin-
ing connection to the afterlife with tangible proof of that afterlife. Even
after one of the Fox Sisters confessed in the 1880s to perpetrating a "rap-
ping" hoax, the belief system continued to soar in popularity for several
decades to come, inspiring curious minds from Queen Victoria, Pierre
Curie (husband to Marie, who was notably skeptical), and Arthur Conan
Doyle, creator of Sherlock Holmes.

In truth, Spiritualism—though defined, codified, and popularized in
the 1800s—has long been a great influence in art history. Artists have fre-
quently claimed a touch of some unknown, intangible force guiding them
toward creation; the ancient Romans believed in the existence of creative
spirits, or *genii*, who inhabited the walls of an artist's home or studio and
secretly shaped the outcome of a work of art (the transference of the term
genius from a spirit to an artist himself/herself is a meaningful one as art

became more of an individual, glorified undertaking during the Italian Renaissance). Even Albrecht Dürer, the supreme German Renaissance painter, printmaker, and draughtsman, believed that his own self-portrait (1500, Alte Pinakothek, Munich) was divinely sanctioned, a notion further highlighted by the artist's decision to model his appearance and gesture on medieval depictions of Christ. In each case, spiritual or divine inspiration motivated an artist toward action. At the height of Spiritualism's rise, however, there came a twist to this time-worn concept: What if an artist was merely a vehicle for a *spirit's* artistic creations? *Ghost art*, you may mutter snidely, and I hear you: it seems a bit far-fetched, to say the least. But some Spiritualists claimed that they were creative vessels for the dead, producing works of art not of their own accord, but of a ghost's. As if that's not interesting enough, two of the most prominent Spiritualist artists may have even made history, with the help of their otherworldly, artsy guides.

The Spooky Side of Surrealism

Surrealist art burst onto the scene in the early twentieth century as a way to free the untapped creative powers of the unconscious mind—think the brain-bending eye candy of Salvador Dalí's melting clocks. But it wasn't just about going beyond reality—it also engaged in the otherworldly. The world of the occult played a large role in the development of one of art's most mystifying movements. Surrealist founder and leader, André Breton, consulted clairvoyants before beginning the creative process; Swiss artist Kurt Seligmann famously performed a magic ritual to "summon the dead" at a happening in 1948; Breton and several pals created their own deck of tarot cards in 1940–41. This interest in belief beyond the rational fits perfectly within Surrealism's aims: to challenge society's traditional ways of seeing and understanding the world.

In the summer of 1871—when Wassily Kandinsky was but five years old and toddling around Odessa—Georgiana Houghton (1814–84) was busy

preparing for the opening of her very first art exhibition, *Spirit Drawings in Water Colours*, to be held at the New British Gallery on London's Bond Street. The prolific artist, a relative unknown at age fifty-seven, had prepared 155 intricate watercolors alive with swirls of bold color and magnificently layered spiral forms, like tiny vortices meant to draw the beholder into their roiling centers. Houghton had toiled for ten years to complete her works, and she was ready to share them with the world—but the world didn't seem too ready to receive them. Having had trouble finding a gallery receptive to presenting her works, she rented the New British Gallery with her own meager funds and produced her exhibition independently (gotta love the confidence of this woman!). Everything was carefully considered: the layout of the exhibition, the frames Houghton rented specifically for the occasion, even the self-produced catalog replete with an introduction to Houghton's symbology and artistic philosophies. For four months, she championed her own work, even spending five days a week—from 10:00 a.m. through 5:30 p.m.!—in the gallery, chatting up visitors and offering detailed explanations of her work.

For the most part, it did not go well.

A significant reason behind the exhibition's failure was the artwork itself: though artistically proficient and technically stunning, her paintings were strange and unknowable to the general public. Take, for example, Houghton's 1861 painting, *The Eye of God* (Victorian Spiritualists Union, Melbourne, Australia), whose imagery is explained by Victorian scholar Rachel Oberter as follows:

[W]e see a tangle of transparent straight, wavy, and spiraling lines flowing out of the left corner of the paper and up from the bottom edge of the page as white filaments float across the surface. No recognizable forms appear; all that is visible are lines and colors—yellow, sepia, and blue. There is an organic quality to the undulations, a sense of microscopic detail, and a feeling of being in a deep-sea world or otherwise mysterious place. The vagueness of the imagery contrasts with the specificity of the title, which evokes a dense underlying symbolism.

Criticisms of Georgiana Houghton's paintings were fierce: one reviewer even said, "If we were to sum up the characteristics of the exhibition in a single phrase, we would pronounce it symbolism gone mad." Likewise, London's *Daily News* compared Houghton's spiral scenes to "tangled threads of coloured wool," ultimately deeming them as "the most extraordinary and instructive examples of artistic aberration." Even a review that seemed positive on the surface—*The Era*'s arts critic called the show "the most astonishing exhibition in London at the present moment"—was a veiled denunciation: it was astonishing in its inscrutability, its bizarreness. Of the 155 paintings in the show, Houghton sold only one, and the cost of the exhibition was so great that it brought the artist to the brink of bankruptcy.

To be fair, the dueling artistic vogues in London during this time were the early stirrings of Impressionism—still a barely known entity—and the intricately detailed, narrative-based paintings of the Pre-Raphaelites, each of which was representative (and in the case of the Pre-Raphaelites, figurative). This was particularly true of the Pre-Raphaelites who favored images of "serious subjects"—love, death, poverty, fine literature, mythology—produced with over-the-top Realism. (A wonderful example, Sir John Everett Millais's gorgeous *Ophelia* [1851–52, Tate Britain, London], presents the *Hamlet* character's suicide with such detail that botanically minded viewers can easily identify the luscious flowers that surround her.) Georgiana Houghton's work was the opposite of these popular styles, so it is of little surprise that it was met with such disdain. And yet Houghton's oddball, nonrepresentational images were only part of the problem. The other half was her inspiration for her paintings: they stemmed, she wrote, from numerous spirits who took over her brush, effectively using Houghton as a medium. *She* didn't paint these, Houghton declared—*spirits* did, and she deemed her works "spirit paintings" so as to make their genesis perfectly clear.

Born in 1814 in Las Palmas de Gran Canaria (Canary Islands), Georgiana Houghton was the seventh of twelve children born to Mary Ann and

George Houghton, a merchant who traded in wine and brandy. Little is known of Georgiana's early life, except that art—especially painting—was of prime importance to her; she trained as a painter, dedicating much of her young life to her craft while living, unmarried, with her parents. However, upon the death of her younger sister Zilla, in 1851, Georgiana was so distraught that she gave up painting entirely to mourn Zilla's loss. Years passed, until her life changed dramatically in 1859 when a cousin informed her of the work of a nearby neighbor, "by whose means the spirits of those we had lost could communicate with use who were still remaining." Intrigued, Houghton attended her first séance and was stunned to receive "spirit-communication" from Zilla via a series of table-tapped messages. These messages, Houghton later reported in her autobiography, *Evenings at Home in Spiritual Séance* (originally published in 1881, Trübner & Co., London) were awash with details that only the sisters could have known; Houghton, thus, was convinced of the ability of Spiritualist activities to connect the living with the spirits of the dead and to foster communication via individuals as mediums.

For two years, Houghton immersed herself in the world of noted Spiritualists, engaging in table tapping, transcribing messages brought forth via the use of a planchette (Ouija board precursor alert!), and eventually becoming a medium herself, aided by "a guardian band of seventy archangels" whom she identified by name: Ezimor, Gliovus, Minax, Jarno, and the archangel Gabriel, among others. Houghton—an Anglican with a strong belief system—saw Spiritualism as many adherents did during the Victorian era: as an add-on to her Christian faith, not as a deterrent. In 1861, her archangel guardians inspired her to attempt a new manner of message translation, not through words but through images. Attaching a series of colored pencils to her planchette, Houghton created her first "spirit drawing" and began styling herself as a "drawing medium."

To Capture a Ghost: Spirit Photography

The birth of photography in the nineteenth century was a revelation: a way to record everyday moments and create art in an utterly new and modern manner. To many, though, the photographic process was mysterious, more a conjuring than a chemical process. This sensation—that photography was strange or unknowable—was easily exploited and gave rise to a trend known as spirit photography in the latter half of the century. Artists and mediums, such as the pioneering spirit photographer/charlatan William Mumler, claimed the ability to capture a ghost's image, which could then be purchased (for a pretty penny, naturally) by the deceased's family. In the United States—a country still reeling from the ravages of the Civil War and grieving en masse for its lost sons—spirit photography soared in popularity, providing solace in small doses. Even those in society's upper echelons were not immune to the allure of spirit photography: one of Mumler's most famous clients was Mary Todd Lincoln. For her, Mumler produced a surreal image of the pensive widow alongside her husband, who had been assassinated five years prior. Honest Abe, insubstantial and hazy, appears to rest his hands on her shoulders, reassuring and calming. Alas, Mumler was merely capitalizing upon photography's numerous quirks—particularly double exposures and light reflection—and not really summoning the dead. And yet a question arises: If Mumler's ruse provided any modicum of comfort to the bereaved, does it minimize the despicable nature of his manufactured images?

While many Spiritualist adherents in the nineteenth century claimed a connection to angels, spectral guides, or other supernatural beings, Georgiana Houghton alleged a relationship with a particular set of spirits, in addition to her archangel guardians, who visited her during her drawing sessions: two famed Renaissance painters, Antonio Correggio and Tiziano Vecellio (known as Titian). These renowned artists, Houghton claimed, were the true authors of many of her works of art, using her simply as a

go-between who facilitated the holding of a brush or pencil. Her own artistic training, combined with her gift as a medium, made her an ideal candidate for communion with these Renaissance greats, which she proudly proclaimed on the back of her drawings. For *The Eye of God*, Houghton reported Correggio's influence, writing on the image's reverse, in part, "God is essentially omniscient . . . [Correggio] endeavored through Georgiana's hand, to represent The Eye of God, the Three Persons of the Trinity, with the Ever Watchful Eye looking down on man's most trifling acts as well as his more important ones, and seeing at the same time the consequences of them." Most of these inscriptions are in the first person, lending them the feel of automatic writing, guided not by Houghton's consciousness but through that of the spirit's: *The Eye of the Lord* (c. 1864, Victorian Spiritualists Union, Melbourne, Australia) is similarly described with a lengthy introductory sentence: "I, Tiziano Vecellio, have been permitted through the hand of Georgiana to represent, as well as I have been able, the Ever Watchful Eye of the Lord." As such, these artworks form a perfect and personal Holy Trinity for Georgiana: an equal play between her solvent Christian faith, her dedication to her mediumistic calling, and her passion for the visual arts.

Houghton was adamant that her spirit drawings be shared with a wide audience so that others would be inspired by her messages and find strength, as she did, in her religious convictions. For ten years—between 1861 and her 1871 exhibition—she held weekly afternoon receptions, opening her home to visitors every Wednesday to view her drawings and discuss her Spiritualist philosophies. As she wrote in *Evenings at Home in Spiritual Séance*, these receptions reflected her wish to relay "[w]hat the Lord hath done for my soul by granting me the Light now poured upon mankind by the restored power of communion with the unseen." Alas, it seems that she reached relatively few minds with her message. With the commercial disaster of her self-funded exhibition and an unfortunate, misguided friendship with the discredited spirit photographer Frederick Hudson, her work and ideas came under intense scrutiny as the Spiritualist movement began to lose steam, and she rejected both art and spirit

communications for several years, only producing the occasional spirit drawing. After her death in 1884 at age seventy, Houghton fell into obscurity, as many women artists do, and today, only around fifty of her works have been identified.

Like Houghton, another woman lingering on the fringes of art history—this time, a contemporary of Wassily Kandinsky—has an additional claim to the title of a "pioneer of abstraction." Hilma af Klint (1862–1944), a long-forgotten Swedish artist, is a recent art world darling thanks to a record-breaking 2018–19 exhibition at the Solomon R. Guggenheim Museum in New York, *Hilma af Klint: Paintings for the Future*. The exhibition became a word-of-mouth sensation and attained the status of the highest-attended exhibition in the Guggenheim's sixty-year history, welcoming more than six hundred thousand visitors in six months and breaking records for corresponding catalog sales (the last record holder in that department? A 2009 catalog on none other than Wassily Kandinsky).

Born in Stockholm in 1862, Hilma af Klint was the fourth of five children born to Captain Fredrik Victor af Klint, an admiral and mathematician, and his wife, Mathilda Sontag. In the early 1880s, she began attending a technical school that emphasized courses in portrait painting; she would later graduate with honors from Stockholm's Royal Academy of Fine Arts with the intent to become a traditional landscape, portrait, and botanical painter—genres of art that were considered of lesser importance than mythological, religious, or history painting, and therefore much more suitable for a woman to pursue (see chapter 2).

During the same period that af Klint was immersed in her artistic studies, she experienced a personal loss similar to Georgiana Houghton's: the death of her sister, Hermina, in 1880. Like Houghton's loss of her sister Zilla, Hermina's death caused af Klint to seek out séances with hope of communicating with her deceased sibling, and like Houghton, she came away convinced of Spiritualism's veracity. The links between Hilma af Klint and Georgiana Houghton are surprising, their stories running parallel in

multiple ways yet separated by a couple of decades and by thousands of miles. From all accounts, it appears that neither of these women were aware of the other, nor of each other's works.

Soon after her introduction to Spiritualism, Hilma af Klint established a sisterhood with a group of like-minded women who held weekly séances to contact spirits they referred to as the High Masters. These women, who called themselves *De Fem*, or *The Five*, translated their séances in meticulous notes and identified six major masters whose messages they intercepted: archangels named Amaliel, Ananda, Clemens, Esther, Georg, and Gregor. According to af Klint, it was Amaliel who, during a séance in 1906, instructed her to "paint on an astral plane" and represent "the immortal aspects of man." To af Klint, this was akin to an artistic commission, which she deemed "the great commission, which I carried out in my life." Up to this point, af Klint had engaged in the creation of a few automatic drawings during her séances with The Five, but Amaliel and Ananda essentially asked her to up the ante, much to the chagrin of her cohort, who, according to Guggenheim curator Tracey Bashkoff, "warned af Klint that the intensity of this kind of spiritual engagement could drive her into madness." Nevertheless, af Klint persevered and began the most ambitious project of her life, which would ultimately produce nearly two hundred spiritually inspired paintings: a series called *Paintings for the Temple*.

The eponymous temple of af Klint's series is an imaginary one, a vision conceived by the artist as a rounded space with a spiral path wherein seekers could forge a spiritual journey (how eerie and wondrous that her major solo exhibition should be held in the Guggenheim, of all places, known for its famous architecture built upon Frank Lloyd Wright's spiral design!). Through her dealings with the High Masters, af Klint conceptualized her spiritual path as a combination of Christian tenets, occultist beliefs, and scientific research, even including bits and pieces of Buddhist and Rosicrucian thoughts—and her paintings, acting both as decoration for this temple and as the spiritual pathway to the temple itself, codified her notions.

Af Klint's early rush of inspiration, in the years from 1906 to 1908, produced nearly half of her *Temple* paintings, though their degrees of abstraction varied severely from one year to the next. An early subseries of the

Temple, called *Primordial Chaos*, presents viewers with an array of blue-and-green jewel tones that recall af Klint's background as a botanical illustrator: quick glances at the *Chaos* works, such as *Group 1, Primordial Chaos, No. 13* (1906–7, Hilma af Klint Foundation, Stockholm), show a preoccupation with the natural world, summoning thoughts of snail shells, twisting vines, writhing snakes, and lots of large-bloomed flowers (can she be viewed, then, as a precursor to Georgia O'Keeffe too?). About her process, she claimed, "The pictures were painted directly through me, without any preliminary drawings and with great force. I had no idea what the paintings were supposed to depict; nevertheless, I worked swiftly and surely, without changing a single brushstroke." Af Klint, it seems, painted like a woman possessed—like Georgiana Houghton, she was the medium for an otherworldly artist.

As Hilma af Klint developed her conceptual vocabulary, not only did her paintings change, but so did her alignment with her masters. While in 1906, she noted in her journal that "Amaliel draws a sketch, which H [Hilma] then paints," by 1907, she had begun to take some agency over her images, declaring, "It was not the case that I was to blindly obey the High Lords of the Mysteries but that I was to imagine that they were always standing by my side." In 1908, she paused her work on *Paintings for the Temple* in order to care for her mother, who had recently gone blind. This break lasted a long four years, but upon her return to painting in 1912, she, in the words of Guggenheim curatorial assistant David Max Horowitz, "was in conscious control of [her paintings'] execution . . . she no longer experienced an external spirit acting through her. She instead perceived messages that she decided how to interpret and express in her paintings, bringing her more closely in line with traditional conceptions of art-making."

During this phase, up until the cessation of her mediumistic painting, af Klint's paintings grow simpler in structure, filled less with identifiable objects or symbols derived from the natural world and taking inspiration, instead, from geometric shapes. Shapes that began as framing devices in

her *Tree of Knowledge* paintings from 1913 on, for example—built out of circles and radiating lines—become the primary focus in later series like *The Swan, No. 12* (1915, Hilma af Klint Foundation, Stockholm). *The Swan, No. 12* is a beautiful distillation of shape and texture, paring down af Klint's early rambunctious symbolism. Perhaps linked to the artist's personal separation from her spirit guides, these paintings grow not only increasingly minimal, but also cleaner—her lines are thinner and sharper. I can't help but muse that works painted in her possessed state are messier, made with a greater sense of urgency; under her own influence, af Klint was thoughtful and more purposeful, and sparser in her iconography.

Hilma af Klint completed *Paintings for the Temple* in 1916, and by 1917, she had given up mediumistic creation altogether, though she continued painting of her own accord for the remainder of her life. Many of her later paintings, though not inspired by the High Masters, are nevertheless similarly abstract, trading in the same symbolically heavy details as before and inspired by an additional interest in theosophy. She even veered back, gradually, toward figural representation, creating watercolors of birds and plant life in between her geometric experimentations. But her ongoing relationship to the spirit realm—and the paintings inspired by her High Masters—she kept stowed away and shared with only a select few. In this manner, she was rather different from Georgiana Houghton, who craved dialogue with others.

Historians often point to a significant event in af Klint's life that would affect her remaining years: a 1908 meeting with the Austrian philosopher and leader of the esoteric Anthroposophy religion, Rudolf Steiner. Steiner, whose personal beliefs were modeled on theosophical tenets, was a remarkable luminary in af Klint's mind, and feeling emboldened by their shared interest in both science and spirituality, the artist found the courage to share her artwork. Sadly, their meeting only ended in disappointment for both: Steiner not only misunderstood her (admittedly convoluted) symbology, but also questioned her role as a medium, declaring her lack of agency a weakness. Such assessment must have been devastating to af Klint considering her high esteem of Steiner and may have additionally contributed to her four-year absence from painting. It may further explain her

declaration of authorship as time progressed, as she sought to position herself as an independent creator once and for all.

Curiously, a second assessment of Steiner's made an even larger impression: Steiner suggested that af Klint's work be hidden away until fifty years had passed, sure in his estimation that they would not be well received or appreciated. Af Klint took this to heart and appears to have only exhibited her paintings once: at an Anthroposophical conference in London twenty years later, in 1928. Little information remains of the reception of this London show, but an entry in af Klint's 1932 journal stipulated that her works remain hidden from public view for twenty years after her death, a request that was then translated into her will. When af Klint passed away at age eighty-one in 1944, her wish was honored, and perhaps it was carried out a little too well: her paintings were not shown again publicly until they were included in a 1986 group exhibition at the Los Angeles County Museum of Art, called *The Spiritual in Art: Abstract Painting 1890–1985*. Knowing of the artist's current superstar cachet and record-breaking power, it seems almost unfathomable that she was practically unknown thirty years ago.

Given the outsider status assigned—with good reason—to Georgiana Houghton and Hilma af Klint, as well as their relatively recent (re)discoveries by the art world and beyond, some have questioned these women's roles as the pioneers of abstraction. In the comments section (which I typically avoid!) of an online article on Smithsonian.com dedicated to reviewing the Guggenheim's af Klint exhibition, one user commented that "af Klint was certainly ahead of her time, but given that she sequestered her beautiful work on the suggestion of Steiner, could you really call her a pioneer? What other artists (abstract or otherwise) were aware of, let alone inspired by, her work?" I understand this impulse, the need to draw a family tree from a progenitor down to the descendants of a particular style—it's an impulse that's practically inescapable in art history as we grasp for straws of influence. Cézanne begat Picasso, Warhol begat Jeff Koons, and so forth. True, my example here is a (snarky!) simplification, but you get the gist. This need does beg a broader question: Does a pioneer, or any purported "first,"

require a following to confirm her, or his, status? In this case, should we not proclaim Houghton and af Klint as originators of abstraction if most of the world has, until recently, been unaware of their work?

While these are valid comments, I can't help but point out the gendered nature of these discussions. Would these same questions be lobbed at a recently (re)discovered male artist? Is dethroning an acknowledged master—itself a gendered term!—like Wassily Kandinsky the problem, or is any bias against Houghton or af Klint based on sexism? If so, the same systems of repression that have long thwarted female artists (see chapter 11) might still be at play today, if on a subconscious level. It leads me to wonder, perhaps cynically, if this bias had any effect on af Klint and Houghton's proclamations as mediumistic artists. By asserting their works as "created" by otherworldly beings, both artists could have hoped, in some small way, to subvert the prejudices against women artists. This feels especially possible in Georgiana Houghton's case—not only was she simply a medium for her spirit guides, but her spirit guides, in some cases, were incredibly renowned and known entities: Correggio and Titian. These men, she said, used her as their translator—no, a woman wasn't the artist here! As such, it's not dissimilar to Amantine Lucile Aurore Dupin's (defensive?) adoption of a male nom de plume; any criticisms of George Sand's writings, then, would have been based on the author's writings, not on her gender.

Did Women Actually Invent ART, Period?

Recent scientific analyses posit that the majority of prehistoric cave painters—the world's first known artists—were *women*, not men. In 2013, archaeologists from Penn State University released a report concluding that approximately 75 percent of cave art was created by women. How did they come to this conclusion, you ask? By studying the length of fingers in extant handprints found in caves throughout France and Spain—and how those finger lengths are relative to one another. Here's an anatomical deep dive: typically, women tend to have ring and index fingers of about the same length, whereas men's

ring fingers tend to be longer than their index fingers. In examining ancient handprints, then, women are the artistically driven of the caveman set. So while the big names of art are mostly celebrated men (Michelangelo, Picasso, Leonardo), it's exciting to think that perhaps we wouldn't have gotten anywhere if women hadn't done it in the first place.

A secondary criticism of the move to proclaim Houghton and af Klint as the mothers of abstraction is based on another niggling factor: symbolism. Some have quibbled that these women cannot be considered pioneers of abstract art, as their works are suffused with motifs—however abstract— that imply religious or philosophical intent or meaning. Art educator Fred Ross of the Art Renewal Center (Port Reading, New Jersey), writes, "For modernists, 'abstract' means 'non-objective' or 'non-representational' or 'non-figurative'. For them, abstract means that which does not have any meaning outside of itself. In a very real sense 'abstract' modern art is actually meaningless." This is a strange statement, and one with which I heartily disagree, and perhaps Mr. Ross and I differ on our own definitions of *meaning*. But even when considering an abstract painting by Jackson Pollock, for example—all rhythmic splatter and splashes of color—who's to say that there isn't any kind of meaning therein? Or what about Kazimir Malevich's infamous *Black Square* of 1913 (State Tretyakov Gallery, Moscow, and itself at the center of a long-standing dispute with Kandinsky's camp over this very same "world's first abstract" argument). It's abstract, yes, and it's just a black square, sure—but it, too, was suffused with a new kind of spiritual or symbolic meaning with Malevich's original display of the piece in the upper corner of a gallery wall, purposefully mimicking the placement of traditional Russian icons. Must an abstract painting mean nothing at all to be abstract?

For my part, I'll always advocate for a reassessment of art history to include more diverse voices, difficult and long though that process may be (and a process that even I admit is daunting—one look at the mostly male, white artists covered in my own book attests that there is still much work

to do in order to bring art history to any level of inclusivity). My own reassessment of the century-long debate over the "founder" of abstraction is fueled by a good hard look at the facts surrounding the lives and works by these two women. Af Klint and Houghton painted nonrepresentational works that, even to our contemporary eyes, look abstract in the same way a Kandinsky or a Mondrian does. And af Klint and Houghton painted them years—in Houghton's case, decades!—before Kandinsky and his "pioneering" pals. Ultimately, though the Spiritualist source of these women's works is fascinating and strange, their otherworldly authorship is only a small detail—who cares whether High Masters, long-dead Renaissance greats, or your dear cousin Bertha inspired your painting? Facts are facts, and these make one thing very clear: the first abstract artist sure wasn't Kandinsky.

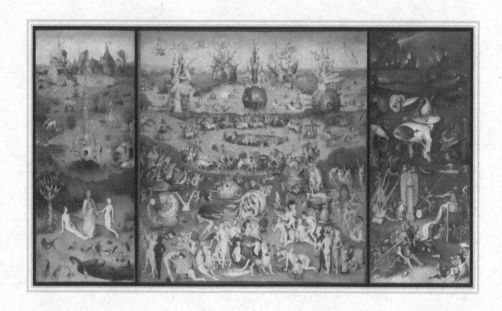

Hieronymus Bosch, *The Garden of Earthly Delights*, c. 1503–1515

CHAPTER 10

Booty Tunes:
The "Butt Music" of Bosch's
The Garden of Earthly Delights

Hieronymus Bosch mastered a whole genre by merging the realism of
Flemish painting with fantastic allegories of the human condition. His
pictures of vermin and birds in men's clothing, atrocities, and weirdly
juxtaposed objects use the realism of the earlier masters as a means of stark
caricature. It was in this form, the most extreme possible, that character and
moral differentiation were introduced into the realm of realistic depiction.

ROY WAGNER, ANTHROPOLOGIST

That Hieronymus Bosch. What a weirdo.

TERRY PRATCHETT AND NEIL GAIMAN, AUTHORS

Art history rarely goes viral, but when it does, it is typically driven by
the ridiculous and frequently nuzzled in a delicious layer of hilarity.
Think, for example, of the star status given to an unremarkable early
twentieth-century fresco titled *Ecce Homo* by Spanish artist Elías García
Martínez, when a recent restoration effort by a well-meaning elderly
woman went spectacularly wrong. A standard, fairly boring image of Jesus
Christ was transformed, practically overnight, into a complete disaster
with a swirling, simian face—and the internet went *nuts*. Images of this
so-called *Beast Jesus* (also known as *Potato Jesus* and *Monkey Jesus*) be-
came a top meme of 2012, inspiring countless tweets, parodies, and Hal-
loween costumes. *Beast Jesus* has remained so popular that the tiny town
of Borja, Spain—the home of the wonky fresco (population as of the most

recent census, in 2018: 4,922)—opened a museum to support its accidental masterpiece, and tourism has increased ninefold.

It wasn't until February 2014 that art again reached an internet-led pinnacle. And this time, it struck again with a truly memorable vengeance. As with *Beast Jesus*, it hit the world squarely in the funny bone—especially because it was about one of the silliest things in the world: musical butts, as composed by a famous Northern Renaissance master named Hieronymus Bosch (1450–1516).

As an art history student in the late 1990s, I was unprepared for Hieronymus Bosch.

An image of the Dutch Renaissance painter's *The Garden of Earthly Delights* (c. 1480–1505, Museo Nacional del Prado, Madrid) lit up my college lecture hall screen with a riotous burst of color and detail (and butts. So many butts.) unlike anything I had ever seen before. As my eyes panned across the image, I experienced a rush of emotions: calm and ennui as I viewed the left panel, a pristine, if odd, Edenic paradise; second, a confused stupor, as I squinted to determine what the myriad figures were doing *and in what positions*?! in the titular garden of the central scene; and finally, stunned into silence, disturbed by the torture ongoing in a nightmarish inferno.

I had almost no idea what was going on, really, in Bosch's acclaimed and bizarre tableau. All I knew was that I absolutely *loved* it because of its blatant strangeness.

It turns out that I'm not alone in this sentiment. For more than five hundred years, Bosch has been both terrifying and thrilling fans with his off-the-wall paintings brimming with religious and moral fanaticism (or at least we *think* they are brimming with religious and moral fanaticism—more on that question in a moment). At the Prado Museum, *The Garden of Earthly Delights* is a top draw, second only, perhaps, to Diego Velázquez's equally curious courtly scene known as *Las Meninas* (1656). But Bosch's power far surpasses that of Velázquez for most Prado tourists, simply out of pure weirdness. The figures in Velázquez's panel are at least recognizable

and somewhat grounded in reality: the infanta, her handmaidens, Velázquez himself in the role of royal painter. But what the hell is happening in Bosch's *Garden*? Your guess is as good as mine. And the picture's diligently detailed absurdity and oddness is the primary reason that the work of art endures today. Its bizarre hellscape, for example, has been so influential that it inspired the term *Boschian* as a synonym for "nightmarish" or "terrible." Very little of *The Garden of Earthly Delights* makes sense, which is why it is so damned memorable. It looks like the work of a madman.

Everyone Loves Bosch: Pop Culture and Earthly Delights

Dr. Martens, Christian Dior, children's coloring books, writer Michael Connelly, designer Alexander McQueen, director Guillermo del Toro, and more—what do they have in common? Major influence from one oddball medieval painter. Through heaps of merchandise and cultural centerpieces, Hieronymus Bosch—particularly *The Garden of Earthly Delights*—suddenly became what *The Atlantic* called "the Trendiest Apocalyptic Medieval Painter," soaring in popularity in the mid-2010s. Why the precipitous increase in fascination with Bosch? Art historian Craig Harbison credits our own unsettled, and *unsettling*, times as a reason for the artist's twenty-first-century renaissance—something that Bosch himself may have similarly experienced. "[His age] was a little bit like today, people feeling like everything is sort of falling apart," he said. "It leads to an artistic burst of fantasy and imagination."

But a madman Hieronymus Bosch wasn't . . . or at least we don't *think* so. This acknowledgment of uncertainty is a common refrain for Bosch researchers, because an awful lot of Bosch's inspiration, ideas, and life history remains lost to us. Due to a variety of reasons—particularly political instability in his hometown and the passage of half a millennia—hardly any records survive that mark the main highlights of Bosch's existence. We

do know some generalities, though: the man who would eventually style himself as Hieronymus Bosch was born Jheronimus van Aken in the wooded town of 's-Hertogenbosch, modern-day Netherlands, in the 1450s—the exact date, or year, is unknown, and is an early hint of the lack of biographical detail to come. Bosch was one in a long family line of artists and artisans spanning six generations, so an aptitude for the visual arts was not a surprise, and a natural assumption can be made that he received his early artistic training at home, most likely from his father, the artist Anthonius van Aken. As he aged, Bosch became an acclaimed artist who flourished not only in supportive 's-Hertogenbosch circles (which inspired his adopted name, "Bosch," as a nod to hometown pride), but also elsewhere in Europe, as noble families clamored for commissions. Bosch didn't care much for traveling, though, so it's a testament to his work and reputation that courtiers apparently came to *him* to request works of art. He married, but never had children, instead acting as a kind of father figure to 's-Hertogenbosch's artists, who learned the basics of draftsmanship in Bosch's own workshop. Pious and philanthropic, he joined the Brotherhood of Our Lady, a religious and social charity that provided a moralistic center to the town and Bosch's own life. He was a homebody who stayed in 's-Hertogenbosch for the remainder of his days, where a funeral mass was held in his honor at the Church of St. John in August 1516, according to records held by the Brotherhood of Our Lady.

And that's basically it—all that is known about the creator of the funkiest, creepiest works of the Northern Renaissance. This lack of knowledge about Bosch's life makes understanding his unique iconography even harder—we can't psychoanalyze him, for example, to really figure out the meaning of his images. Hundreds of years later, scholars are still debating everything from Bosch's sources and his symbolism to whether or not he was a Rosicrucian (no), an astrologer (definitely not), or a drug addict (probably not?). All that can be said, according to author Reindert Falkenburg in his impeccably researched *The Land of Unlikeness: Hieronymus Bosch, The Garden of Earthly Delights* (2011, Brill Academic Publishers, Inc.), is that, even today,

"Bosch's [painting] remains utterly opaque and ambivalent...." Bosch, and his works, are a true mystery to us.

They were also somewhat inscrutable, or at least indescribable, to his own audiences. The earliest record of the reception of *The Garden* comes from Antonio de Beatis, secretary to the Spanish cardinal Luis of Aragon, who recorded seeing the painting on a visit to the palace of Count Henry III of Nassau in Brussels in mid-1517. Beatis writes, "Then there are some paintings of diverse bizarre things ... things so pleasant and fantastic that, to those who have no knowledge of it, it cannot be described well in whichever way." Even Bosch's contemporaries couldn't make heads or tails of the exact goings-on in his most acclaimed work of art.

Regardless, it is generally agreed that there is a certain fire-and-brimstone Christianity at the center of most Bosch paintings, and even a brief glance at *The Garden of Earthly Delights* seemingly supports this: touring the triptych, or three-paneled painting, from left to right first presents the viewer with a vision of a flora-and-fauna-filled Paradise before the Fall of Man. Here, a red-robed God holds Eve's hand as he introduces her to her spouse, Adam, among a bevy of real and imagined creatures (hooray, unicorns!). The animals, and the environment in which they dwell, are far more interesting than their human and deity counterparts. A cat skitters off with a mouse in its mouth, while a seal with a bulbous head emerges from a pond nearby. The crustacean-inspired fountain dribbles water into a second pond, teeming with ducks and strange lizards, including one that has sprouted three heads. An albino giraffe stands watch over the scene. It is Edenic and magical; as noted in Genesis, Adam and Eve are innocently nude here, and don't know their own nakedness—which further contrasts with God's voluminous robes.

The central panel accelerates the narrative into the future and into the Garden of Earthly Delights itself, where humanity, post-Fall, is focused more on satisfying desires than acting in a godly prescribed manner. These desires are blatantly body focused: the dozens—or hundreds!—of nude human beings frolicking alongside more bodies of water (and more of those funky fountains), indulging in group feeding frenzies on oversized fruit, and even crawling in, out, and around one large fruit, clamshells, eggs, and

strange bubble-like containers. Kissing, caressing, and playing—not only together but also with and among huge birds—these figures care little about anything other than pleasure and satisfaction. It certainly looks like they are having a good time—heck, a group of figures stampede around the center of the painting riding not only horses, but pigs, lions, cats, and more, which looks pretty great to me. But my enthusiasm for this scene is tempered by the nature of the third and final panel.

Dark and dim in comparison to the bright and colorful panels before it, the last panel of the triptych, on the farthest right side, presents viewers with dozens of ways that a wayward person might be tortured for all eternity. It ain't pretty, but it sure is fascinating: a pair of gigantic ears moves across the blackened landscape, wielding a sharp knife and trampling bodies as it goes; a bird-headed, blue-bodied demon swallows humans whole and then defecates them out in an equally blue bubble; a pig dressed in a nun's habit tries to kiss a *very* uninterested man; and a part-tree, part-egg figure (with a face modeled after Bosch's own, rumor has it) presides hugely over the scene with shifty eyes and a smile as mystifying as that of *Mona Lisa*. It's hell, to be sure, but it's unlike any other depiction of hell out there.

Much has been debated about the malevolent goings-on in Bosch's third panel, but the artist's powers of creativity and invention can never be in doubt. In fact, they are heightened by their connections to our own reality, tentative though they may be. For example, his inclusion of everyday or commonplace objects—playing cards, metal keys, lanterns, the aforementioned ear cutlery—increased to a massive scale, gives them an absurdity and menace otherwise absent from real life (the inclusion of many creepy monsters in and around them don't hurt either). Musical instruments make up a sizable portion of this panel, and are ripe enough alone to make a juicy thesis for some eager student—you're welcome, art history grads!—drums, tinkling bells, a triangle, a bagpipe, a hurdy-gurdy, a lute, a harp, a trumpet, a variety of woodwinds are all present, and—naturally!—a wooden flute, being played by some poor damned soul via his rear end. "It's like watching a gig by the late-medieval equivalent of The Who," noted a journalist from the UK's *Guardian* newspaper when presented with these images.

These last few details beg a basic question: Why such a focus on musical instruments? Music is most definitely a *thing* in this painting, but the reason why may not be totally obvious to viewers today and needs a little explaining. If we accept the general theme of *The Garden of Earthly Delights* as the dangerous progression of humankind from innocence to perdition, then the instruments are a reminder that music was long seen by naysayers as a direct road to sin. Because music leads to dancing, which leads to touching, which leads to . . . well, *you know*. As such, the instruments act as symbols of lust, and these, at the very least, were probably recognizable as such by Bosch's contemporary audiences. (Turns out that the dad from *Footloose* may have been onto something all along.)

Hell is waiting for you, ye horrible sinners, Bosch appears to be saying with his iconic work. But what isn't always mentioned in traditional art-historical analyses is that Bosch has a supremely incredible sense of humor about it all. Sure, he's imparting religious and moral advice to viewers, but he's also obviously lighthearted about it. There are too many playful, ridiculous, and just plain *funny* elements included in each panel, but especially in his hell landscape, and we shouldn't ignore this injection of levity, which truly separates his work from the many medieval apocalyptic paintings that are precursors to Bosch's designs. If he really wanted to scare the bejeezus out of us, he might have simply cooked up a scene of the damned screaming in misery and drowning in a fiery pool of lava, as many had done in art before (though, to be fair, variations on these themes are present in *The Garden* too). Bosch, though, goes above and beyond. The randy nun-pig and the massive ears alone are enough to make you giggle, and watching a bevy of people forced to participate in a sinister hell choir led by a pink turbaned frog-man is pretty excellent too. Hieronymus Bosch didn't need to add these wacky little elements, but he may have done so for two reasons: first, he wanted to be sure that viewers would look closely and really immerse themselves in his scenes, and second, he wanted us to *laugh*.

Hieronymus Bosch's use of humor is too often overlooked in most interpretations of *The Garden of Earthly Delights*, though most of us understand

it on a fundamental level. After all, even though he is playing upon a learned art vocabulary stemming back to the Middle Ages, when strange and fantastical beasts were frequently presented in illuminated manuscripts and Gothic church architecture, Bosch takes it up a notch in pure quirk, even in his hellscape. If we focus simply on a righteous tone, we are missing an important part of what makes Bosch such a compelling artist. Part of the reason we so easily leave humor out of the story is that the subject matter—from creation to the Fall to damnation—is a grim one, for sure. And even the format of the work of art—the triptych—has religious overtones, typically used as the configuration for Christian altarpieces. But have *you* ever seen a work of art this overtly erotic, outlandish, and funny in a church? I'm guessing not.

The reasons behind Hieronymus Bosch's solicitation of laughter through his works of art may have been a little subversive. John Chrysostom, archbishop of Constantinople in the fourth century CE, and an early father of the Christian Church, denounced laughter as sinful because of its many consequences. In 387 CE, Chrysostom wrote that

> to laugh, to speak jocosely, does not seem an acknowledged sin, but it leads to acknowledged sin. Thus laughter often gives birth to foul discourse and foul discourse, to actions still more foul. Often from words and laughter proceeds railing and insult; and from railing and insult, blows and wounds; and from blows and wounds, slaughter and murder.

Such strict commentary on the sheer evil produced by laughter—which also might explain why no one seems to be having a good time in medieval art—was carried through into Bosch's own time, when Desiderius Erasmus Roterodamus, known simply as Erasmus, produced his own treatise on laughter. Erasmus, a Dutch Christian scholar whose lifetime runs practically parallel to that of Bosch, commented that "loud laughter and the immoderate mirth that shakes the whole body are unbecoming . . . because they distort the mouth and show a dissolute mind." Bottom line: laughter is the worst, and many spent centuries suppressing or vilifying it.

Why So Serious? Humor in Art History

Art is often taken *sooo* seriously. But artists have been having fun—
for the sake of fun!—for centuries. Some of the most famous works in
art history were created in a humorous light and still bring us a good
chuckle today. My favorite example is Marcel Duchamp's irreverent
L.H.O.O.Q. (1919, Centre Pompidou, Paris; reproductions elsewhere),
one of the artist's signature "ready-mades," which are detailed in
chapter 11. Using a cheap postcard reproduction of Leonardo da Vin-
ci's seminal *Mona Lisa*, Duchamp simply scrawled a mustache and
beard onto Mona's face in pencil and added the initials "L.H.O.O.Q."
as a caption below. The cheeky act of desecrating an icon of art his-
tory shocked audiences, but the caption took the hilarity up a notch:
the initials are a comical pun. When pronounced in French, the let-
ters sound similar to the phrase *"Elle a chaud au cul,"* which roughly
translates, in English, to "She has a hot ass." What better way to
skewer the legacy of art history's *grande dame*—and the solemnity of
fine art itself?

But then the rebellion began. Scholars and philosophers in the late fif-
teenth century—concurrent with Erasmus's rise to fame—published essays
proclaiming the positive benefits of a fit of the giggles: "Laughter's purpose
is to recreate weary and melancholy spirits," noted one document in praise
of laughter. The inclination to laugh—a natural human reaction—was
praised as energizing and even lifesaving in dark and uncertain times. Plus,
the bonding that can occur among individuals or groups who engage in
laughing or joking together could not be overlooked. What better way to
promote community and engagement? In the twenty-first century, much
has been written about the stress-relieving and healing benefits of laughter,
but during Bosch's era, this was radical. It presented a resistance to the old-
school, religiously mired ways of interpreting emotions and their conse-
quences, and because of this, the new theory of "good" laughter was slow to

take hold. Think of Bosch, then, receiving a commission to create a pedantic triptych about human damnation—but instead of playing it straight and narrow, he equally pokes fun at the whole thing as a laugh by filling its infernal scene with preposterous hybrid demons and goofy oversized objects. *We're all going to hell, so why not have fun with the process?*

Five hundred years on, you would think that Bosch's visual wisecracks have lost their power, having been analyzed and pored over for years. But as with any other cultural masterpiece, it is rediscovered anew by the next generation. In early 2014, Bosch escalated in popularity thanks to a college student with a musical penchant and a sharp pair of eyes—and thanks to the resulting laughter, the world of art history was made an internet star again, and with musical absurdity to boot. How very Boschian.

In late January 2014, Amelia Hamrick, a twenty-year-old honors student studying at Oklahoma Christian University in Oklahoma City, had seen a slide of *The Garden of Earthly Delights* as part of a course on Western thought and expression. Like many others before her, she was intrigued with the peculiar world envisioned and detailed by Bosch, and wanted to take another look on her own time. A *closer* look. And when she did, she found something interesting near the lower left of the "hell" panel. Hamrick, an accomplished musician, was particularly amused by all those humongous instruments. Her eyes scanned around the large lute, only to spot a figure half crushed under its weight. That this person is nude is a given, considering the rest of the humans frolicking around each of Bosch's three panels. But this one has something a little extra special going on: a rear-end tattoo of musical notations, similar to sheet music.

This poor "butt music man" isn't a hidden figure in Bosch's panel—and a nearby soul even points to the guy's bum to bring further attention to it—but when *The Garden* is practically a *Where's Waldo* of oddities, it makes sense that some things would be less noticeable than others. Hamrick, though, focused on that figure and did something no one had ever considered before: she opted to transcribe Bosch's notations into a modern, playable format.

In approximately thirty minutes, Hamrick had completed her experiment via the use of musical composition software and—one assumes—a magnifying glass with which to peer closely at this small musical bottom. Transcribed for electric keyboard, she made a few assumptions (she guessed that "the second line of the staff is C, as is common for [Gregorian] chants of this era," she later wrote) and then output her final composition, which she uploaded as a thirty-second sound clip—complete with accompanying sheet music—onto a Tumblr blog under the screen name chaoscontrolled123. And off it went into the online void. It was a lark, a post created at 1:00 a.m., Hamrick says, a joke she called the "600 years [sic] old butt song from hell." (It's more like five hundred plus years, but who's counting?) What she didn't expect, though, was the massive response her little ditty received.

Within days, the "butt song from hell" had been heard and shared thousands of times, spreading quickly on social media thanks to its winning combination of butts and the bizarre (who doesn't love them both?). By mid-February 2014, Amelia's unassuming composition appeared in posts by the UK's *Guardian*, the BBC's *Culture* blog, and many others, and news and television organizations from around the world reported on this ridiculous finding. Even *Anderson Cooper 360* profiled the college student and her discovery for their segment "The Ridiculist." The clip itself is worth seeking out, not just for Hamrick's exuberant retelling of the birth of her butt song, but also for Cooper's well-meaning head nods along to the completed tune, though he did note that the music could "use a little percussion, perhaps a *back* beat," thus illustrating one of the very best things about Hamrick's unexpected classic: its ability to inspire puns galore. As for me, I heard about the transcription on Artnet.com, one of the primary websites for visual arts news and articles and found myself unable to contain my own glee. I not only posted it to my social media accounts, but also happily forwarded it to my art-loving pals as well.

So how does this "butt song from hell" actually sound? Not great—which makes sense, I suppose, if you consider its assumed torturous usage. The clunky notes, as transcribed by Hamrick and uploaded to YouTube, seem to have no rhyme or reason, skipping tones and jumping intervals haphazardly. There's no melody to follow, and it's certainly not destined to

become a Billboard Hot 100 contender anytime soon. Even Hamrick herself confessed, "This is a *really* bad Gregorian chant." This concept was solidified quickly when another Tumblr user—this one going by the name of wellmanicuredman—transformed the song into a proper Gregorian chant, which at least makes the tune a bit more palatable. The best part? The absurd lyrics wellmanicuredman composed for the occasion:

> *Butt song from hell*
> *This is the butt song from hell*
> *We sing from our asses while burning in purgatory*
> *The butt song from hell*
> *The butt song from hell*
> *Butts*

The Rear That Roiled: Diego Velázquez's *Rokeby Venus* (1647–51) and Female Aggression

One of the most gorgeous goddesses of all time (and the only surviving nude by artist Diego Velázquez (1599–1660), the *Rokeby Venus* has been a centerpiece of London's National Gallery since its acquisition in 1906—and it made a splash with museumgoers right away, gaining fervent admirers for its depiction of Venus's round and ample behind. Some men practically salivated over the painting, and that lascivious attention royally pissed off one Mary Richardson, a Canadian/British activist who attacked the painting with a meat cleaver on March 10, 1914. Why did Richardson do this? Though originally claiming a suffragist motivation, she admitted forty years later that she just didn't like "the way men visitors gaped at it all day long." And *this* is why we need security guards (and great conservation teams) in museums.

Naturally the interpretations of this new old song didn't stop there. Kent Heberling, a musical composer and performer based in Milwaukee, Wis-

consin, released his own take on Hamrick's handiwork, revisioning it as a guitar-squealing metal composition. A band called An Dro, with contribution from classical guitarist James Spalink, released their track "Hieronymus Bosch Butt Music" on their 2017 album *Loose Change* (you can listen to it on Spotify). It has been transcribed into guitar tabs and recorded on the historically accurate hurdy-gurdy and lute, and far beyond. In short, step aside, *Beast Jesus*. A new silly art-historical king has been crowned.

Turns out that Hamrick may not have been the first person to decipher the posterior piece after all. In 1978, a Spanish group called Atrium Musicae, based in Madrid, released *Codex Glúteo*, under the direction of musicologist and scorer Gregorio Paniagua. Their inspiration? Our friend the "butt music man," of course. Their first track, "Introitus, Obstinato I - Organa, Codex Glúteo"—which gives the album its name—starts slowly with the same kind of whirring hurdy-gurdy noise you might expect from one of Bosch's devilish instruments, before increasing in tempo to a strikingly medieval-sounding work. But I'll go to bat for Hamrick's innovation here, because (in my humble, nonmusical opinion) Atrium Musicae's recording appears to be one of inspiration rather than adaptation. Hamrick's "butt song from hell" is a literal transcription, note for note, of Bosch's painted score, whereas Gregorio Paniagua's take isn't. It's more of an homage than a reproduction. Given, too, that the *Codex Glúteo* also incorporates traditional music of the medieval and early Renaissance period, Atrium Musicae presents listeners with an interpretation of demonic music that might have been found during Bosch's own era, if such a tune had been written.

What's wonderful is that Amelia Hamrick's contribution to the melodic canon was not the first time Hieronymus Bosch's *The Garden of Earthly Delights* has made musical headlines around the world, albeit with less obvious joy and internet stardom. In 2010, a group of musicians and curators from the Bate Collection, one of the world's great repositories of modern and historical musical instruments (Oxford, UK), found themselves equally

curious about the abundance of musical elements in Bosch's hell panel—some imaginary, some identifiable. Bate staff wondered: what, indeed, does this satanic orchestra sound like when performing together? Over a series of months, experts crafted physical reproductions of the Boschian objects, which included a flute, drum, trumpet, hurdy-gurdy, harp, lute, and bagpipes—only to determine that all but two of the instruments weren't actually able to be played. As the manager of the Bate Collection, Andy Lamb, noted to London's *Times*, "I have tried to coax a few harmonious notes out of one of the wind instruments. The racket that comes out of it is horrible." As for the other instruments, they were all "either impossible to make or painful to hear."

While I empathize with the musicians at the Bate Collection—who surely felt disappointment that they couldn't jam out with their version of nightmare music—this outcome seems totally appropriate. This was Bosch's version of hell, after all: a place where sinners, damned for all eternity, would spend their time being tortured to the extreme, not soothed by a relaxing symphony. That Lamb notes their reproduction instruments made "painful" noises fits within this realm. And, again, we can't overlook the pure absurdity of it all. The Bate experiment—and Hamrick's meme sensation—remind us of the humorous nature of Bosch's *The Garden of Earthly Delights*, an underworld that is both terrifying and whimsically amusing at the same time.

All this musical tomfoolery further enhances the idea of Hieronymus Bosch as a smart, subversive painter whose taste for the jocular side of life infuses his works of art—not in opposition to his moralistic message, but possibly *alongside* it. He may have wanted viewers to laugh, all those hundreds of years ago, when he first conceived of the triptych and all its preposterous components. That we're laughing again, in the twenty-first century, about this "butt music" and its many incarnations on YouTube and Vimeo, is no small feat, and it has brought a Renaissance masterpiece to life once again. The longevity of *The Garden of Earthly Delights* is something that art lovers and internet trolls alike can still get . . . behind. (Sorry!)

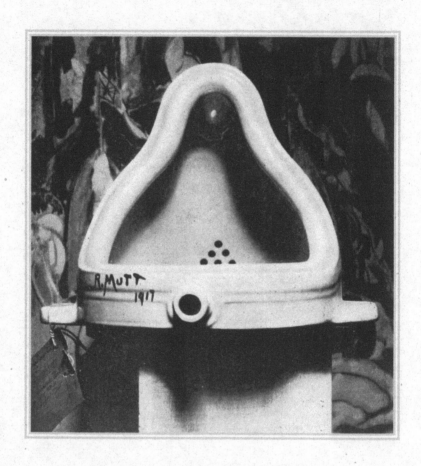

Marcel Duchamp, *Fountain*, 1917 (photograph by Alfred Stieglitz)

A Ready-Made Revelation:
Is a German Baroness Responsible for a Marcel Duchamp Masterpiece?

It is only "art" that ever sustains me—insufficiently always—due to its
bastard position—for—though I distinguish myself . . . I never could make
distinction pay money . . . I fed engine with my rich flowing blood direct.

THE BARONESS ELSA VON FREYTAG-LORINGHOVEN

[The Baroness] is not a futurist. She is the future.

MARCEL DUCHAMP

In 2004, Tate Britain organized a poll in advance of the announcement of
the winner of that year's Turner Prize, the UK's most prestigious annual
award, awarded to the British artist determined to have the most impor-
tant or impactful exhibition of that year. The poll, co-organized by Turner
Prize sponsor Gordon's Gin (cheers!), had two intentions: first, to encour-
age excitement for the upcoming award presentation, and second, to estab-
lish the single most influential work of art of the twentieth century, as
confirmed by the art establishment at the dawn of the twenty-first. Gor-
don's and the Tate organized a panel of five hundred experts—critics, cura-
tors, museum and gallery directors, lauded contemporary artists, and
other art world insiders—and provided them with a predesignated list of
twenty artists and artworks. From the outset, many speculators—and I'd
probably include myself in this category—had a clear winner already in
mind. *It's going to be Picasso*, everyone declared. *And it's going to be Les
Demoiselles d'Avignon.* There was great reason for this assumption. Picasso

is undoubtedly the most famous artist of the century, a name even my young son knows (apparently Picasso's name is synonymous with artmaking in toddler books about mischievous dinosaurs), and his *Demoiselles* (1907, Museum of Modern Art, New York) is a stunner: a breakdown of space, form, and tradition like none other. So it came as somewhat of a shock, perhaps, when the Tate announced that Picasso's seminal painting had garnered *second* place. Instead, the title of the most important and most influential artwork of the twentieth century was given to a urinal.

With the elevation of Marcel Duchamp's cheeky *Fountain* (1917, original lost; numerous replicas are in existence around the world, including a 1964 version at Tate Britain, London)—a store-made urinal simply signed "R. Mutt" and placed on a pedestal—to the top position of modern art came the expected mix of approval and criticism. In a press release discussing the poll results, former Tate curator Simon Wilson admitted the unexpectedness of the choice but quickly celebrated it:

> The choice of Duchamp's *Fountain* as the most influential work of modern art, ahead of works by Picasso and Matisse, comes as a bit of a shock, but is not surprising. It reflects the dynamic nature of art today and the idea that the creative process that goes into a work of art is the most important thing, and that the work itself can be made of anything and can take any form.

The resulting online report from BBC News produced hundreds of online comments, which the BBC then arranged to highlight the debate, giving the general public a say in an otherwise exclusive poll. Some backed the choice and echoed Simon Wilson's analysis: a user named Jamie from Reading, UK, noted, "I'd agree wholeheartedly! *Fountain* is one of the most important works of art ever produced—completely breaking down the perception of what art can and cannot be." J. Amoss from Athens, Georgia, agreed, commenting, "As an artist, I think Duchamp's piece is a checkmate on the art world. Brilliant move and is still a resounding challenge to

everyone. To me, it is like a well-positioned mirror that breaks down my preconceptions." The disavowal of the poll's results was just as swift and numerous. David Anderson from Wakefield, West Yorkshire, sneered, "If five hundred people really consider this the most influential modern art work [sic] of all time, I think we can safely disregard their claim to be experts." Phillip Evans of Wales stated, "It's a urinal. If true artists like Leonardo Da Vinci [sic] saw this they would turn in their graves."

Truly, if there ever was a more divisive work of art, I've yet to encounter it. *Fountain*—more than one hundred years after its art world debut in New York City—still divides viewers into two distinct and vehement "art" and "not art" camps. The contention associated with it appears to be eternally ongoing. So imagine my surprise when I learned another controversy had begun swirling around this most polemical piece, reaching a fever pitch in spring 2019. Critics have long accepted that Duchamp himself didn't "make" *Fountain*—he didn't sculpt porcelain into the shape of a urinal, after all—but now some suggest that he wasn't responsible for the idea for *Fountain* at all. And with this work of art, it's the thought that really counts.

First, let's discuss the man whose idea it was *supposed* to be.

Marcel Duchamp is an interesting nut to crack, and certainly not an easy one at that. Born in Normandy to a family of artists, Duchamp cycled through the most popular art modes of the day in pursuit of a style that was truly his own, but nothing quite fit. It's difficult to know exactly what he was looking for, but one thing can be deduced from much of Duchamp's later works: he wanted to change the idea of what art *was* or what art *could be*. As such, his genre-blending works inspired shock and disapproval from the start.

Duchamp's first major brush with controversy (and sorry/not sorry for that pun) surrounded a painting called *Nude Descending a Staircase No. 2* (1912, Philadelphia Museum of Art, Philadelphia), considered today to be a hallmark of modernist painting. The title urges us to decipher the canvas in order to locate a figure walking down the stairs, but the image is unlike

what you'd expect—frozen in time, like a snapshot, where you see a split second of the action, as you do with most figurative or representational panels. Instead, with the *Nude*, Duchamp nestled each moment, each *movement*, together and atop one another, like a film strip overlapping or stop-motion photography superimposed one frame at a time. It's a stunning work, taking inspiration from Cubism and from Italian Futurist concerns about motion, speed, and mechanization.

Viewers—perhaps even Duchamp himself—read it as a joke, a send-up of the tradition of the nude as a cornerstone of art history. But it did not go over well. Duchamp intended to exhibit the piece in Paris at the 1912 Salon des Indépendants, but it was rejected, with the exhibition committee refusing to hang it (luckily, only one year later, it was accepted and shown at the inaugural exhibition of New York's famed Armory Show, but it was greatly ridiculed there too). That rejection shook Duchamp, and he made an incredible, possibly rash, decision at the age of only twenty-five: he would never paint again.

But just because Duchamp insisted his painting career was over didn't mean that he stopped creating art. After relocating from Paris to New York in 1915 during World War I, he became connected with the city's downtown intellectual and cultural scene, gathering at the home of collector and poet Walter Arensberg, who hosted frequent "salons" in his apartment alongside wife, Louise (Duchamp became extremely close to the Arensbergs, even living in their apartment for a brief stint when he first moved to New York). The city's most creative, avant-garde minds participated in these soirées, and it was here that Duchamp associated with artists Man Ray, Joseph Stella, Francis Picabia, actors Beatrice Wood and Fania Marinoff, dancer Isadora Duncan, and poets Mina Loy, William Carlos Williams, and Arthur Cravan, among many others. Together, this incredible group of individuals debated art, literature, and more, and Duchamp enjoyed collaborating with his fellow salongoers on projects that questioned the mechanics of the cultural world: *What is art, and why? Are there rules to artmaking? And do these rules even matter?*

It was at the Arensberg salon that Marcel Duchamp met poet and artist Elsa von Freytag-Loringhoven for the very first time.

We've all got that one friend who marches to the beat of their own drum, who rejects societal mores, and makes their own way through the world, with often incredible, practically cinematic results. For the Arensberg crowd, it may be difficult to narrow down the list of iconoclasts to pinpoint the strangest of them all, but my money is on Elsa von Freytag-Loringhoven. Born Else Plötz in the province of Pomerania in Prussia (now part of modern-day Germany) in 1874, the future Baroness Freytag-Loringhoven had a tumultuous childhood, replete with an overbearing alcoholic father and a scarred, withdrawn mother. In a 1924 autobiographical poem formatted in her typical nontraditional manner, *Coachrider*, she provides the reader with a glimpse into her terrifying early years:

> *He's Papa—*
> I'm his small daughter—I must obey—those
> Canny—uncanny steps—haaaaaah!
> [. . .]
> Glittering
> Eye—glimmering gun—
> Ter—ri—ble! Mighty—knowing—jolly—fanatic—
> Cunning—cruel—possessed—despotic—detestable
> Horrid! Fi! Fi! I *hate* that Papa! Who am I?

It's understandable that she made a beeline out of her hometown as soon as she was old enough to do so. While still a teenager, she escaped to Berlin with the starry-eyed intention of making it big as an actress and vaudeville performer, traveling around the continent and moving house frequently, all while immersing herself in the avant-garde art scenes popping up everywhere in the last decades of the nineteenth century. She loved the visual arts, always had, and her early life had been full of it. Her mother, whom she loved dearly, enjoyed crafting objets d'art with found objects and trinkets gleaned from everyday life, a familial habit of magpie-like collecting that would play a huge role in Freytag-Loringhoven's artworks later in life. So, too, did the liberal and countercultural communities she explored throughout Germany, and when she was given the opportunity to

study art in Dachau, she jumped at the chance. All this combined to transform her into a broad-minded, experimental artist, a woman who refused to be categorized throughout her life.

Not that Else—who soon preferred the English version of her name, Elsa, over its German equivalent—was eternally nontraditional. She did get married—a few times, in fact—first to an architect named August Endell, and then, when their open marriage failed, she went on to marry August's friend, the poet and writer Felix Paul Greve (later assuming the more Anglicized name of Frederick Philip Grove, under which he would enjoy praise as a Canadian novelist, translator, and memoirist). Elsa's marriage to Greve produced one of the most fascinating elements of her early biography. Two years after their 1907 marriage, the couple found themselves in great financial turmoil, unable to pay off their massive debts. And like a heroine of a Lifetime made-for-TV movie, Elsa made a simple decision: she opted to help her husband fake his own death. After his supposed suicide, Felix Greve fled the country, ending up on a small farm in Sparta, Kentucky, approximately forty-two miles from Cincinnati. Elsa joined him there the following year, and together they worked to start their lives anew.

Spoiler alert: the marriage didn't last. Greve deserted his wife in late 1911, and to support herself financially Elsa left Sparta and sought work as an artists' model, moving from Cincinnati to Philadelphia onward to New York City, where she settled in 1913. That same year, not long after her relocation to the city, she met her third and final husband, a German baron by the name of Leopold von Freytag-Loringhoven, and they married later that year. Unfortunately, the baron had only his title to share with his new wife, as he lacked both money and property, so the newly dubbed Baroness Elsa von Freytag-Loringhoven continued her modeling gigs, as well as working a stint in a cigarette factory.

As it does for many innovators, bohemians, and aesthetes, New York suited Elsa. She gravitated toward artists and provocateurs with the same conviction as she had in Berlin and Munich, and it was within the art and literary scene of early twentieth-century New York that she really found her tribe. One of her favorite gatherings was the "meeting of the minds" at

the Arensberg apartment, where she mingled with the Arensberg salon who's who, including none other than Marcel Duchamp. It was within this exciting, cutting-edge environment that the baroness found the most inspiration, leading her to produce the poetry that she's most known for today, compositions that memorably shattered many expectations of what poetry could be: frank, forthright, sexual, fractured, and onomatopoeic. (Example: one of her most controversial poems, "A Dozen Cocktails—Please," reads, in part, "No spinsterlollypop for me—yes—we have / No bananas / I got lusting palate / I / Always eat them"

It is within this enlivening art scene that Freytag-Loringhoven may have helped conceive the world's most infamous ready-made.

During the 1910s, a new, strange art movement erupted in response to the terror and bloodshed of World War I. Though war has been a reality of humankind for millennia, the scope of World War I and its repercussions was unspeakable, unthinkable, and, to many, it seemed almost nonsensical— a *world* war? *How ridiculous that we could all be embroiled in turmoil of this magnitude?* Some visual artists, like Ernst Ludwig Kirchner, Otto Dix, and Käthe Kollwitz, coped with this new, unfathomable reality by creating harsh, solemn works that reflected the struggles of the front or the drudgery of everyday existence during wartime. A select group of artists, however, felt that the best solution was to mock the pure weirdness of it all—so why not go the whole hog with the idea of *nonsense* and make *nonsensical art*? In visual art, poetry, dance performance, and more, Dada was born—a movement that rejected logic, tradition, history, and rationality all around. Even the name was ridiculous, evoking a reference to childish language . . . or maybe a colloquial French phrase for hobby horse . . . or maybe nothing at all (there are myriad theories on the naming and history of the movement, which further illustrates its nontraditionality). Dadaists like Hugo Ball, Hans Arp, Hannah Höch, Tristan Tzara, and Marcel Duchamp created bizarre poems from text cut from magazines or newspapers and then randomly assembled them into illogical phrases; they distributed antiwar

manifestos and early twentieth-century equivalents of the zine; they en-
gaged in satirical sound and song performances; and they created collages
that rejected basic tenets of art aesthetics.

Perhaps the most enduring legacy of Dada was its interest in
overturning—or at least redefining—two concepts: first, how art is cre-
ated, and second, how art is defined. I know. You're probably reading this,
thinking, *What the heck does that even mean?* Let me give you the perfect
example by way of Duchamp's purported gift to art history: the ready-
made.

Around 1913, Marcel Duchamp, the anti-artist, started taking readily
available everyday items—products that were mass-produced, super com-
mon, and easily identifiable—and began presenting them as Art with a
capital A. A bicycle wheel attached to a stool. A windowpane. A snow
shovel. Typically, these objects would never be considered art—these are
utilitarian things, meant to be appreciated for their functionality, not to be
admired for their beauty or enjoyed on an aesthetic level. But Duchamp
opted to shove this (arbitrary) delineation aside. With the debut of the
ready-made, Duchamp made an anarchical and confusing declaration: art
could be anything, simply because an artist deemed it to be a work of art.
The artist, usually envisioned as some kind of godlike creator, could basi-
cally create nothing with his own hands and would still be considered that
godlike creator, at least in his or her own mind. Art moved from a process
of making to a process of thinking: if you *think* it is art, apparently it *is* art.

Whoops: When Art Is Mistaken for Trash

Since the birth of the ready-made in the early twentieth century,
the line between art and not art has gotten blurry, to say the least. In
the past two decades, though, the distinction between the two has
been so minuscule in several cases that actual works of art have
been thrown into the trash. *Like actual garbage.* An art installation
of empty champagne bottles and confetti was swept away and

discarded at Museion Bozen in Bolzano, Italy, by an overzealous cleaner in 2014; in 2018, Swiss artist Carol May's *Unhappy Meal*—a sculpture that parrots the iconic McDonald's kids' meal box with a frown swapped in for its usual smile—was tossed at a Hong Kong art fair. And even the VIPs aren't immune: in 2001, Damien Hirst, one of the enfants terrible of contemporary art, created an installation at a London gallery that contained, in part, beer bottles, ashtrays, half-drunk cups of coffee, and newspaper. You can probably guess where it ended up. Most infamous, though, was one woman's reaction to British artist Tracey Emin's controversial creation, *My Bed* (1998, private collection; on long-term loan to Tate Britain, London). In 1999, Emin exhibited her *actual* unmade bed surrounded by extremely personal detritus: stained sheets, condom wrappers, bottles of vodka, a pregnancy test, and used tissues. This concept so incensed one woman that she drove two hundred miles to *clean it up*, though she was quickly restrained by security guards. When asked why she intended to disrupt Emin's artwork, the woman replied, "I thought I would clean up this woman's life a bit. . . . She will never get a boyfriend unless she tidies herself up."

This was huge. It was also crazy-making for the art establishment, let alone the average Joe. In a review titled "Nothing Is Here: Dada Is Its Name," an art critic for *American Art News* (today's *ARTNews*, one of the industry's top periodicals) sneered that Dada in general—and the ready-made in particular—was "the sickest, most paralyzing and most destructive thing that has ever originated in the brain of man." Sure, the critic was a little hyperbolic, but he had the right to be so indignant because this seemingly goofy concept bore the weight of big questions: Does a single individual have the right to determine what is or what isn't art? Can a person be called an artist if they didn't actually create anything? If you shun millennia of artistic training and well-established rules and practices, does art remain a rarefied or significant achievement of humankind? *Does art matter anymore?!*

• • •

Like Duchamp, Baroness Elsa von Freytag-Loringhoven loved to scour her surroundings for functional, everyday items and transform them into works of art through the power of her own declarations. Within the downtown New York art scene of the Arensberg apartment and beyond, she began debuting "sculptures" composed of objects scavenged off the street—literally. Legend has it that her first ready-made coalesced in her mind while en route to her wedding to Baron Freytag-Loringhoven. Walking to her ceremony, she discovered a very rusted metal ring—a construction or manufacturing element, not the kind you wear on your finger—and she was enchanted by it, viewing it as a good luck charm for her impending marriage. In a sweet, sentimental nod to her husband, she grabbed it, titled it *Enduring Ornament* (1913, private collection), and voilà—Art with that capital A. (Sad but true side note: as the baroness's biographer, Irene Gammel, notes, "the artwork would prove much more enduring than the marriage itself," as the baron left his wife a year later to enlist in the German army at the beginning of World War I. He committed suicide five years later after spending the intervening years as a prisoner of war in France.)

The baroness's studio was further testament to her dedication to such "creations." American painter George Biddle recounted his memories of Elsa in his 1939 autobiography, writing:

> [Her studio] was crowded and reeking with strange relics, which she had purloined over a period of years from the New York gutters. Old bits of ironware, automobile tires, gilded vegetables, a dozen starved dogs, celluloid paintings, ash cans, every conceivable horror, which to her tortured yet highly sensitized perception, became objects of formal beauty. And . . . it had to me quite as much authenticity as, for instance, [Constantin] Brancusi's studio in Paris.

Elsa von Freytag-Loringhoven's found objects not only formed the basis of her artistic oeuvre, but also her wardrobe—or the occasional lack

thereof. Biddle similarly recalled her striking presence, highlighting a truly memorable encounter:

> Having asked me, in her harsh, high-pitched German stridency, whether I required a model, I told her I should like to see her in the nude. With a royal gesture she swept apart the folds of a scarlet raincoat. She stood before me quite naked—or nearly so. Over the nipples of her breasts were two tin tomato cans, fastened with a green string around her back. Between the tomato cans hung a very small birdcage and within it a crestfallen canary. One arm was covered from wrist to shoulder with celluloid rings, which she later admitted to having pilfered from a furniture display at Wanamaker's. She removed her hat, which had been . . . trimmed with gilded carrots, beets, and other vegetables. Her hair was close cropped and dyed vermillion.

Freytag-Loringhoven cut an impressive, surprising, and unusual figure—a living, breathing Dada sculpture—and many were drawn to her lusty, idiosyncratic personality. Both William Carlos Williams and Djuna Barnes reported their love for her, and others must have been equally attracted to her (photographer Berenice Abbott memorably concluded, "The Baroness was like Jesus Christ and Shakespeare all rolled into one and perhaps she was the most influential person to me in the early part of my life."). For her part, though, the baroness had her eyes trained on one potential lover. Not long after her marriage and her third husband's desertion, she was introduced to Marcel Duchamp and quickly became infatuated with him. Example: one day, in a "spontaneous piece of performance art," she stripped down and rubbed her naked body with a newspaper article discussing Duchamp's much-discussed and derided painting, *Nude Descending a Staircase No. 2*. While writhing with the paper, she recited a poem of her own making, which concluded with the line, "Marcel, Marcel, I love you like Hell, Marcel." (Wow. That's making a statement, all right.) Duchamp, though, demurred and politely declined her sexual advances, and did his best to keep their relationship a professional one,

encouraging collaboration and continued discussion of their shared inter-
ests in the usage of found objects and in challenging the norms of artistic
production and philosophy. But was *Fountain*, the most controver-
sial ready-made, Duchamp's own idea? Or was this a Duchamp/Freytag-
Loringhoven collaboration?

According to the traditional narrative, *Fountain* began as an in-joke and a
challenge to art world expectations and rules. In 1916, several New York-
based artists and critics founded the Society of Independent Artists, which
was established with the intent of producing annual exhibitions of avant-
garde art. Among the founding members was Marcel Duchamp, who acted
as an artistic adviser and member of their governing board, and who as-
sisted in the adoption of the society's constitution, which included a rather
relaxed policy: as long as an artist paid an entrance fee to the society's ex-
hibitions, whatever artwork they submitted would be automatically ac-
cepted for show. What a difference this was from the way the art world
usually worked, where every artwork was vetted and juried within an inch
of its life—in comparison, the Society of Independent Artists boasted an
anything-goes attitude that Duchamp, as a natural-born rebel, was eager to
test out. And thus he allegedly visited a plumbing warehouse, where he
chose a simple urinal, brought it home to his studio, turned it on its side,
scrawled a pseudonymic signature ("R. Mutt," the autograph read, itself a
purported double reference to the J. L. Mott Iron Works as well as the fa-
mous *Mutt and Jeff* comic strip), and off went the newly christened yet
untitled artwork, destined for the Society's 1917 exhibition and eternal no-
toriety.

Given that *Fountain* was meant to challenge the Society's rules and
regulations—and, *no biggie, just to question the definition of art entirely*—it
was submitted to the Society's governing board anonymously. It proved to
be a good move because even though the board was ostensibly bound by
their constitution to accept all artwork submitted with an entrance fee,
they nevertheless took strong exception to the artwork now known as
Fountain, believing that a piece of "sanitary ware"—and one so obviously

associated with bodily waste—was completely vulgar and could never be considered a work of art. Though it wasn't specifically noted, there was an inherent misogyny, gentle though it may have been, in the attack on *Fountain*'s "indecency": such an object was proclaimed abhorrent to the tender minds of women, long targeted as the prime demographic for art-related events. Thus, after a fiery debate, the board voted to suppress *Fountain* from the annual exhibition, which opened to the public on April 10, 1917. Note the word choice here, which was quite deliberate: Duchamp later confirmed that "a work can't be rejected by the Independents," based on their constitution, and *Fountain*, instead, was "simply suppressed." The vote of suppression generated the Society's first scandal: it caused a rift within the governing board, and several members—including Duchamp and Walter Arensberg—resigned in protest, stating that the decision not only violated the newly set constitution, but was also tantamount to censorship.

Fountain existed in a strange no-man's-land for the duration of the annual exhibition of the Society of Independent Artists. Though it was "suppressed" from being shown, it could not be returned to its maker, as it had been submitted anonymously—or at least by the imaginary figure of R. Mutt. Duchamp detailed the fate of the ready-made late in his life to French journalist Pierre Cabanne, noting, "The *Fountain* was simply placed behind a partition and, for the duration of the exhibition, I didn't know where it was. I couldn't say that I had sent the thing, but I think the organizers knew it through gossip. No one dared mention it." But just because the work of art was out of sight didn't mean it was out of the minds of the collective public. On the contrary, it loomed rather large in the conversation surrounding the show, overshadowing the other works on exhibition. When the exhibition opened, the Society of Independent Artists faced enormous pressure from the contemporary art community over their decision to suppress *Fountain*. An established Dadaist zine, *The Blind Man*, covered the exhibition extensively and highlighted the hypocrisy of the board's lack of adherence to its own constitutional tenets, thereby bringing wider attention to the *Fountain* scandal (to be fair, Marcel Duchamp himself was one of the organizers of *The Blind Man*, so it wasn't a particularly

unbiased editorial, but its bottom line was nevertheless valid, as it followed
in the footsteps of Duchamp—and Elsa von Freytag-Loringhoven!—by
questioning the definition of art *and* its definers). The anonymous editorial
defended *Fountain* as a work of art, reading, in part:

> Mr. Mutt's fountain is not immoral, that is absurd, no more than a bath-
> tub is immoral. It is a fixture that you see every day in plumbers' shop
> windows. Whether Mr. Mutt with his own hands made the fountain
> has no importance. He CHOSE it. He took an ordinary article of life,
> placed it so that its useful significance disappeared under the new title
> and point of view—created a new thought for that object.

In response to this criticism, the Society, unwavering in its position,
released a public statement declaring, "The *Fountain* may be a very useful
object in its place, but its place is not in an art exhibition and it is, by no
definition, a work of art."

After the close of the exhibition, Duchamp discovered the location of
the hidden *Fountain* and after retrieving the offending sculpture, he
immediately transferred it to the studio of his friend, the renowned pho-
tographer Alfred Stieglitz, who is reported to have given the work its
tongue-in-cheek title. Stieglitz photographed it for posterity, choosing to
capture the object on display in his studio in front of *another* work of art—
a painting by Marsden Hartley titled *The Warriors* (1913, private collec-
tion). To me, this seems like a direct statement of intent: *Fountain is* a work
of art, just as *The Warriors*, an oil painting, is. Just as important as this bold
statement is Stieglitz's picture itself as proof that *Fountain* ever existed,
because soon after its documentation, the work of art inexplicably disap-
peared, lost forever to history. Duchamp biographer Calvin Tompkins sug-
gests that it was most likely discarded as garbage.

Several replicas of *Fountain* exist today, most formulated during the
1950s and 1960s with Duchamp's approval and to his specifications (inter-
estingly enough, these replicas are more hand produced than the origi-
nal ever was—they are sculpted of earthenware and painted to imitate
porcelain—which is wonderfully ironic, given the original ready-made's

patently non-handmade quality). But even if Duchamp rejected the ideas of reproductions and no replicas were commissioned, it wouldn't matter much. After all, Duchamp himself once declared, "I was interested in ideas—not merely in visual products." The thought of *Fountain* and all it implied was enough to change the world of art—presaging the advent of Conceptual art and more—and Marcel Duchamp has long been deified as the agent of this change.

Edmonia Lewis's *Cleopatra*: An Epic Lost-and-Found Tale

Edmonia Lewis's masterpiece *The Death of Cleopatra* was the star of the 1876 Centennial Exhibition in Philadelphia and a stunner of neoclassical sculpture—but only a few years after its debut, it was presumed lost forever. Where did it go? What follows is the strange, century-long adventure of this misplaced marble monument. After Lewis's style fell out of fashion in her later years, she placed the work in storage before selling it to "Blind John" Condon, a saloon owner in Chicago. Condon's side hustle was a horse racing track in nearby Forest Park, Illinois, where his favorite mare, Cleopatra, frequently ran. When Cleopatra died, Condon was so distraught that he refashioned Lewis's sculpture as her headstone, with the stipulation that neither it, nor the horse's grave, be moved from its site. But as the horse track changed hands—and morphed from golf course to Navy base to post office—the de facto owners of Cleopatra's gravestone ignored Condon's stipulation and moved the giant marble sculpture to a scrap yard, where it sat, ignored and unkempt.

Bring in the Boy Scouts! A retired fireman serving as a Scout troop leader "found" the work at the scrap yard in the late 1980s and declared it a perfect fit for a Scout service project. Together the boys cleaned and painted Cleo before presenting her as a gift to the Historical Society of Forest Park. And yet, nearly one hundred years after it "disappeared," *The Death of Cleopatra* was still deemed lost. But Historical Society director Frank Orland had an inkling that their

latest acquisition was more important than it seemed. Through a co-
pious amount of research, Orland Sherlocked his way into an as-
sumption that Edmonia Lewis had sculpted the Society's *Cleopatra*,
and his sleuthing tipped off Marilyn Richardson, an independent cu-
rator and Edmonia Lewis scholar. Richardson was hopeful but wary:
was Lewis's most prized work of art about to be rediscovered? A visit
to Forest Park Historical Society's storehouse provided all the an-
swers she needed: *there she was*, Cleopatra in all her deathly glory,
surrounded incongruously by discarded Christmas decorations, half-
empty paint cans, and other typical storage-unit detritus. Today, *The
Death of Cleopatra* is a star attraction at the Smithsonian American
Art Museum (Washington, D.C.), a far more appropriate environ-
ment for such a stunning masterpiece. Though I've gotta say that it is
still kinda cool that it was a horse's gravestone for a while.

In late March 2019, the American novelist and essayist Siri Hustvedt
released an editorial on *The Guardian* website in conjunction with the
publication of her latest book, *Memories of the Future* (2019, Simon &
Schuster). Hustvedt begins her article with an incendiary and timely ques-
tion: "Why is it hard for people to accept the intellectual and creative au-
thority of artists and writers who are women?" During the research phase
of writing her novel, Hustvedt sought to identify an "insurrectionist inspi-
ration" for her narrator, a woman living in New York City in the late 1970s.
Elsa von Freytag-Loringhoven provided the perfect historical precedent
with her fascinating and absurdist rejection of societal norms at the begin-
ning of the twentieth century. As she explored Freytag-Loringhoven's biog-
raphy, though, Hustvedt became enraged, learning that evidence points
toward the baroness as an "author" of *Fountain*, either alongside Duchamp
or in lieu of him—and yet most storied art institutions, like Tate Britain,
have not budged on their pronouncement of Duchamp as its creator. "I
don't believe the people involved in these attributions were all monsters
out to destroy the reputation of [an] artist or thinker. [But] the evidence
was there. They couldn't see it. Why?" Hustvedt asked. Her questions—as
well as her certainty and multiple scholarly citations—piqued my interest.

It suddenly seemed possible that everything I knew about *Fountain*'s creation was wrong.

The evidence upon which Siri Hustvedt relies on for her novel—and the justification used by many academics, in recent years, to dethrone Duchamp as *Fountain*'s maker—was first cited by biographer Irene Gammel, whose *Baroness Elsa: Gender, Dada, and Everyday Modernity—A Cultural Biography* (2002, MIT Press) is the fundamental text on the little-known artist's life. Gammel argues that Duchamp himself may have revealed the true author of *Fountain* in a letter dated April 11, 1917, to his sister, Suzanne. The letter reads, in part:

> Tell this detail to the family: The Independents have opened here with immense success. *One of my female friends under a masculine pseudonym, Richard Mutt, sent in a porcelain urinal as a sculpture* [italics mine]. It was not at all indecent—no reason for refusing it. The committee has decided to refuse to show this thing. I have handed in my resignation and it will be a bit of gossip of some value in New York—I would like to have a special exhibition of the people who were refused at the Independents—but that would be a redundancy! And the urinal would have been lonely.

Much has been made of this letter, which was only discovered in 1982 and has been co-opted by both sides of the Duchamp/Freytag-Loringhoven dispute. Pro-Duchamp art historians have proposed *Duchamp himself* as the "female friend" referenced in the letter, as he sometimes inhabited an alter ego: a woman he named Rrose Sélavy, whose moniker is a Dadaesque pun on the French phrase "Eros, c'est la vie," or "Love, such is life," and whose appearance was probably modeled upon the glamorous and dramatic Freytag-Loringhoven herself. Duchamp, as "Rrose," was immortalized in a series of photographs by the Dada and Surrealist artist Man Ray, featuring Duchamp dressed delightfully in drag, with a fur-lined coat, befeathered hats, gleaming jeweled rings, and darkly painted lips. Thus the female friend could have been Duchamp, in the guise of Rrose, who anonymously submitted *Fountain* for exhibition. But I'm claiming malarkey on

this theory, simply because surviving references and documentation of Rrose Sélavy—particularly those Man Ray images—point to her conception in the early 1920s. While it is possible that Duchamp experimented with alternative personalities and gender performance prior to this time, this explanation reads as a convenient excuse to me, and not credible given *Fountain*'s 1917 timeline.

"Neuter Is the Only Gender That Always Suits Me": Claude Cahun

In 1917—the same year that begat *Fountain*—a young photographer born Lucie Renée Mathilde Schwob adopted the ambiguously gendered name of Claude Cahun. Fascinated with the concept of personal identity and angered by the strict definitions of gender in early twentieth-century France, Cahun established a nonbinary existence *way* before it was in the news and, unlike Marcel Duchamp, they *lived* their gender performance and fluidity, which was considered quite radical. Cahun's artwork bears out these concerns. From the late 1910s through the 1930s, they produced a series of stunning and strange self-portraits in various guises: as a weightlifter, a shaved-head aristocrat, a puppet, a begoggled aviator, a Buddhaesque holy man. These images (perhaps created in association with their life partner, the similarly ambiguously named Marcel Moore) are playful yet pointed statements about the limitations that Claude—as a self-identified Jewish lesbian artist living in continental Europe during the stormy interwar years—surely experienced during [their] career. As such, it's possible you haven't heard of them—they were too *out there* for their time. But as author Aindrea Emelife notes in a 2016 BBC culture blog, Claude Cahun is the perfect artist for *our* own time. "At a time when Miley Cyrus shouts from the rooftops about being gender-neutral, and when television series such as *Orange is the New Black* welcome transgender characters into their billings, perhaps this is that moment [to celebrate Cahun] . . . [They] shook the foundations and helped . . . sow the seed for the idea to challenge the binaries of gender."

Another faction of Duchamp historians concedes that Baroness Freytag-Loringhoven was indeed the "female friend" who entered *Fountain* into the exhibition, but not as its creator. The baroness, these folks argue, was recruited by Duchamp as a smokescreen delivery person, intended to distance Duchamp from the object and to maintain his anonymity in order to properly challenge the board's adherence to the Society's newly instated constitution. Freytag-Loringhoven, then, would have been a willing coconspirator, but not the progenitor of the world's most infamous ready-made. A variation on this argument was made in late 2019 by Duchamp expert Bradley Bailey, who noted in an article in *The Burlington Magazine* that it was Duchamp's friend, a woman named Louise Varèse, who submitted the work to the Society. Bailey claims that this finding "definitively discounts" the possibility of the baroness's involvement—but it actually begs a secondary question: If Freytag-Loringhoven didn't schlep *Fountain* across town, could she nevertheless have been involved in its artistic inception?

Admittedly, these suppositions are all based on semantics: What does Duchamp mean, exactly, when he notes that a female friend "sent in" the porcelain urinal? Does the phrase connote this friend as the artwork's creator (and we all know how loosey-goosey the term *creator* is within the context of ready-mades), with the phrase effectively acting as a synonym for submission of the work to the exhibition? Or does "sent in" simply mean that this woman delivered the work into the hands of the governing board? You can surely see the difficulty in establishing the facts here. But one thing is most curious: nowhere in Duchamp's letter does he insinuate that the sculpture was ultimately his creation or idea, an idea that his sister, Suzanne (herself a captivating and oft-overlooked Dada artist), surely would have appreciated. *No way*, the pro-Duchamp arguments continue. *Duchamp wouldn't have revealed* Fountain *as his creation to Suzanne, because she would have blown his anonymous cover*. Again, I call BS here, because Suzanne was based in France and did not engage in the same New York–based artistic circles as her famous older brother. There was no danger of revealing Duchamp's supposed secret, especially because Europeans in 1917—embroiled in the First World War—most definitely had other concerns pressing on their minds.

A few tantalizing clues might connect *Fountain* to Elsa von Freytag-Loringhoven. Contemporary newspaper reviews of the Society of Independent Artists' annual exhibition investigated the *Fountain* scandal and noted that the supposed artist, Richard Mutt (merely deemed "R. Mutt" in *Fountain*'s signature, a choice potentially made to keep the gender of its artist ambiguous), was said to be living in Philadelphia at the time of the 1917 exhibition. Is it just a coincidence that Elsa von Freytag-Loringhoven had settled, temporarily, in Philly in February 1917 and did not move back to New York until the following year? And what is the meaning of the pseudonym R. Mutt? As noted earlier, Duchamp claimed it as a reference to the wholesale plumbing company—J. L. Mott—from whom he purchased the urinal. Such an explanation is thrown into question with the knowledge that this particular urinal model was never carried in J. L. Mott's warehouse, as confirmed through its archived catalogs. A natural counterargument may be that Duchamp misremembered or forgot the location of his plumbing purchase, particularly because he didn't begin expounding upon his "creation" of *Fountain* until after 1935—nearly twenty years after its disappearance—and his recollections about the work's specifics would likely have been blurry. That being said, Irene Gammel and several other scholars have an Elsa-related explanation for the name: Gammel connects "R. Mutt" to the Dada proclivity of punning, of which Freytag-Loringhoven was a master:

> [W]hen the initial is turned around and read phonetically, the pseudonym R Mutt becomes Mutt R or *Mutter* (mother [in the German language]). . . . Indeed, R. Mutt phonetically corresponds to *Urmutter* (great mother). . . . Read phonetically, R. Mutt also suggests most immediately the German *Armut* (poverty), the Baroness's chronic state of impoverishment, frequently referred to in her correspondence.

Who better to make a series of German puns than a German artist, a *provocatrix* whose heritage may have caused concern or complication in April 1917, when the United States joined World War I in the Allied Powers' effort to defeat the Central Powers, including Germany? In conjunction

with the U.S. war effort, strict regulations on the movements and actions of U.S.-based German immigrants were passed on April 6—four days before the opening of the Society of Independent Artists' annual exhibition—and the baroness must have been angered by the forced limitation of her freedoms. Viewed within this context, *Fountain* became a political statement, toppling not only art world conventions but also pinpointing where Freytag-Loringhoven's alliances lay: with her *Urmutter*, her *Mutterland*, Germany.

The R. Mutt puns don't stop there. The baroness was a known lover (or hoarder?) of dogs—confirmed by George Biddle's description of the dozen dogs in her studio—and as an English term for a mixed breed, *mutt* would have been a recognizable idiom for the baroness. Taking things even further, Gammel reminds us that Freytag-Loringhoven's favorite profanity was a word of her own making: *shitmutt*, a portmanteau that combines two of the artist's primary concerns—bathroom and dog humor.

A deeper dive into Elsa von Freytag-Loringhoven's artistic output reveals an ongoing obsession with corporeal humor, with an expressed interest in bodily fluids. A convincing case may be made that *Fountain* has an ideological sister, an artwork from the same year titled *God* (1917, Philadelphia Museum of Art, Philadelphia). Consisting of a twisted cast-iron plumbing trap upended (like *Fountain*!) and attached to a wooden miter box, *God* shares the same aesthetic DNA as *Fountain* as an elevation of a functional, everyday item associated with urine and/or feces to the status of fine art. The history of *God* even eerily mirrors the revisionist theory of *Fountain*'s attribution. *God* was ascribed to a male friend of the baroness's for decades: a man named Morton Livingston Schamberg, an American painter and photographer who, like Duchamp, exhibited as a member of the Society of Independent Artists and was part of the Arensberg salon. As Alfred Stieglitz did for *Fountain*, Schamberg famously photographed *God*, leading to the assumption that his image was a documentation of *his* artistic creation, sadly an all-too-common fate for art produced by women over the centuries. In recent years, art historians have confirmed that it was the highly collaborative baroness who conceived of the work of art and scavenged its parts, leaving Schamberg to assemble the work and photograph

it. As such, it is a collaboration between Freytag-Loringhoven and Scham-
berg, and it is to the credit of the Philadelphia Museum of Art that they
have reattributed it as such. Is it too out of line, then, to question whether
Duchamp and Freytag-Loringhoven collaborated in a similar fashion?

Many have wondered why Elsa von Freytag-Loringhoven never claimed
herself as *Fountain*'s creator or cocreator (the latter being Irene Gammel's
proposition for a final attribution of the work). The truth of the matter is
that she didn't have the opportunity. Recall that although *Fountain* made a
huge stir with its submission and rejection from the exhibition of the Soci-
ety of Independent Artists, its disappearance provoked its own forgetting.
The art world moved on, Duchamp moved on, and so did the baroness, who
decamped permanently to Europe in spring 1923. She died from gas as-
phyxiation in her Paris apartment in 1927 at the age of fifty-three, and the
circumstances of her passing are still up for debate: some claim it was
accidental, while others have concluded it was a suicide. Eight years after
the baroness's death, French writer and Surrealist theorist André Breton
resurrected *Fountain* from the depths of history, and it was Breton who
reattributed it to Marcel Duchamp in a retrospective article extolling
Duchamp's artistic output. For his part, Duchamp "confirmed" Breton's
attribution in the 1930s and spent the following decades basking in art-
historical esteem as his ready-mades entered the artistic canon at midcen-
tury (plus, becoming a great granddaddy of modern art was bound to pay
better than a gig as a professional chess player, which had been Duchamp's
primary profession from the 1920s through the mid-1940s). He later over-
saw the commission and fabrication of those various replicas, all of which
certainly meant big money for the art institutions who coveted them and
further glory for the artist who claimed them as his "creations." At the time
of Duchamp's death in October 1968, he was considered an art god, cham-
pioned by neo-Dadaists and newly lauded Conceptual artists. Acclaimed
American painter Jasper Johns wrote an obituary for Duchamp in *Artfo-
rum* magazine, claiming, "Marcel Duchamp, one of this century's pioneer
artists, moved his work through the retinal boundaries which had been

established with Impressionism into a field where language, thought, and vision act upon another. . . . The art community feels Duchamp's presence and his absence. He has changed the condition of being here." And when Duchamp's now infamous April 11 letter to Suzanne Duchamp was discovered in 1982, it was received as a fluke, a misunderstanding, as rabble-rousing as the baroness herself. Even today, many within the art-historical community still feel the pro-baroness argument to be tentative and circumstantial (and they may be right). In short, Elsa von Freytag-Loringhoven never had a chance.

A further difficulty in attempting to corroborate Freytag-Loringhoven's involvement in *Fountain*—as well as any other potential ready-mades or other creations—is that few examples of her artwork exist today. There's little to use as a comparison. Or maybe they *do* exist but are languishing in collections the world over under the name of a more famous (male) artist. Just as harmful to the baroness's artistic reputation was her own dedication—like Duchamp and other Dadaists—to anti-art, or the assertion that art traditions should be challenged and/or rejected. For Freytag-Loringhoven, this often meant dragging her creations into the everyday realm (think of the bizarre, outrageous costumes she'd wear) instead of surrendering them to hallowed artistic spaces. Though she occasionally exhibited her works of art, she chose not to sell them at galleries or art shows, and it was ultimately this high-minded, practically transgressive idea that not only kept her in dire financial straits throughout her life, but also forged a path toward her own evaporation from art history—by not selling art, no collectors or curators could purchase her art, and the cycle of sanctification spurred on by critical analysis and museum inclusion eluded her. By not envisioning her creations as Art with that capital A, the ready-mades of Elsa von Freytag-Loringhoven simply became *objects* and could be discarded, just as *Fountain* probably was.

Nearly forty years have passed since a connection between Freytag-Loringhoven and *Fountain* was first posited, but not much has changed in terms of argument or attribution. While it's true that the art world moves

slowly (and attribution is a notoriously tricky and fickle business—see chapter 8), most museums and critical texts still declare *Fountain* to be an iconic Duchamp ready-made, solely the brainchild of one of the most eminent artists of the twentieth century. On its website, Tate Britain details Irene Gammel's suggestion that the baroness was involved in the work's inception, but points to the lack of hard evidence supporting Gammel's theory—as well as Freytag-Loringhoven's brash personality, implying that she would have spoken publicly about her involvement with *Fountain* during the 1917 brouhaha—as the determining fact for its attribution to Duchamp. Regardless, a movement to reconsider Elsa von Freytag-Loringhoven within the scope of art history—particularly within Dada and surrounding the legacy of the ready-made—has been gaining traction in recent years (#JusticeForElsa occasionally makes the rounds on social media, though when you search for the hashtag on Twitter, for example, you'll find more snarky posts dedicated to the blockbuster Disney film *Frozen* than to our baroness).

For my part, I was surprised, humbled, and enthusiastic to learn of Freytag-Loringhoven's life and work, let alone her hypothetical contribution to the most important artwork of the twentieth century. I'm all about the reframing, revision, and reassessment of art history, particularly to feature diverse stories about women, people of color, and non-cisgender artists (among others) who have been overlooked and overshadowed for decades, if not centuries. But my interest in expanding the art-historical canon is not awash in naivety. The essential question—*was Elsa von Freytag-Loringhoven involved in the "making" of Fountain?*—might seem trite, but even bigger questions and implications lurk just beyond it, and these questions have the potential to make some people very, very angry. *What would it mean if Elsa von Freytag-Loringhoven created* Fountain? *What would happen if we recast the creator of this piece—the work of art officially declared by art world insiders as the most influential and important of the last century—as a woman? Was this strand of modern art born not of a father, but of a mother?* Truth be told, I don't have the answers to these puzzles, but I do know one thing for sure: art history is looking a hell of a lot more interesting these days.

Andy Warhol, *Time Capsule 44*, 1890–1973

CHAPTER 12

Toenails and Junk Mail:
Andy Warhol's Time Capsules

The idea is not to live forever. It is to create something that will.

ANDY WARHOL, ARTIST

"What is it with you and time capsules?"

"I like the idea of a permanent record," he explains. "Something to say, This Is Who I Am, even when I'm not that person anymore . . ."

HARRIET REUTER HAPGOOD, AUTHOR

I was a podcast fan long before I started my own show, bingeing the likes of NPR's *Fresh Air* and *Wait! Wait! Don't Tell Me*, as well as *Pottercast*, one of the first Harry Potter fan downloads (nerd alert), for years. But an all-time favorite, in the pre-*Serial* era, was—and still is—Ira Glass's *This American Life* (*TAL*). I know—it's not an earth-shattering, out-of-the-box confession, as *TAL* has long been a critically lauded and beloved radio program. I recall one episode in particular that had an especially interesting eleven-minute segment. In "Your Junk in a Box," contributor and *TAL* cult favorite Starlee Kine covered the incredible work being done by a group of folks in Pittsburgh who spend their time cataloging an insanely high number of time capsules—610 of them, to be exact. That number alone, and the fact that there are people who spend their workdays studying actual time capsules, was intriguing enough. But I was flabbergasted when I learned that these time capsules were all created and kept by a single person, and

that person wasn't some random guy. This obsessive capsule creator was none other than Andy Warhol (1928–87).

As an art historian and hardworking curator, I was fascinated (and not a little bit ashamed) that I hadn't known about Andy Warhol's time capsules—and yes, that's what he called them, even though they aren't like the bury-in-the-backyard type of time capsules you're probably imagining right now. But I take solace in the knowledge that only a small number of people—mainly his assistants—knew of Warhol's time capsules, and his feverish collecting and containing was largely kept a secret during his lifetime. It might seem as if these capsules are of minor interest to those who are fans of Warhol's Pop Art, but in fact the opposite should be true: taken together, these 610 capsules can be considered one stellar, strange, unwieldy work by one of the most unique minds in modern art.

It's hard to imagine a world without Andy Warhol. He's considered one of the two most influential and popular artists of the twentieth century, alongside Pablo Picasso. And like Picasso, he's got great name and brand recognition: mention Andy Warhol to a passerby, and they probably can either visualize his iconic art—think garish silkscreen paintings of Marilyn Monroe or Jackie Kennedy, or lines of canvases depicting Campbell's Soup cans—or even envisage the artist himself, with his all-black hipster clothes, dark sunglasses, and a shock of white hair. He vastly affected the art world, but also extended far beyond it, inspiring musicians, filmmakers, fashion and graphic designers, and more. And we can't escape him, not that many art aficionados *want* to escape him. As Phoebe Hoban, the biographer of Warhol acolyte Jean-Michel Basquiat wrote, "To legions of art students, Warhol was the white-wigged Wizard of Oz, his famous career a grail to every MFA and struggling downtown artist in residence."

Many Warhol fans gravitate toward that white wig, his mysterious and eccentric personality, and the glam of The Factory, his ultra-cool studio-cum-den of artists and aesthetes, which was frequently filled to the brim with silvery tinfoil, heroin-chic models, and drugs. But Andy Warhol's beginnings were rather humble in comparison to the lifestyle afforded by his

meteoric rise. He was born Andrew Warhola in Pittsburgh on August 6, 1928, and though American-born, Andy was deeply affected by the outsider status of his immigrant parents, who moved from Slovakia before Andy's birth and maintained very strong ties to their Slovakian roots. In fact, like many newcomers to America, the Warhola family specifically chose their new home for its Slovakian population, with Pittsburgh as the epicenter of a sizable enclave of Eastern European immigrants. To young Andy, this probably felt a little bit like belonging and yet not belonging—he was American, yes, but also *not quite*, by virtue of his family ties.

This sensation of being an outsider persisted through much of Warhol's childhood and was made more intense by bouts of severe illness. In 1936, when he was eight years old, he contracted Sydenham's chorea—also known as Saint Vitus's dance—a rare and sometimes fatal disease of the nervous system that causes involuntary movements in one's limbs. He was bedridden for several months during that year and continued to have periods of confinement throughout his youth. Such ailments kept him separate from other children, as he missed large portions of schooling (and probably contributed to a developing fear of doctors and hospitals that ballooned to severe hypochondria in later life). But there was a silver lining. To cope with his illness and feelings of isolation, Andy deeply bonded with his mother, who shared her love of art and taught him to draw so he could pass the time on bedrest. Around this same period, Mama Warhola bought her son his first camera. Drawing and photography soon became the young Warhol's two biggest passions and would ultimately change his life—and art history.

Andy Warhola pursued art throughout his young life, eventually graduating from the Carnegie Institute for Technology (now Carnegie Mellon University) in 1949 with a bachelor's degree in design. Soon after graduation, he moved to New York City, the heart of the postwar art world, to begin his career and develop his own personal branding, an element that would grow increasingly important to him. One of the first things he did upon arrival was to drop the final "a" from his last name, altering Warhola into Warhol. It would be just the beginning of meticulous crafting of the iconic Andy Warhol persona.

Best Friends Forever: Warhol and Basquiat

Andy Warhol and Jean-Michel Basquiat: they're the coolest odd couple in art history, their funky friendship still much-admired and discussed today. Legend has it that the two artists first met after the young and broke Basquiat crashed a business lunch between Warhol and art critic Henry Geldzahler in 1979. After spotting the artist, Basquiat—a longtime Andy fan—burst into the restaurant and attempted to sell Warhol a postcard of his artwork. Geldzahler balked, but Warhol caved, becoming one of the first collectors of Basquiat's works. After the pair was reintroduced at Warhol's Factory in 1982, they became nearly inseparable, with each artist benefiting from the energy and ideas of the other. With Warhol's advice and connections, Basquiat grew from an up-and-coming graffiti artist to the creator of some of the most expensive works of art available at auction today (Basquiat's own canvases garner nearly as much in sales as his friend's canvases). For his part, Warhol, who had long stopped painting by hand by the 1980s, so admired Basquiat's gesturalism that he returned to hand painting, entering a new and reinvigorated period in his late career.

Originally, Warhol was a commercial artist—a highly successful one at that, creating award-winning content for the likes of *Glamour* magazine, where he landed his first job. But as the 1950s came to a close, he began focusing more of his time on painting, and in the early 1960s he debuted his brand-new concept: Pop Art, which focused on the high-art presentation of mass-produced consumer and commercial items. In 1962, he exhibited a series of thirty-two paintings at the Ferus Gallery in Los Angeles, which painstakingly replicated the look of Campbell's soup cans. To top it off, all of Warhol's canvases were lined together on a shelf that ran the length of the gallery, effectually giving the space the look and feel of a grocery store. Living approximately 50 years later, it might be hard for some of us, especially those of us born after Warhol's heyday, to understand the

sensation that this caused throughout the art world, which permeated into the cultural experience of the time. But in 1962, this was huge. Why would a fine artist devote his time to painting images of something used every day, something mass-produced, something so *common*? Andy Warhol lived and breathed this wonderful, befuddling concept, pioneering Pop Art as a purposeful mishmash of popular culture, mass media, and traditional fine art methodology, all with a wink of humor and irony. In 1964, for example, he—with the help of carpenters and several assistants working in an assembly line fashion—replicated the look of Brillo soap pads boxes so exactly that his plywood versions thoroughly confused audiences, who thought he was simply displaying a bulk grocery purchase, years before the invention of Costco. When viewers realized his Brillo replications were to be considered Art with a capital A, some became incensed.

Okay, I'm not the first person to admit this, and I certainly won't be the last, but you may be aware that the art world can sometimes be a tiny bit *elitist*. Especially prior to the mid-twentieth century, the long-assumed purpose of art was to glorify or beautify human existence. It was supposed to be transcendental—art is among the special things that set us, as humans, apart from other of earth's creatures, right? *So why would Andy Warhol want to bring art down in this way?* (Many asked the same question of Marcel Duchamp during his heyday too—see chapter 11.) Indeed, much of the response to the Campbell's soup series, for example, was not positive at the outset. *The Los Angeles Times* critic who covered the 1962 exhibition wrote, "This young 'artist' is either a soft-headed fool or a hard-headed charlatan." A snarky gallery down the street took the criticism further by stacking a pile of *actual* soup cans in the window, advertising them for sale at two for thirty-three cents. All joking and criticism aside, Warhol's Pop Art made his career and shot him to superstar status (a term which he would popularize, by the way—even if he didn't invent it, as is frequently reported). It was also a breakout moment for the art world, with the production of art that was truly democratic, spoke to the Everyman, and in a detached and ironic way, captured the idea of consumer America in one fell swoop. When asked by Gene Swenson, an art critic for *ARTnews*, to define Pop Art, Warhol simply replied, "It's liking things."

. . .

Consumerism—consuming both stuff and ideas—was a passion for Andy Warhol, and he bought into the concept at a very early age. While on bed-rest as a child, his third preoccupation—after drawing and photography—was collecting images and autographs of celebrities he idolized. At around ten years old, Andy began a scrapbook documenting his love of celebrity culture, and his long bouts of illness provided him with the opportunity to spend innumerable hours writing fan mail to his favorite movie stars, re-questing autographs and promotional photography. This scrapbook, which he maintained for four years, included images of luminaries like Car-men Miranda, Jane Russell, Mae West, and—his all-time favorite—Shirley Temple, many of which are emblazoned with best wishes "To Andy" or "To Andrew." Shirley's note is adorably misspelled, reading "To Andrew Worhola [sic], from Shirley Temple." (Shirley Temple's autograph may have been an especially personal gain for Warhola on a couple different levels—as a child frequently unable to connect to other children, the attachment provided by a kid star must have been profound. Similarly, some reports noted that he learned English at a comparatively late age in childhood, as his parents spoke Ruthenian—a Slovak dialect closely linked to Ukrainian—at home. His primary English teacher, then? Shirley Temple films.) Though Warhol stopped adding new autographs and photos to his scrapbook around 1942, he didn't stop collecting all things celebrity. In fact, his fasci-nation with fame, as well as his instinct to acquire objects, only increased as he grew older. As Amy Barclay, a curator at the National Museum of Victoria, notes in her essay, "Andy Warhol: To Have and to Hold, a Portrait of the Artist as Collector," "[Collecting] was not a hobby [for Warhol]; it was a function of daily life."

And oh my, what a collector he was! Prolific, compulsive, and inter-ested in practically anything and everything, Warhol's collections span the gamut between fine art and antiques worth millions of dollars, to accessible—even low-brow!—Fiestaware dishes, decorative cookie jars, and costume jewelry. Once an idea hit—*I love Art Deco, I want to know more about it!*—he became insatiable and worked incessantly to grow his

holdings. Close friends knew Andy as a hunter-gatherer who trawled not only the finest galleries and auction houses in New York City, but also its flea markets and junk shops in search of the best objects and best prices, and in the last decade of his life, he began every morning with a bargain hunt in the company of friends. And like the best cast members of *Hoarders* or *Storage Wars*, Andy proclaimed that he was "always looking for that five-dollar object that's really worth millions."

It was only a select few who knew of Andy's urge to collect and to purchase. But almost no one knew the extent of his obsession, the results of which he kept hidden away at home. Even his dearest pals were not allowed to enter his inner sanctum, the mid-nineteenth-century town house he occupied at 57 East Sixty-Sixth Street in Manhattan's tony Upper East Side. Partially this was because Warhol had had a bad experience—to put it mildly—with an equally obsessive individual in the late 1960s (see below), and he fiercely guarded his privacy. The other factor, though, was that his collecting had gotten so out of hand that at the time of his death in 1987, his town house was so chock-full of stuff that he only occupied a fraction of his five-story, twenty-seven-room home, reportedly living solely in his kitchen and bedroom. (And I'll go ahead and say what we are all thinking: *What about the bathroom?!*)

The Shooting of Andy Warhol . . . and His Death Twenty Years Later

In 1966, schizophrenic women's rights activist Valerie Solanas met Andy Warhol and attempted to persuade him to produce a play she had written. When Warhol demurred, it stunned and disappointed Solanas, who was left seething and plotting. Two years later, she exacted revenge: on June 3, 1968, she shot the iconic artist, rendering him severely injured, and even briefly declared dead. This shooting intensified the deep fear of hospitals, doctors, and all medical procedures in Andy—already a known hypochondriac—and he avoided

them at all costs. Many believe that Solanas's attack, then, spurred his *actual* death in February 1987 after an acute gallbladder infection. His death could have been avoided, some argue, if he had sought traditional medical treatment sooner.

All of this—Andy Warhol the super intense pack rat, the obsessive collector—was secret during his lifetime. It was only after his death when the renowned auction house Sotheby's was charged with managing and auctioning Warhol's estate that this ultra-private side came into the public eye. And poor Sotheby's didn't know what they were in for when they agreed to sell more than ten thousand individual objects in an unprecedented sale, one that took ten days to complete and became known colloquially as the garage sale of the century due to its mix of ultra-posh and completely lowbrow items. It was witnessed by a celebrity-packed audience: Joan Didion, John Gregory Dunne, Dick Cavett, Warren Beatty, and others reportedly ogled the goods in the standing-room-only auction.

Just when it looked as if Andy's Crazy House of Crap would be the epitome of Warhol wackiness, another surprise was revealed. Among the antiques and housewares not chosen for the estate sale were many cardboard boxes filled to the brim with the most random *stuff*: newspaper clippings, sketches, exhibition announcements, personal photographs, comic books, advertisements, toenail clippings, moldy food wrapped in napkins, dead ants, a mummified foot, and used condoms (grrooosssssssssss). What was even more surprising was the number of these boxes: more than six hundred in total, spread throughout Andy's town house, studio, and various storage facilities in New York and New Jersey. It seemed, at first, like a mishmash of items stored irregularly. Only later was it revealed that there was a deliberateness to the entire scheme. Behold: Andy Warhol's time capsules.

The birth of Andy Warhol's time capsules began, appropriately, during a move. In 1974, Warhol was preparing for a dual transition—changing both

house and studio simultaneously—and naturally needed a bunch of supplies to facilitate the process. His assistants bought some high-quality cardboard boxes, and as he packed up his belongings into them, Andy noticed that these weren't your everyday boxes—these were high-quality archival containers, meant to stand the test of time. Inspiration struck—and collection-prone Andy decided to use these containers to create his own archive, filling boxes at his desk with whatever detritus felt necessary to save at that moment. While he was partially influenced by friend and playwright Tennessee Williams, who, Andy noted, "saves everything up in a trunk and then sends it out to a storage place," Andy regulated the activity not only in size and shape of the container but also in his approach. Initially he conceived of a consistent and reasonable timeline for these newly dubbed "time capsules," aiming to fill one box per month. When each box was at capacity, he then ordered it moved to long-term storage. He shared this philosophy in his book *The Philosophy of Andy Warhol (From A to B and Back Again)* (1975, Harcourt, Inc.), advising his readers:

> What you should do is to get a box for a month, and drop everything in it and at the end of the month lock it up. Then date it and send it over to Jersey. You should try to keep track of it, but if you can't and you lose it, that's fine, because it's one less thing to think about and another load off your mind.

These time capsules acted like an unofficial archive, supplying the artist with a specific space for anything worth saving or remembering (which, in Warhol's mind, was practically everything—a pair of Clark Gable's shoes mingle with a pile of junk mail, and photos of friends molder next to—of course!—a Campbell's soup can, unopened and certainly *not* tasty anymore). It allowed him to cleanly pack up objects in a mostly organized manner, without the fear of losing or forgetting them—not that he often accessed them after he sent "it over to Jersey." Sometimes he went a bit too far with his capsule creations, though, dropping in items still necessary for ongoing projects. One Warhol employee, Vincent Fremont, noted that contracts for commissions were sometimes thrown into capsules without

being reviewed or signed, leaving Factory workers scrambling for weeks on end to locate them.

Ironically, though, the time capsules also allowed him to forget. Packing away the clutter and detritus of his life freed up Warhol's mind, like moving files to an external drive to gain more space on your laptop. The time capsules are curious and contradictory, then, in their function, occupying what Thomas Sokolowski, previous director of the Andy Warhol Museum, calls "a realm between presence and disappearance." In this way, Warhol's cardboard boxes functioned both similarly—and yet rather differently—than a traditional time capsule.

I can't think of any kid—especially an American one—who isn't in love with the idea of a time capsule. There is something so optimistic, so intimate, and just plain *fun* about trying to pack a container with objects that symbolize this moment in time with the intention of preserving it for the future. And when time capsules first made a splash in the United States, Andy Warhol was a child and may very well have been inspired.

In 1937, a group of organizers from the Westinghouse Electric and Manufacturing Company began preparing the first-ever time capsule for the 1939 World's Fair in New York. The concept behind the time capsule—the notion of a container that preserves the details of a period for future consumption—was not new; in fact, it was millennia old, with some historians claiming *The Epic of Gilgamesh*—the world's earliest known work of literature, written sometime between 2150 and 1400 BCE—as the world's first time capsule reference.

Like any good marketing department, the folks at Westinghouse rebranded the well-established concept with a catchy, PR-friendly name befitting the approaching Space Age, coining their missile-shaped container a time capsule (a vast improvement on their semiapocalyptic proposed phrase *time bomb*, which wouldn't have played well given the impending entry of the United States into World War II). Inside they housed a variety of everyday items meant to epitomize the epoch, including several issues of

Life magazine, a variety of seeds (tobacco, flax, cotton, and rice primary among them), a dollar in change, and a single packet of Camel cigarettes. In addition, rolls of microfilm contained a dictionary of approximately one million words from the English language and a copy of a Sears Roebuck catalog. Not the most thrilling choices, perhaps, for long-term presentation, but at least one major item is protected therein: a letter from Albert Einstein, in which he states, in part, "Our time is rich in inventive minds, the inventions of which could facilitate our lives considerably. . . . We have learned to fly and we are able to send messages and news without any difficulty over the entire world through electric waves. However . . . people living in different countries kill each other at irregular time intervals, so that also for this reason any one [*sic*] who thinks about the future must live in fear and terror." This combination of pride, hope, and fear is the emotional crux of the power of time capsules both then and now.

The capsule was buried on September 23, 1938, at 12:59 p.m., the precise moment of the autumnal equinox. The site of the capsule was one of the biggest draws of the 1939 World's Fair, with more than 44 million visitors clamoring for a look at the capsule's site between April 30, 1939, and October 27, 1940. Today, it remains housed fifty feet below the ground in Flushing Meadows–Corona Park, where it's due to stay until it is opened in the year 6939—*five thousand years* after the start of the fair. This is the most ridiculous element—and an outrageously hopeful one, I must add—of the Westinghouse Time Capsule I (so named to distinguish it from a second Westinghouse capsule buried at the 1964 World's Fair. That capsule contains a copy of a Beatles record, though, so it wins my vote for the cooler of the two World's Fair compilations).

Though Andy Warhol and his family were not among the millions who attended the 1939 Fair, it is probable that he knew of the event and of its most popular exhibit. The Westinghouse Time Capsule I was the most highly publicized aspect of the fair, with a press release celebrating its creation and contents distributed to newspapers across the country, including *The Pittsburgh Post-Gazette*, young Andy Warhola's hometown daily. It's fascinating to think that this potential exposure, albeit indirect, to the concept of a time

capsule may have stuck with him as he aged, springing to mind nearly four decades later with the conception of his own capsule project.

As all time capsules do, Andy Warhol's capsules capture—whether intentional or not—the zeitgeist of his times, though not always in an expected order. Polaroids and photobooth strips mix with art exhibition announcements, newspaper clippings, and movie stills and posters, all from different years or periods. Though Warhol began actively creating his capsules in the mid-1970s, much of their content is older, comprised of an assortment of objects that he had amassed throughout his lifetime but had not yet distributed or organized in any way. The time capsules provided a way to systematize portions of his obsessive collecting and documenting, to which he alluded in *The Philosophy of Andy Warhol*, writing, "My conscience won't let me throw anything out, even when I don't want it for myself." Over time, the capsules proved more manageable when kept to a shorter time period or when organized around a particular theme or event (Warhol had a "Concorde Box," wherein he kept souvenirs, silverware, and documentation of his numerous transatlantic flights on the now-defunct Concorde supersonic passenger jet to give just one example). The box-of-the-month eventually won out as the artist's preferred methodology for systematizing his life, though perhaps as to be expected, Warhol's prolific collecting meant that he typically superseded his own capsule goals. The original intention—to save one box of items per month—should have yielded approximately 150 time capsules in the thirteen years Andy actively engaged in this project. By the time of his death in February 1987, he had amassed 610.

While the abundant remnants of an era are an interesting aspect of Warhol's time capsules, they are not the most vital revelations found therein. More important, they preserve the secretive artist's professional concerns, personal preoccupations, and human mundanity in equal measure. Time Capsule 21, for example—detailed piece by piece in the wonderful *Andy Warhol's Time Capsule 21*, published by the Andy Warhol Museum in Pittsburgh in 2004, portrays this mix. Capsule 21 is considered a magnum opus among other capsules, as it contains a huge number of

sketches and source material for multiple projects, including the original newspaper article from the *New York Mirror* that inspired his iconic painting *129 Die in Jet!* (1962, Museum Ludwig, Cologne). In addition, Warhol saved nine copies of the 1969 inaugural copy of *Inter/View* magazine, his "Crystal Ball of Pop," wherein the artist served up interviews from celebrities of all flavors (this publication lives on today, under the simpler name *Interview*). He also included a full-page ad from *Arts* magazine promoting *Inter/View*, all of which connotes his pride in adding "publishing mogul" to his long list of accomplishments.

On the banal end, business cards litter the capsule. One, from a company called Odyssey, Ltd., notes its dealings in "primitive arts" and "exotic clothing and crafts," which connects nicely with the now-known reality of Warhol-as-collector. My favorite, though, is an invoice for purchases from an antique dealer, with one of the items sold to Warhol listed as a "Tin Painted Spittoon." The utter normality of the included phone bills, collect call messages, and income tax documents rounds out the picture of Warhol-as-person.

Wigging Out: Warhol's Pileous Prized Possessions

Stars—they're insecure, just like us! Pop Art superstar Andy Warhol began donning wigs in his twenties after experiencing significant premature baldness. Horrified, he bought a wig to cover his head . . . and immediately fell in love with the accessory. He owned more than forty wigs at one point—most were a variation on platinum, silver, and light gray—and he cherished each of them: they functioned not only as a head covering, but as one of the most iconic aspects of the Warhol brand or mythology. Such a recognizable look not only makes for an easy, fun Halloween costume today, but also an expensive goal point for serious wig collectors (which is a thing, believe it or not): in 2006, one of Warhol's famed toupees fetched nearly $11,000 at auction.

• • •

The time capsules provide us with something extraordinary—an insider's look at a person so private and mysterious that few gained access to the *real* Andy Warhol. But like those silvery wigs and the alteration of his last name, Warhol's unknowability was part of his brand, manufactured not necessarily out of need for confidentiality—though that surely was some motivation—but more for the cool factor. He once reported, "I'd prefer to remain a mystery. I never give my background, and anyway, I make it all up different every time I'm asked." Truman Capote, author of *In Cold Blood* and *Breakfast at Tiffany's*, wittily synthesized his enigmatic friend in one perfect line, noting, "He was a sphinx without a secret." *Burn!*

That sense of mystery, too, gives us a glimpse into the ultimate intentions for Andy Warhol's time capsules. Yes, *sure*, they were for archival and organizational purposes, but the artist went so above and beyond with this project—610 boxes, for goodness sake!—that it is entirely likely there was something else going on behind it. A hint exists in Andy's diary in a notation written shortly before his death. "I took a few time capsule boxes to the office. They are fun—when you go through them there's things you really don't want to give up. Some day [*sic*] I'll sell them for $4000 or $5000. I used to think $100, but now that's my new price." If Warhol had been able to follow through with this plan, his time capsules may have functioned like grab bags full of surprises, luring clients with the tantalizing gamble of the unknown. A fortunate buyer may have ended up with something like Time Capsule 21 with its wealth of source material and art-related items. Another buyer, though, might have inadvertently purchased a box containing one of those rotten food scraps—which might be a lucky or unlucky thing, depending on your opinion. The most famous food "preserved" in a Warhol time capsule, for example, was a piece of Caroline Kennedy's sixteenth birthday cake, which might be pretty rank, but also would have made a supremely amazing story to tell at parties for the rest of your natural life.

I, for one, am actually glad that Warhol never lived long enough to dole out his time capsules piecemeal for $5,000 a pop. Each box can be consid-

ered its own ecosystem, a controlled yet equally spontaneous combination of the trivial and the vital, fascinating in its own right. But as a whole, the capsules become an incredible work of art, an installation taken to the obsessive, consumerist extreme. Some may laugh at the designation of these junk-filled cardboard boxes as art. The capsules certainly bear no physical resemblance to his classic silkscreened paintings like the *Marilyn Diptych* (1962, Tate Modern, London) or *Silver Car Crash (Double Disaster)* (1963), which set the record for the highest price for an Andy Warhol painting in 2013 when it was sold to a private collector for $105 million. At the same time, the time capsules make perfect sense within the artist's body of work. Warhol's creations frequently toed the line between the important and the inane, between highbrow and pop culture. Think of those Brillo boxes and Campbell's soup cans, both humdrum items elevated and transformed into subject matter for masterpieces through Andy Warhol's mediation. The contents of the 610 time capsules—an ashtray, a greeting card, a belt buckle—undergo a similar apotheosis and are given their "fifteen minutes of fame," as the artist himself once famously quipped. Even the repetitious act of capsule creation is reminiscent of the image multiplication inherent in many of Warhol's most archetypical silkscreen paintings. Most important, they function as a mega self-portrait, edited and idealized (as most self-portraits are) and yet extraordinarily intimate. It's the Andy Warhol we would have otherwise never seen, a glimpse behind the Ray-Bans and under the white wig. "Never has the concept of self-storage been so ironically redefined," opined curator Amy Barclay.

A wonderful consumer-minded postscript was added to this tale in mid-2014. In 1994, the Andy Warhol Foundation gifted the entirety of the time capsules to the Andy Warhol Museum in Pittsburgh, where each box has been stored and maintained. Over the years, the capsules have been opened one by one, with the contents meticulously examined and documented. At least one time capsule is on view at the museum at any given time, and capsule elements and archival materials are frequently integrated into exhibitions to provide context and further elaboration for Warhol's life and work. They are also a great incentive for fundraising, and the Warhol Museum smartly organized *Out of the Box* events where visitors could

witness the unveiling of a capsule for the cost of museum entry (a bargain at twenty dollars, if you ask me). For the Museum's twentieth anniversary, they took it up a notch and auctioned off the opportunity to be a part of history—to open the very last of Andy Warhol's time capsules, with the proceeds supporting the museum's exhibitions and programming. The ploy worked, and an anonymous bidder paid $30,000 for the privilege of examining the surprises therein alongside museum archivists and curators.

I think Andy would have loved that.

Acknowledgments

ArtCurious, the podcast, began as a one-woman project—but *ArtCurious*, the book, was a team effort from its inception. First, huge thanks go to my agent, William Clark, who took a risk on an unknown entity (me!) and allowed me to be an addition to his exclusive roster. Thank you, William. You made me feel special from the very beginning, and your thoughtfulness, joy, and enthusiasm for all things art (and Paris!) influenced this book's tone and vision.

Second, I can't imagine writing this book without having my editor, Meg Leder, walking me through the process. Upon our first phone call—before a book deal was even offered—I experienced a buzzy and immediate kinship with her, a strange "She's the one!" feeling that signaled that we were about to embark on an incredible journey together. After our first lunch meeting a few months later, I left with the confirmation that not only was my writing in excellent hands with her, but I have made a new, irresistible friend. Thanks, Meg. You're tops.

At Penguin Books, thanks to Patrick Nolan for his curiosity and interest in this project, and for being an enthusiastic and encouraging fellow traveler (Macedonia was well worth the visit, Patrick). Thank you to copy editor Susan Lee Johnson and to the whole Penguin team, including Shannon Kelly, Amy Sun, Matt Giarratano, Carlynn Chironna, Emma Brewer, Cassie Garruzzo, Colin Webber, Rebecca Marsh, Britta Galanis, Nora Alice Demick, and Mary Stone.

Several early supporters of the *ArtCurious* podcast helped me stay motivated and on target, and some even assisted with marketing, audio

editing, graphic design, promotion, social media, and more (and still do!), while others offered me a listening ear, margaritas, and coffee. Special shout-outs go to Natalie Broyhill (GIF goddess); Emily Crockett (Twitter pro); Linda Dougherty (boss—and friend—extraordinaire); Laura Finan (the essence of calm); Caroline Haller (queen of Instagram planning); Kat Harding (my person!!); Shannon Johnstone (fine purveyor of author photos and dog cuddles); Megan Marshall Kaiser (sanity saver and number one margarita pal); Molly Matlock (calmness and creativity idol); Dave Rainey (graphics guru); Hannah Roberts (editing expert); Ben and Carrie Sigrist (true parenting heroes and truest of friends); Steve and Judy Spiro (who are all things to me, as family should be), Janis Treiber (AC's first promoter!), and Juli Kempton Woodward (bestie, always). I love you all.

Both book and podcast have benefited from the help of talented research assistants over the past three years, especially as I worked to maintain the audio show while in the process of writing these chapters. Thanks to researchers Kelsey Breen, Kyle Canter, Alexandra Cengher, Holly Chang, Nick Duncan, Valerie Genzano, Patricia Gomes, Adria Gunter, Kristin Hansen, Grace Harlow, Bernadette Keating, Grace Kim, Abby MacDonald, Joce Mallin, Jodi McCoy, Arina Novak, Luke Peterson, Stephanie Pryor, Bryn Robbins, Shella Seckel, Emily Maude Snow, Raven Todd Da Silva, Claire Wagner, Rachel Whitaker, and Jessica Wollschleger. Extra-super special thanks to NCMA librarians Natalia Lonchyna and Erin Rutherford for their further research and reference expertise (and all-around greatness). And I raise a pumpkin spiced latte to my friend and colleague, Michele Frederick, for providing extra proof that still life paintings are indeed freaky (even if only relegated to a sidebar).

Without financial backing, I could not have grown the podcast to its current iteration, which ultimately begat this book. Boundless gratitude to James and Bernadette Goodnight for their ongoing support and belief in all things *ArtCurious*. Anchorlight Raleigh has been a wonderful partner since our second season, and I'm thrilled to be affiliated with such an incredible, versatile organization. Thanks to Shelley Smith, Anchorlight's director, for her creativity and kindness. VAE Raleigh's fiscal sponsorship

makes it all happen—thanks especially to Brandon Cordrey and Erika Corey. Additional bonus points to the fine folks at AdvertiseCast.

In both undergraduate and graduate school, I benefited from the brilliance and general awesomeness of many art history professors, particularly at the University of California, Davis, and the University of Notre Dame. My indebtedness, especially, to Dianne Sachko Macleod, Kathleen Pyne, Robin Rhodes, and Randy Coleman.

To the course counselor who registered me (without my permission!) into my first introductory art history course, circa 1998: wow, thank you for doing that. Sorry I was so grumpy about it. And to the teaching assistant for that same course: I can't remember your name, but you utterly changed my life the day you casually remarked, "You'd make a great art historian." This journey began with you two. Thank you.

My parents, David and Elizabeth Ward, raised me to believe I could do anything and could be great at whatever I attempted to do. And I'm so thankful for this, because their eternal love, dedication, support, and resources allowed me to pursue my dreams (and still do, always). I was pretty terrified of disappointing them when I changed my major to art history—after all, who in their right mind was going to major in something that seemed so trite to so many in the twenty-first century?—only to find that they were rather enthusiastic right from the get-go. Thank you, Parentals, for everything. I love you incredibly much, and I wish and hope that these small words can effectively express my gratitude.

Sweet Felix, you were such an awesome baby and toddler that, when you were scarcely over a year old, I felt emboldened and inspired enough to tackle beginning a podcast from scratch—not a small feat. As you've grown, you've helped to diffuse my stress levels with your infectious humor and frequent cuddles, and your own attempts at "podcasting" are everything to me. I love you a million billion gummy bears in the whole world, always and forever. Now, please go play and let me take a nap.

Last, to Josh. I scoffed when you first mentioned that you thought *Art-Curious* should be a book, but your gentle persistence, encouragement, and faith in me and my abilities eventually wore me down (in the best way

possible). Your dreams for me have allowed me—and us, I hope—to consider a bigger, bolder, and more satisfying life. All credit goes to you: this book was your idea. You're my favorite collaborator, reader, editor, idea generator, producer, manager, and podcast fan. You're also my favorite everything else, and I'm so lucky that I get to spend my life loving you.

Bibliography and Recommended Reading

CHAPTER 1: YOUR MOM'S FAVORITE PAINTER WAS A BADASS: CLAUDE MONET AND THE SUBVERSIVE IMPRESSIONISTS

Boime, Albert. "The Salon des Refusés and the Evolution of Modern Art." *The Art Quarterly* 32, Spring (1970).

Clark, T. J. *The Painting of Modern Life: Paris in the Art of Manet and His Followers.* Princeton: Princeton University Press, 1999.

Kendall, Richard. *Monet by Himself: Paintings, Drawings, Pastels, Letters.* London: Little, Brown, 2003.

Lewis, Mary Tompkins, ed. *Critical Readings in Impressionism and Post-Impressionism: An Anthology.* Berkeley: University of California Press, 2007.

Tucker, Paul Hayes. *Claude Monet: Life and Art.* New Haven: Yale University Press, 1997.

Wildenstein, Daniel. *Monet.* Köln: Taschen, 1994.

——. *Monet: The Triumph of Impressionism.* Koln: Taschen, 2003.

SIDEBARS

Payne, Stewart. "Cataracts the Key to Monet's Blurry Style." *The Telegraph*, May 16, 2007. Accessed December 30, 2018: https://www.telegraph.co.uk/news/uknews/1551703/Cataracts-the-key-to-Monets-blurry-style.html\.

Richardson, John. "Degas and the Dancers." *Vanity Fair*, January 31, 2015. Accessed January 7, 2019: https://www.vanityfair.com/news/2002/10/degas200210\.

Shanahan, Mark. "Renoir Haters Picket Outside Museum of Fine Arts." *The Boston Globe*, October 5, 2015. Accessed January 7, 2019: https://www.bostonglobe.com/lifestyle/names/2015/10/05/renoir-haters-picket-outside-museum-fine-arts/e0ybbZMdhVclxN01wfmaYM/story.html\.

"The Dark Side of Impressionism." *Artsy*, July 12, 2013. Accessed January 7, 2019: https://www.artsy.net/article/ssoftness-the-dark-side-of-impressionism\.

CHAPTER 2: SECRETS AND LINES: THE CIA/ABEX CONNECTION

Art Interrupted: Advancing American Art and the Politics of Cultural Diplomacy. Athens: Georgia Museum of Art, University of Georgia, 2012.

Bartley, Russell H. "The Piper Played to Us All: Orchestrating the Cultural Cold War in the USA, Europe, and Latin America." *International Journal of Politics, Culture, and Society*, vol. 14, no. 3 (Spring 2001): 571–619.

Bender, Thomas. "Behind the Scenes of Abstract Expressionism." *The New York Times*, January 1, 1984, section 7: 7.

Bennett, James T. *Subsidizing Culture: Taxpayer Enrichment of the Creative Class.* New York: Routledge, 2017.

Burstow, Robert. "The Limits of Modernist Art as a 'Weapon of the Cold War': Reassessing the Unknown Patron of the Monument to the Unknown Political Prisoner." *Oxford Art Journal*, vol. 20, no. 1 (1997): 68–80.

Coleman, Peter. *The Liberal Conspiracy: The Congress for Cultural Freedom and the Struggle for the Mind of Postwar Europe.* New York: The Free Press, 1989.

Collins, Bradford R. "*Life* Magazine and the Abstract Expressionists, 1948–51: A Historiographic Study of a Late Bohemian Enterprise." *The Art Bulletin*, vol. 73, no. 2 (June 1991): 283–308.

Davis, Stuart. "What About Modern Art and Democracy?" *Harper's Magazine*, vol. 188, no. 1123 (December 1943): 16–23.

Doss, Erika. *Benton, Pollock, and the Politics of Modernism: From Regionalism to Abstract Expressionism.* Chicago: The University of Chicago Press, 1991.

Dossin, Catherine. "To Drip or to Pop? The European Triumph of American Art." *Artl@as Bulletin*, vol. 3, issue 1 (Spring 2014): 79–103.

Genter, Robert B. "Barnett Newman and the Anarchist Sublime." *Anarchist Studies*, vol. 25, no. 1 (Spring 2017): 8–31.

Golub, Leon. "A Critique of Abstract Expressionism." *College Art Journal*, vol. 14, no. 2 (Winter 1955): 142–147.

Guilbaut, Serge. *How New York Stole the Idea of Modern Art: Abstract Expressionism, Freedom, and the Cold War.* Translated by Arthur Goldhammer. Chicago: The University of Chicago Press, 1983.

"Jackson Pollock: Is He the Greatest Living Painter in the United States?" *Life*, August 8, 1949.

Johnston, Gordon. "Revisiting the Cultural Cold War." *Social History*, vol. 35, no. 3 (August 2010): 290–307.

Landau, Ellen G., ed. *Reading Abstract Expressionism: Context and Critique.* New Haven: Yale University Press, 2005.

Mathews, Jane de Hart. "Art and Politics in Cold War America." *The American Historical Review*, vol. 81, no. 4 (October 1976): 762–787.

Menand, Louis. "Unpopular Front." *The New Yorker*, October 17, 2005.

Sandler, Irving. *The Triumph of American Painting*. New York: Praeger Publishers, 1970.

Saunders, Frances Stonor. *The Cultural Cold War: The CIA and the World of Arts and Letters*. New York: The New Press, 2013.

Setiwaldi, Ajinur. "Historical Controversy of 'Advancing American Art' Revisited. *Assignment: Radio*, podcast audio, March 18, 2013. Accessed January 30, 2020: https://www.kgou.org/post/historical-controversy-advancing-american-art-revisited\.

Sivard, Susan. "The State Department 'Advancing American Art' Exhibition of 1946 and the Advance of Modern Art." *Arts Magazine*, vol. 58, no. 8 (April 1984): 92–99.

Sooke, Alastair. "Was Modern Art a Weapon of the CIA?" BBC News, October 4, 2016. Accessed January 25, 2020: www.bbc.com/culture/story/20161004-was-modern-art-a-weapon-of-the-cia\.

Spicer, Frank. '*The New American Painting*, 1959', in *Modern American Art at Tate 1945–1980*, Tate Research Publication, 2018. Accessed January 31, 2020: https://www.tate.org.uk/research/publications/modern-american-art-at-tate/essays/new-american-painting\.

Shark, Annabell. "MoMA, The Bomb and the Abstract Expressionists." *Direct Art*, vol. 4, no. 1. Accessed January 21, 2020: http://www.slowart.com/articles/cia.html\.

The New American Painting, as Shown in Eight European Countries, 1958–1959. New York: Museum of Modern Art International Program, 1959.

"*The New American Painting*, Large Exhibition, Leaves for Year-Long European Tour Under Auspices of International Council at Museum of Modern Art—Press Release." Museum of Modern Art website, March 11, 1958. Accessed January 31, 2020: https://www.moma.org/momaorg/shared/pdfs/docs/press_archives/2342/releases/MOMA_1958_0025.pdf\.

Wilford, Hugh. *The Mighty Wurlitzer: How the CIA Played America*. Cambridge: Harvard University Press, 2008.

"Worldwide Propaganda Network Built by the C.I.A." *The New York Times*, December 26, 1977. Accessed January 29, 2020: https://www.nytimes.com/1977/12/26/archives/worldwide-propaganda-network-built-by-the-cia-a-worldwide-network.html.

SIDEBARS

Blakemore, Erin. "Scientists Analyze the Physics of Jackson Pollock's Famous Painting Technique." *The Washington Post*, November 9, 2019. Accessed February 1, 2020: https://www.washingtonpost.com/science/scientists-pour-over-the-secrets-of-jackson-pollocks-famous-painting-technique/2019/11/07/945d2628-00ec-11ea-8501-2a7123a38c58_story.html\.

"Music 'Hidden' in Last Supper Art." BBC News, November 10, 2007. Accessed January 29, 2020: http://news.bbc.co.uk/2/hi/europe/7088600.stm\.

Schreyach, Michael. "'I am Nature': Science and Jackson Pollock." *Apollo: The International Art Magazine* (July 2007): 35–43.

Silverman, Robert. "The Russian Spy Who Duped My Dad." *Salon*, February 9, 2014. Accessed January 25, 2020: https://www.salon.com/test/2014/02/09/the_russian _spy_who_duped_my_dad_partner/.

CHAPTER 3: WAS BRITISH PAINTER WALTER SICKERT REALLY JACK THE RIPPER?

Baron, Wendy. *Sickert: Paintings*. New Haven: Yale University Press, 1993.

Carr, Caleb. "Dealing with the Work of a Fiend." *The New York Times*, December 15, 2002.

Cornwell, Patricia. *Portrait of a Killer: Jack the Ripper Case Closed*. New York: G. P. Putnam's Sons, 2002.

——. *Ripper: The Secret Life of Walter Sickert*. Seattle: Thomas and Mercer, 2017.

Daniels, Rebecca. "Walter Sickert and Urban Realism: Ordinary Life and Tragedy in Camden Town." *The British Art Journal*, vol. 3, no. 2 (Spring 2002): 58–69.

Fuller, Jean Overton. *Sickert and the Ripper Crimes: The Original Investigation into the 1888 Ripper Murders and the Artist Walter Richard Sickert*. Oxford: Mandrake, rev. 2002.

Jones, Jonathan. "Walter Sickert Was Jack the Ripper? Nonsense! He Was Actually Dracula." *The Guardian*, December 3, 2013. Accessed May 13, 2019: https://www .theguardian.com/artanddesign/jonathanjonesblog/2013/dec/03/walter-sickert -jack-ripper-sex-evil\.

Knight, Stephen. *Jack the Ripper: The Final Solution*. London: Panther Books, 1977.

Pelowski, Paul, ed. *Sickert and Thanet: Paintings and Drawings by W. R. Sickert 1860–1942*. Exhibition catalog. Kent: Ramsgate Library Gallery, 1986.

"Portrait of a Killer: Jack the Ripper, Case Closed." Book review (starred). *Publishers Weekly*, November 11, 2002.

Rubenhold, Hallie. *The Five: The Untold Lives of the Women Killed by Jack the Ripper*. Boston: Houghton Mifflin Harcourt, 2019.

Ryder, Stephen P. "Patricia Cornwell and Walter Sickert: A Primer." Casebook.org. Accessed May 13, 2019: https://www.casebook.org/dissertations/dst-pamandsickert .html\.

Sawyer, Diane. "Stalking the Ripper." *Primetime*. ABC, August 8, 2002.

Tickner, Lisa. *Modern Life & Modern Subjects: British Art in the Early Twentieth Century*. New Haven: Yale University Press, 2000.

Wright, Barnaby, ed. *Walter Sickert: The Camden Town Nudes*. London: Paul Holberton Publishing, 2008.

SIDEBARS

Graham-Dixon, Andrew. *Caravaggio: A Life Sacred and Profane*. New York: W. W. Norton & Co., 2012.

Speigel, Lee. "Look! Is That a UFO Over Jesus' Head?" *The Huffington Post*, December 27, 2016. Accessed October 3, 2019: https://www.huffpost.com/entry/ufos-in -renaissance-art_n_5679991de4b014efe0d7044b\.

CHAPTER 4: SENTIMENTAL, CHEESY, AND . . .
SOCIALLY CONSCIOUS: NORMAN ROCKWELL AND THE 1960S

Ball, Howard. *Murder in Mississippi: United States v. Price and the Struggle for Civil Rights*. Lawrence: University Press of Kansas, 2004.

Bernstein, Richard. "Shedding Light on How Simpson's Lawyers Won." *The New York Times*, October 16, 1996. Accessed January 23, 2019: https://www.nytimes.com /1996/10/16/books/shedding-light-on-how-simpson-s-lawyers-won.html\.

Gerstein, Josh. "Art Sends Rare W.H. Message on Race." *Politico*, August 24, 2011. Accessed January 2, 2019: https://www.politico.com/story/2011/08/art-sends-rare -wh-message-on-race-061677\.

Hennessey, Maureen Hart, and Anne Classen Knutson. *Norman Rockwell: Pictures for the American People*. New York: H. N. Abrams, 1999.

Huie, William Bradford. "The Shocking Story of Approved Killing in Mississippi." *Look*, vol. 20, no. 2 (January 24, 1956): 46–48, 50.

Kamp, David. "David Kamp on Norman Rockwell." *Vanity Fair*, January 31, 2015. Accessed January 22, 2019: https://www.vanityfair.com/culture/2009/11/norman -rockwell-200911\.

"Norman Rockwell's *The Problem We All Live With* to be Exhibited at The White House—Press Release." Norman Rockwell Museum website. July 05, 2011. Accessed January 22, 2019: https://www.nrm.org/2011/05/norman-rockwells-the -problem-we-all-live-with-to-be-exhibited-at-the-white-house\.

Pero, Linda Szeckely. *American Chronicles: The Art of Norman Rockwell*. Stockbridge: Norman Rockwell Museum, 2007.

Petrick, Jane Allen. *Hidden in Plain Sight: The Other People in Norman Rockwell's America*. Miami: Informed Decisions Publishing, 2013.

Rockwell, Abigail. "Norman Rockwell and the Post: A Fruitful Relationship: The Saturday Evening Post." *The Saturday Evening Post*, May 18, 2016. Accessed January 15, 2019: https://www.saturdayeveningpost.com/2016/05/a-fruitful-relationship\.

SIDEBARS

Nesbett, Peter T., and Michelle DuBose. *Jacob Lawrence: Paintings, Drawings, and Murals (1935–1999): A Catalogue Raisonné*. Seattle: University of Washington Press, 2011.

CHAPTER 5: THE LADY VANISHES: THE (MULTIPLE) THEFTS AND FORGERIES OF THE *MONA LISA*

Charney, Noah. *The Thefts of the Mona Lisa: On Stealing the World's Most Famous Painting.* New York: ARCA, 2011.

Clark, Kenneth. *Leonardo da Vinci.* New York: Penguin Books, 1993.

Decker, Karl. "Why and How the *Mona Lisa* Was Stolen." *The Saturday Evening Post,* June 25, 1932.

Kemp, Martin. *Leonardo by Leonardo.* New York: Callaway Press, 2019.

Scotti, R. A. *Vanished Smile: The Mysterious Theft of the Mona Lisa.* New York: Vintage Press, 2010.

TEA/AECOM. "2018 Theme Index and Museum Index." Accessed October 11, 2019: https://www.aecom.com/content/wp-content/uploads/2019/05/Theme-Index-2018-5-1.pdf\.

SIDEBARS

Associated Press. "Mona Lisa's Hidden Symbols? Researcher Says Yes." *CBS News,* January 12, 2011. Accessed January 10, 2019: https://www.cbsnews.com/news/mona-lisas-hidden-symbols-researcher-says-yes\.

Daley, Jason. "Was Mona Lisa's Enigmatic Smile Caused by a Thyroid Condition?" *Smithsonian Magazine,* September 10, 2018. Accessed January 10, 2019: https://www.smithsonianmag.com/smart-news/mona-lisa-may-have-had-thyroid-disorder-180970245\.

Ratcliffe, James. "Why the Gardner Museum's Paintings May Never Be Found." *Apollo,* May 18, 2016. Accessed July 10, 2019: https://www.apollo-magazine.com/why-the-isabella-stewart-gardner-museums-paintings-may-never-be-found.

Sayej, Nadja. "Will Boston's $500m Art Heist Ever Be Solved?" *The Guardian,* January 19, 2018. Accessed July 10, 2019: https://www.theguardian.com/artanddesign/2018/jan/19/boston-art-heist-isabella-stewart-gardner-museum\.

"The Theft." Isabella Stewart Gardner Museum website. Accessed July 10, 2019: https://www.gardnermuseum.org/about/theft-story#chapter1\.

Villarreal, Ignacio. "Italian Researcher Silvano Vinceti Claims He Has Found Symbols in 'Mona Lisa'." *ArtDaily,* January 11, 2011. Accessed July 10, 2019: http://artdaily.com/news/44112/Italian-Researcher-Silvano-Vinceti-Claims-He-has-Found-Symbols-in—Mona-Lisa-\.

CHAPTER 6: A CORPSE CORNUCOPIA: RENAISSANCE ARTISTS, ANATOMY, AND THE MYTH OF BODY TRAFFICKING

Bambach, Carmen. "Anatomy in the Renaissance." Heilbrunn Timeline of Art History, the Metropolitan Museum of Art website, October 2002. Accessed September 29, 2019: https://www.metmuseum.org/toah/hd/anat/hd_anat.htm\.

Brown, Elizabeth A. R. "Authority, the Family, and the Dead in Late Medieval France." *French Historical Studies*, vol. 16, no. 4 (Autumn 1990): 803–832.

Carlton, Genevieve. "Turns Out Michelangelo and Da Vinci Trafficked Dead Bodies for Their Art." Ranker. Accessed October 9, 2019: https://www.ranker.com/list /anatomy-in-renaissance-art/genevieve-carlton\.

Clayton, Martin, and Ron Philo. *Leonardo Da Vinci: The Mechanics of Man*. London: Royal Collection Enterprises Ltd., 2010.

Howse, Christopher. "The Myth of the Anatomy Lesson." *The Telegraph*, June 10, 2009. Accessed October 3, 2019: https://www.telegraph.co.uk/comment/columnists /christopherhowse/5496340/False-myth-of-the-anatomy-lesson.html\.

Jones, Roger. "Leonardo Da Vinci: Anatomist." *The British Journal of General Practice: The Journal of the Royal College of General Practitioners*, vol. 66, no. 599 (June 2012): 319.

Land, Norman E. "Michelangelo, Giotto, and Murder." *Explorations of Renaissance Culture*, vol. 32, issue 2 (December 2006): 204–224.

Laurenza, Domenico. "Art and Anatomy in Renaissance Italy: Images from a Scientific Revolution." *The Metropolitan Museum of Art Bulletin*, vol. 69, no. 3 (Winter 2012): 4–48.

Martin, John Jeffries. *The Renaissance: Italy and Abroad*. Abingdon-on-Thames: Routledge, 2002.

Mavrodi, Alexandra, and George Paraskevas. "Mondino De Luzzi: A Luminous Figure in the Darkness of the Middle Ages." *Croatian Medical Journal*, vol. 55, no. 1 (February 2014): 50–53.

Park, Katharine. "The Criminal and the Saintly Body: Autopsy and Dissection in Renaissance Italy." *Renaissance Quarterly* 47, no. 1 (1994): 1–33.

——. *Secrets of Women: Gender, Generation, and the Origins of Human Dissection*. Brooklyn: Zone Books, 2010.

——. "That the Medieval Church Prohibited Human Dissection," *Galileo Goes to Jail and Other Myths about Science and Religion*, ed. Ronald L. Numbers. Cambridge: Harvard University Press, 2009.

Righthand, Jess. "The Anatomy of Renaissance Art." *Smithsonian Magazine*, October 18, 2010. Accessed October 8, 2019: https://www.smithsonianmag.com/science -nature/the-anatomy-of-renaissance-art-36887285\.

Rox, Philippa. "What Leonardo Taught Us about the Heart." BBC News, June 28, 2014. Accessed October 8, 2019: https://www.bbc.com/news/health-28054468\.

Santing, Catrien. "Andreas Vesalius's 'De Fabrica corporis humana,' depiction of the human model in word and image." *Netherlands Yearbook for History of Art, vol. 58: Body and Embodiment in Netherlandish Art* (2007–8): 58–85.

Shwayder, Maya. "Debunking a Myth." *Harvard Gazette*, April 7, 2011. Accessed September 12, 2019: https://news.harvard.edu/gazette/story/2011/04/debunking-a-myth\.

Sooke, Alastair. "When Leonardo Da Vinci Met Death: Dissected Corpses, Embryos and Hearts Sculpted Out of Glass." *The Telegraph*, May 2, 2019. Accessed October 4, 2019: https://www.telegraph.co.uk/art/artists/leonardo-da-vinci-met-death-dissected-corpses-embryos-hearts\.

Sterpetti, Antonio V. "Cardiovascular Research by Leonardo Da Vinci (1452–1519)." *Circulation Research*, vol. 124, no. 2 (January 18, 2019): 189–191.

Vasari, Giorgio. *The Lives of the Most Excellent Painters, Sculptors, and Architects*. New York: Modern Library Classics, 2006.

SIDEBARS

Cronenwett, Molly L. *Mary as Mortal: Unraveling the Rejection of Caravaggio's* Death of the Virgin. Master's Thesis, University of North Carolina, Chapel Hill, 1999.

Hall, James. *Michelangelo and the Reinvention of the Human Body*. New York: Farrar, Straus and Giroux, 2005.

Majumdar, Bappa. "Human Bone Smuggling Racket Uncovered." *Reuters*, June 19, 2007. Accessed October 8, 2019: https://www.reuters.com/article/us-india-bones/human-bone-smuggling-racket-uncovered-idUSDEL10463220070619\.

Tsoi, Grace. "China's Ghost Weddings and Why They Can Be Deadly." BBC News, August 24, 2016. Accessed October 8, 2019: https://www.bbc.com/news/world-asia-china-37103447\.

CHAPTER 7: THE (POSSIBLE) MURDER OF VINCENT VAN GOGH

"125 Questions and Answers." Van Gogh Museum website. Accessed March 23, 2019: https://www.vangoghmuseum.nl/en/125-questions/questions-and-answers\.

Anderson, Ariston. "Venice: Julian Schnabel Says Van Gogh Film 'At Eternity's Gate' Is 'Impossible' to Explain." *The Hollywood Reporter*, October 3, 2018. Accessed March 23, 2019: https://www.hollywoodreporter.com/news/julian-schnabel-says-van-gogh-film-at-eternitys-gate-is-impossible-explain-1139299\.

Bailey, Martin. "Van Gogh: It Was Suicide, Not Murder." *The Art Newspaper*, October 25, 2018. Accessed March 23, 2019: https://www.theartnewspaper.com/blog/van-gogh-it-was-suicide-not-murder\.

Benson, Gertrude R. "Exploding the Van Gogh Myth." *The American Magazine of Art*, vol. 29, no. 1 (January 1936): 6–16.

Gogh, Vincent Van. *The Letters of Vincent Van Gogh*. Edited by Ronald de Leeuw. London: Penguin, 1997.

Meedendorp, Teio, and Louis Van Tilborgh. "The Life and Death of Vincent van Gogh." *The Burlington Magazine*, vol. 155, no. 1325 (July 2013): 456–462.

Naifeh, Steven, and Gregory White Smith. *Van Gogh: The Life*. New York: Random House Trade Paperbacks, 2012.

SIDEBARS

Bailey, Martin. "Gauguin Blames Van Gogh over Ear Incident." *The Art Newspaper*, June 7, 2019. Accessed July 23, 2019: https://www.theartnewspaper.com/blog /gauguin-blamed-van-gogh-over-ear-incident-yellow-house-arles\.

Kaufmann, Hans, and Rita Wildegans. *Van Goghs Ohr: Paul Gauguin und der Pakt des Schweigens*. Berlin: Osburg Verlag, 2008.

Neuendorf, Henri. "Woman Gifted Van Gogh's Ear Finally Identified." *Artnet*, July 20, 2016. Accessed July 23, 2019: https://news.artnet.com/art-world/van-gogh-ear -gabrielle-berlatier-566720\.

Samuel, Henry. "Van Gogh's Ear 'Was Cut off by Friend Gauguin with a Sword.'" *The Telegraph*, May 4, 2009. Accessed July 23, 2019: https://www.telegraph.co.uk /culture/art/art-news/5274073/Van-Goghs-ear-was-cut-off-by-friend-Gauguin -with-a-sword.html\.

Wolf, Paul. "Creativity and Chronic Disease Vincent van Gogh (1853–1890)." *Western Journal of Medicine* 175, no. 5 (2001): 348.

CHAPTER 8: THE ODYSSEY OF AN ODDITY, OR THE MANY ADVENTURES OF *SALVATOR MUNDI*

Adam, Georgina. "Leonardo's Salvator Mundi Has Been Marketed as a Rock Star." *The Art Newspaper* 27, no. 295 (November 2017): 5.

Alberge, Dalya. "Paris Louvre 'Will Not Show' World's Most Expensive Painting Amid Doubts Over Authenticity." *The Telegraph*, February 16, 2019. Accessed August 3, 2019: https://www.telegraph.co.uk/news/2019/02/16/paris-louvre-will-not-show -worlds-expensive-painting-doubts\.

Bailey, Martin. "Your First Chance to See the 'New' Leonardo." *The Art Newspaper*, no. 227 (September 2011): 38–39.

——. "Is This a Leonardo?" *The Art Newspaper*, no. 229 (November 2011): 109.

Christie's. "The Last Leonardo Da Vinci—Salvator Mundi | Christie's." YouTube, October 10, 2017. Accessed August 3, 2019: https://www.youtube.com/watch?v =hCHD-6s2tes\.

Clark, Kenneth. *Leonardo da Vinci*. New York: Penguin Books, 1993.

Cole, Alison. "Salvator Mundi: Expert Uncovers 'Exciting' New Evidence." *The Art Newspaper*, no. 304 (September 2018): 1–9.

Corbett, Rachel. "8 Things You Should Know About Leonardo Da Vinci's 'Salvator Mundi,' His Holy Mona Lisa." *Artnet News*, October 11, 2017. Accessed August 10, 2019: https://news.artnet.com/art-world/8-things-know-100-million-da-vinci -discovery-salvator-mundi-1111775\.

Davis, Ben. "The Perplexingly Popular Conspiracy Theory That 'Salvator Mundi' Is Connected to #Russiagate, Explained." *Artnet News*, January 10, 2019. Accessed August 11, 2019: https://news.artnet.com/opinion/debunking-the-perplexingly

-popular-conspiracy-theory-that-salvator-mundi-is-connected-to-russiagate-1434352\.

Daliville, Margaret, Martin Kemp, and Robert Simon. *Leonardo's 'Salvator Mundi' and the Collecting of Leonardo in the Stuart Courts.* Oxford: Oxford University Press, 2019.

"Embassy Statement on Art Work Purchase." The Embassy of The Kingdom of Saudi Arabia website, December 8, 2017. Accessed August 10, 2019: https://www.saudiembassy.net/news/embassy-statement-art-work-purchase\.

Farago, Jason. "That $450 Million Leonardo? It's No Mona Lisa." *The New York Times,* November 16, 2017. Accessed August 5, 2019: https://www.nytimes.com/2017/11/15/arts/design/salvator-mundi-da-vinci-painting.html\.

Freeman, Nate. "Christie's to Offer Last Leonardo Painting Left in Private Hands at November Contemporary Sale, Estimated at $100 M." *ARTnews,* October 10, 2017. Accessed August 4, 2019: http://www.artnews.com/2017/10/10/christies-to-offer-last-leonardo-painting-left-in-private-hands-at-november-contemporary-sale-estimated-at-100-m\.

Harris, Shane, Kelly Crow, and Summer Said. "Saudi Arabia's Crown Prince Identified as Buyer of Record-Breaking Da Vinci." *The Wall Street Journal,* December 8, 2017. Accessed August 10, 2019: https://www.wsj.com/articles/saudi-arabias-crown-prince-identified-as-buyer-of-record-breaking-da-vinci-1512674099\.

Kemp, Martin. "Doubly Lost: Why the *Salvator Mundi*'s Failure to Show Up at the Louvre is to be Greatly Regretted." *The Art Newspaper,* January 30, 2020. Accessed January 30, 2020: https://www.theartnewspaper.com/comment/doubly-lost-salvator-mundi-fails-to-show-up-at-the-louvre\.

——. *Leonardo by Leonardo.* New York: Callaway Press, 2019.

——. "Sight and Salvation: Martin Kemp Sifts the Evidence That Leonardo da Vinci Painted the Newly Emerged Work Salvator Mundi." *Nature* 479, no. 7372 (2011): 174.

Kinsella, Eileen. "Leonardo's 'Salvator Mundi' Is Coming to the Louvre Abu Dhabi, the Museum Says." *Artnet News,* December 6, 2017. Accessed August 11, 2019: https://news.artnet.com/art-world/leonardo-da-vincis-450m-blockbuster-salvator-mundi-is-en-route-to-louvre-abu-dhabi-1171523\.

Kirkpatrick, David D. "Mystery Buyer of $450 Million 'Salvator Mundi' Was a Saudi Prince." *The New York Times,* December 6, 2017. Accessed August 11, 2019: https://www.nytimes.com/2017/12/06/world/middleeast/salvator-mundi-da-vinci-saudi-prince-bader.html\.

——. "Saudi Crown Prince Was Behind Record Bid for a Leonardo." *The New York Times,* December 8, 2017. Accessed August 11, 2019: https://www.nytimes.com/2017/12/07/world/middleeast/saudi-crown-prince-salvator-mundi.html?module=inline\.

Hope, Charles. "A Peece of Christ." *London Review of Books*, vol. 42, no. 1 (January 2, 2020). Accessed February 3, 2020: https://www.lrb.co.uk/the-paper/v42/n01/charles-hope/a-peece-of-christ?mc_cid=d56c679452&mc_eid=1fb6cc70a6\.

"Leonardo da Vinci: *Salvator Mundi.*" *Post-War and Contemporary Art*, sale catalog, Christie's, sale date November 15, 2017.

Lewis, Ben. *The Last Leonardo: The Secret Lives of the World's Most Expensive Painting*. New York: Ballantine Books, 2019.

Rea, Naomi. "Masterpiece in the Middle East: Da Vinci's 'Salvator Mundi' Will Debut at the Louvre Abu Dhabi This Fall." *Artnet News*, June 28, 2018. Accessed August 5, 2019: https://news.artnet.com/art-world/salvator-mundi-louvre-abu-dhabi-september-18-1309967\.

Ruiz, Cristina. "'We Want Salvator Mundi' for Leonardo Blockbuster, Louvre Says." *The Art Newspaper*, February 18, 2019. Accessed August 5, 2019: https://www.theartnewspaper.com/news/we-want-salvator-mundi-louvre-says\.

Snow-Smith, Joanne. "The Salvator Mundi of Leonardo Da Vinci." *Arte Lombarda*, Nuova Serie, no. 50 (1978): 69–81.

Sutton, Benjamin, Hrag Vartanian, Zachary Small, and Hakim Bishara. "Is Leonardo's 'Salvator Mundi' Going to the Louvre? [UPDATED]." *Hyperallergic*, December 8, 2017. Accessed August 6, 2019: https://hyperallergic.com/414171/is-leonardos-salvator-mundi-going-to-the-louvre\.

"The Rediscovery of a Masterpiece: Chronology, Conservation, and Authentication: Leonardo's Salvator Mundi—Its History, Rediscovery and Restoration." Christie's, November 3, 2017. Accessed August 5, 2019: https://www.christies.com/features/Salvator-Mundi-timeline-8644-3.aspx\.

SIDEBARS

Calfas, Jennifer. "Banksy Shredded a Piece of Art That Sold for $1.4 Million. Now It's Worth Double, According to an Art Expert." *Money*, October 8, 2018. Accessed May 23, 2019: http://money.com/money/5418695/banksy-girl-with-a-balloon-self-destruct-double\.

Martin, Guy. "Clues and Legal Liabilities: What Happened After Banksy Shredded His Own $1.4 Million Artwork." *Forbes*. January 2, 2019. Accessed May 23, 2019: https://www.forbes.com/sites/guymartin/2018/12/31/clues-and-legal-liabilities-what-happened-after-banksy-shredded-his-own-1-4-million-artwork/#2ba389b661c7\.

North Carolina Museum of Art: Handbook of the Collection. Raleigh, NC: 2010.

CHAPTER 9: SÉANCES AND SURPRISES:
THE SPIRITUALIST WOMEN WHO INVENTED MODERN ART

Abbott, Karen. "The Fox Sisters and the Rap on Spiritualism." *Smithsonian Magazine*, October 30, 2012. Accessed September 12, 2019: https://www.smithsonianmag.com/history/the-fox-sisters-and-the-rap-on-spiritualism-99663697\.

"About Hilma Af Klint." Hilma af Klint Foundation website. Accessed September 12, 2019: https://www.hilmaafklint.se/about-hilma-af-klint\.

Althaus, Karin, Matthias Mühling, and Sebastian Schneider, eds. *World Receivers: Georgiana Houghton, Hilma af Klint, Emma Kunz, and John Whitney, James Whitney, and Harry Smith*. Catalog of an exhibition held at Lenbachhaus, Munich, 2018.

Bashkoff, Tracey R., and Julia Voss. *Hilma af Klint: Paintings for the Future*. New York: Guggenheim Museum, 2018.

Bishara, Hakim. "Hilma af Klint Breaks Records at the Guggenheim Museum." *Hyperallergic*, April 23, 2019. Accessed September 4, 2019: https://hyperallergic.com/496326/hilma-af-klint-breaks-records-at-the-guggenheim-museum\.

Brown, Mark. "Spiritualist Artist Georgiana Houghton Gets UK Exhibition." *The Guardian*, May 5, 2016. Accessed August 25, 2019: https://www.theguardian.com/artanddesign/2016/may/05/spiritualist-artist-georgiana-houghton-uk-exhibition-courtauld\.

Burgin, Christine, ed. *Hilma af Klint: Notes and Methods*. Chicago: The University of Chicago Press, 2018.

Davis, Ben. "Why Hilma af Klint's Occult Spirituality Makes Her the Perfect Artist for Our Technologically Disrupted Time." *Artnet News*, October 29, 2018. Accessed September 12, 2019: https://news.artnet.com/exhibitions/hilma-af-klints-occult-spirituality-makes-perfect-artist-technologically-disrupted-time-1376587\.

Ersman, Hedvig, and Johan af Klint. "Inspiration and Influence: The Spiritual Journey of Artist Hilma af Klint." Guggenheim.org. *Checklist* blog, October 11, 2018. Accessed September 4, 2019: https://www.guggenheim.org/blogs/checklist/inspiration-and-influence-the-spiritual-journey-of-artist-hilma-af-klint\.

Freeman-Attwood, Jessica. "The Divine Messages of a Victorian Spiritualist's Drawings." *Hyperallergic*, September 8, 2016. Accessed August 25, 2019: https://hyperallergic.com/321452/the-divine-messages-of-a-victorian-spiritualists-drawings\.

Grant, Simon, Lars Bang Larsen, and Marco Pasi. Edited by Ernst van Claerbergen, and Barnaby Wright. *Georgiana Houghton—Spirit Drawings*. London: The Courtauld Gallery, 2016.

Houghton, Georgiana. *Evenings at Home in Spiritual Séance: Prefaced and Welded Together by a Species of Autobiography*. London: Trübner & Co., Ludgate Hill, 1989.

Kellaway, Kate. "Hilma af Klint: A Painter Possessed." *The Guardian*, February 21, 2016. Accessed September 6, 2019: https://www.theguardian.com/artanddesign/2016/feb/21/hilma-af-klint-occult-spiritualism-abstract-serpentine-gallery\.

Müller-Westermann, Iris, David Lomas, Pascal Rousseau, and Helmut Zander. *Hilma af Klint: A Pioneer of Abstraction*. Stockholm: Moderna Museet, 2013.

Oberter, Rachel. "Esoteric Art Confronting the Public Eye: The Abstract Spirit Drawings of Georgiana Houghton." *Victorian Studies*, vol. 48, no. 2 (Winter 2006): 221–232.

Roethel, Hans K., and Jean K. Benjamin. "A New Light on Kandinsky's First Abstract Painting." *The Burlington Magazine* 119, no. 896 (1977): 770, 772–773.

Ross, Fred. "Abstract Art Is Not Art and Definitely Not Abstract." Art Renewal Center website. Accessed September 12, 2019. https://www.artrenewal.org/Article/Title/abstract-art-is-not-art\.

Schjeldahl, Peter. "Out of Time: Hilma af Klint's Visionary Paintings." *The New Yorker*, October 22, 2018.

Solly, Meilan. "From Obscurity, Hilma Af Klint Is Finally Being Recognized as a Pioneer of Abstract Art." *Smithsonian Magazine*, October 15, 2018. Accessed September 12, 2019: https://www.smithsonianmag.com/smart-news/guggenheim-spotlights-swedish-spiritualist-hilma-af-klint-europes-little-known-first-abstract-artist-180970530\.

Voss, Julia. "The First Abstract Artist? (And It's Not Kandinsky)." Tate Britain website, June 25, 2019. Accessed August 19, 2019: https://www.tate.org.uk/context-comment/articles/first-abstract-artist-and-its-not-kandinsky\.

Williams, Sara. Introduction to *Evenings at Home in Spiritual Séance: Prefaced and Welded Together by a Species of Autobiography* by Georgiana Houghton. London: Trübner & Co., Ludgate Hill, 1989.

SIDEBARS

Choucha, Nadia. *Surrealism and the Occult: Shamanism, Magic, Alchemy, and the Birth of an Artistic Movement*. Rochester: Destiny Books, 1992.

Hughes, Virginia. "Were the First Artists Mostly Women?" *National Geographic*, October 10, 2013. Accessed August 16, 2019: https://www.nationalgeographic.com/news/2013/10/131008-women-handprints-oldest-neolithic-cave-art\.

Kaplan, Louis. "Where the Paranoid Meets the Paranormal: Speculations on Spirit Photography." *Art Journal*, vol. 62, no. 3 (Autumn, 2003): 1–29.

CHAPTER 10: BOOTY TUNES: THE "BUTT MUSIC" OF BOSCH'S *THE GARDEN OF EARTHLY DELIGHTS*

Gibson, Walter S. *The Art of Laughter in the Age of Bosch and Bruegel*. Leider: Primavera Press, 2003.

Falkenburg, Reindert. *The Land of Unlikeness: Hieronymus Bosch, The Garden of Earthly Delights*. Zwolle: WBooks, 2011.

Leith, Sam. "Shocking News from Oxford: You Can't Play a Flute with Your Bottom." *The Guardian*, November 7, 2010. Accessed April 4, 2019: https://www.theguard ian.com/music/2010/nov/07/sam-leith-shocking-news-oxford\.

Moroto, Pilar Silva, ed. *Bosch: The 5th Centenary Exhibition*. London: Thames and Hudson, 2016.

Rowlands, John. *The Garden of Earthly Delights: Hieronymus Bosch*. Oxford: Phaidon, 1979.

Stephens, Amy Dee. "Getting to the Bottom of a 500-Year-Old Mystery." *Vision: Oklahoma Christian University*, Summer 2014.

"The Music Written on This Dude's Butt." "Resident Art Goblin," Tumblr, February 11, 2014. Accessed April 5, 2019: https://chaoscontrolled123.tumblr.com/post/7630 5632587/luke-and-i-were-looking-at-hieronymus-boschs\.

"Weird Detail Found in Historic Painting." *Anderson Cooper 360*, CNN News, March 1, 2014. Accessed April 5, 2019: https://www.cnn.com/videos/offbeat/2014/03/01 /ac-ridiculist-oklahoma-music-art-appreciation.cnn/video/playlists/best-of-the -ridiculist\.

SIDEBARS

"Rokeby Venus: The Painting That Shocked a Suffragette." BBC News, March 10, 2014. Accessed April 14, 2019: https://www.bbc.com/news/blogs-magazine-monitor -26491421\.

Wainwright, Tim. "Hieronymus Bosch, the Trendiest Apocalyptic Medieval Painter of 2014." *The Atlantic*, November 24, 2014. Accessed April 12, 2019: https://www .theatlantic.com/entertainment/archive/2014/11/hieronymus-bosch/381852\.

CHAPTER 11: A READY-MADE REVELATION: IS A GERMAN BARONESS RESPONSIBLE FOR A MARCEL DUCHAMP MASTERPIECE?

Bailey, Bradley. "Duchamp's 'Fountain': The Baroness Theory Debunked." *The Burlington Magazine*, vol. 161, no. 1399 (October 2019): 805–810.

Biddle, George. *An American Artist's Story*. Boston: Little, Brown, 1939.

Birmingham, Stephen. "Art That's Still Armed and Dangerous." *The New York Times*, September 8, 1996. Accessed July 24, 2019: https://www.nytimes.com/1996/09 /08/arts/art-that-s-still-armed-and-dangerous.html?mtrref=undefined&gwh =ADF6BDC09436BA0EEDC3A2B4A150720F&gwt=pay\.

Breton, André. "La Phare de la mariée." *Minotaure*, vol. 2, no. 6 (1935).

Cabanne, Pierre. *Dialogues with Marcel Duchamp*. New York: Viking Press, 1971.

Camfield, William A. "Marcel Duchamp's Fountain, Its History and Aesthetics in the Context of 1917." *Dada/Surrealism* 16 (1987): 71–79.

Cotter, Holland. "The Mama of Dada." *The New York Times*, May 19, 2002. Accessed July 24, 2019: https://www.nytimes.com/2002/05/19/books/the-mama-of

-dada.html?mtrref=undefined&gwh=A2B8620BFD57EF02EA077C1B1C
62AD74&gwt=pay\.

"Duchamp's Urinal Tops Art Survey." BBC News, December 1, 2004. Accessed on May
17, 2019: http://news.bbc.co.uk/2/hi/entertainment/4059997.stm\.

Gammel, Irene. *Baroness Elsa: Gender, Dada, and Everyday Modernity—A Cultural
Biography.* Cambridge: The MIT Press, 2002.

——."Taking Off Her Chemise in Public: New York Dada, Irrational Modernism, and
the Baroness Elsa von Freytag-Loringhoven." *Oxford Art Journal* 28, no. 1 (2005):
135–138.

Higgs, John. *Stranger Than We Can Imagine: An Alternative History of the 20th Cen-
tury.* Toronto: Signal, 2016.

"How Duchamp Stole the Urinal." *Scottish Review of Books.* Accessed July 24, 2019:
https://www.scottishreviewofbooks.org/2014/11/how-duchamp-stole-the-urinal\.

Johns, Jasper. "Marcel Duchamp (1887–1968)."*Artforum*, vol. VII, no. 3 (November 1968).

Jones, Amelia.*Irrational Modernism: A Neurasthenic History of New York Dada.* Cam-
bridge: The MIT Press, 2004.

Lebel, Robert. "Marcel Duchamp." Biographical entry, brittanica.com. Accessed on
May 17, 2019: https://www.britannica.com/biography/Marcel-Duchamp\.

Naumann, Francis. *New York Dada, 1915–23.* New York: Abrams, 1994.

"Nothing is Here: Dada Is Its Name." *American Art News*, vol. XIX, no. 25 (Apr. 2,
1921): 1, 7.

Paijmans, Theo. "Het urinoir is niet van Duchamp." *See All This*, no. 10 (Summer
2018): 18.

Quinn, Bridget. *Broad Strokes: 15 Women Who Made Art and Made History (in That
Order).* San Francisco: Chronicle Books, 2017.

Steinke, René. "My Heart Belongs to Dada." *The New York Times*, August 18, 2002.
Accessed July 24, 2019: https://www.nytimes.com/2002/08/18/magazine/my
-heart-belongs-to-dada.html?mtrref=undefined&gwh=176A53EC1B31C070F4A
ECD2B471A50C9&gwt=pay\.

Tsai, Jamie. "Marcel Duchamp and the Arensbergs." Lecture given to the Art Gallery
Society at the Art Gallery of New South Wales on July 27, 2016. Accessed on
May 17, 2019: https://www.academia.edu/27352425/Marcel_Duchamp_and_the
_Arensberg_Collection\.

SIDEBARS

Emelife, Aindrea. "Claude Cahun: The Trans Artist Years Ahead of Her Time." BBC
News, June 29, 2016. Accessed July 24, 2019: http://www.bbc.com/culture/story
/20160629-claude-cahun-the-trans-artist-years-ahead-of-her-time\.

Jones, Jonathan. "Modern Art Is Rubbish? Why Mistaking Artworks for Trash Proves
Their Worth." *The Guardian*, October 27, 2015. Accessed July 24, 2019: https://

www.theguardian.com/global/shortcuts/2015/oct/27/modern-art-is-rubbish-why
-mistaking-artworks-for-trash-proves-their-worth\.

CHAPTER 12: TOENAILS AND JUNK MAIL: ANDY WARHOL'S TIME CAPSULES

Anderson, Brian. "The Future Is Still Now: Inside Westinghouse's Time Capsule 1."
 Vice, April 30, 2013. Accessed May 9, 2019: https://www.vice.com/en_us/article
 /aeepa5/the-future-is-still-now-inside-westinghouses-time-capsule-1\.

"Andy Warhol: Stars of the Silver Screen." The Andy Warhol Museum website. Ac-
 cessed May 9, 2019: https://www.warhol.org/exhibition/andy-warhol-stars-of-the
 -silver-screen\.

Artner, Alan G. "Andy Warhol's Garage Sale." *The Chicago Tribune*, April 24, 1988.

Barclay, Amy. "Andy Warhol: To Have and to Hold, a Portrait of the Artist as Collec-
 tor." *Andy Warhol's Time Capsules*. Melbourne: National Gallery of Victoria, 2005.

Hoban, Phoebe. *Basquiat: A Quick Killing in Art*. New York: Viking Adult, 1998.

Kine, Starlee. "Thought That Counts." *This American Life*, podcast audio, December
 20, 2013. Accessed May 9, 2019: https://www.thisamericanlife.org/514/thought
 -that-counts/.

Schmidt, Christopher. "Warhol's Problem Project: The Time Capsules." *Postmodern
 Culture*, vol. 26, no. 1 (September 2015).

Smith, John, ed. *Andy Warhol's Time Capsule 21*. Pittsburgh: The Andy Warhol Mu-
 seum, 2004.

Warhol, Andy. *The Philosophy of Andy Warhol (From A to B and Back Again)*. New
 York: Harcourt Brace Jovanovich, 1977.

SIDEBARS

Harron, Mary, and Daniel Minahan. *I Shot Andy Warhol*. London: Bloomsbury, 1996.

Hermann, Michael Dayton, and Reuel Golden, eds. *Warhol on Basquiat*. Cologne:
 Taschen, 2019.

Credits

p. 2 Claude Monet (1840–1926), *Impression: Sunrise*, 1872, oil on canvas, 50 x 65 cm, Musée Marmottan Monet, Paris, France, gift of Don Eugène et Victorine Donop de Monchy, 1940 (inv. No. 4014).

p. 20 Jackson Pollock (1912–1956), *Number 1, 1950 (Lavender Mist)*, 1950, oil on canvas, 221 x 299.7 cm, National Gallery of Art, Washington, D.C. © 2020 The Pollock-Krasner Foundation / Artists Rights Society (ARS), New York.

p. 38 Walter Sickert (1860–1942), *Jack the Ripper's Bedroom*, 1906–1907, oil on canvas, 50.8 x 40.7 cm, Manchester Art Gallery, Manchester, Great Britain, bequeathed by Mrs. Mary Cicely Tatlock, 1980 (1980.303).

p. 58 Norman Rockwell (1894–1978), *Murder in Mississippi*, 1965, oil on canvas, Norman Rockwell Museum, Stockbridge, MA. Printed by permission of the Norman Rockwell Family Agency. Copyright ©1965 the Norman Rockwell Family Entities.

p. 76 Leonardo da Vinci (1452–1519), *Mona Lisa* (*La Joconde*, or *Portrait of Lisa Gherardini*), c. 1503–1506 (with possible later additions), oil on poplar panel, 77 x 53 cm, Musée du Louvre, Paris, France (inv. no. 779).

p. 100 Antonio del Pollaiuolo (c. 1432–1498), *Battle of Nude Men* (or *Battle of Ten Nudes*), c. 1490, engraving on paper, second state.

p. 116 Vincent van Gogh (1853–1890), *Wheatfield with Crows*, 1890, oil on canvas, 50.2 x 103 cm, Van Gogh Museum (Vincent van Gogh Foundation), Amsterdam, The Netherlands (object no. s0149V1962).

p. 140 (attributed to) Leonardo da Vinci (1452–1519), *Salvator Mundi*, c. 1500, oil on walnut panel, 65.6 x 45.4 cm, private collection.

p. 160 Hilma af Klint (1862–1944), *The Swan, No. 12, Group IX SUW*, 1915, oil on canvas, 151.5 x 151 cm, Hilma af Klint Foundation, Stockholm, Sweden.

p. 180 Hieronymus Bosch (c. 1450–1516), *The Garden of Earthly Delights*, c. 1503–1515, oil on panel, 220 x 390 cm, Museo Nacional del Prado, Madrid, Spain (object no. 2823).

p. 196 Marcel Duchamp (1887–1968), *Fountain*, 1917. Original sculpture lost. Photograph by Alfred Stieglitz and originally published in *The Blind Man*, no. 2, page 4 (New York, May 1917). Editors: Henri-Pierre Roche, Beatrice Wood, and Marcel Duchamp.

p. 222 Andy Warhol (American, 1928–1987), *Time Capsule 44*, 1890–1973, mixed archival material, the Andy Warhol Museum, Pittsburgh; Founding Collection, Contribution The Andy Warhol Foundation for the Visual Arts, Inc. (Accession no. TC44) © 2020 The Andy Warhol Foundation for the Visual Arts, Inc. / Licensed by Artists Rights Society (ARS), New York.

Index

Citations in *italics* refer to illustrations.

P.O. 0005157639 20220211